SCULPTURAL MONUMENTS
In an Outdoor Environment

A conference held at the
Pennsylvania Academy of the Fine Arts
Philadelphia
November 2, 1983

Edited by
Virginia Norton Naudé

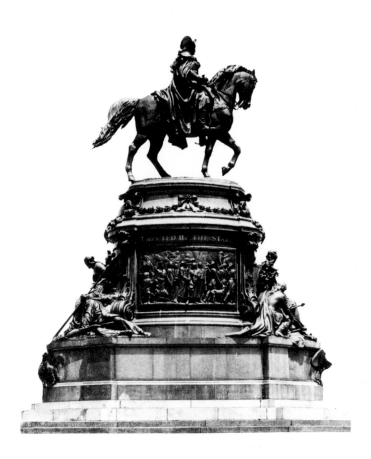

Front Cover: (upper left to lower right)
Rudolf Siemering, *The Washington Monument,* Philadelphia.
Detail. Photograph by Franko Khoury.
Felix de Weldon, *Rear Admiral Richard Evelyn Byrd,* Arlington,
Virginia. National Park Service photograph.
Rudolf Siemering, *The Washington Monument,* Philadelphia.
Detail. Photograph by Franko Khoury.
Henry Moore, *Three Way Piece No. 1: Points,* Philadelphia.
Photograph by Franko Khoury.
Rudolf Siemering, *The Washington Monument,* Philadelphia.
Detail. Photograph by Franko Khoury.

Title Page:
Rudolf Siemering, *The Washington Monument,* Philadelphia.
Detail. Photograph by Franko Khoury.

Copyright © 1985
Pennsylvania Academy of the Fine Arts
Broad and Cherry Streets
Philadelphia, Pennsylvania 19102

Published with the assistance of:
The J. Paul Getty Trust
Samuel H. Kress Foundation
National Museum Act, administered by the
 Smithsonian Institution
Eastern National Park and Monument Association
American Conservation Association

Library of Congress Cataloging in Publication Data
Main entry under title:

Sculptural monuments in an outdoor environment.

 Bibliography: p.
 1. Bronzes—Conservation and restoration—
United States—Congresses. 2. Outdoor sculpture—
Conservation and restoration—United States—
Congresses. I. Naudé, Virginia Norton, 1939–
NB1230.S38 1985 738.1'8 85-3623
ISBN 0-943836-04-2

Designed by Barbara Sosson
Printed in the United States of America

CONTENTS

ACKNOWLEDGMENTS

Everyone involved in the Pennsylvania Academy's endeavor to produce a record of the past history and current thinking about outdoor sculpture conservation wishes to thank Muriel and Philip Berman, who supported the conference, and the following donors of grants which made this publication possible:

> The J. Paul Getty Trust
> Samuel H. Kress Foundation
> National Museum Act, administered by the
> Smithsonian Institution
> Eastern National Park and Monument Association
> American Conservation Association

I am very grateful for the assistance of all the conference speakers (later, authors) who, aside from their individual contributions, offered enthusiasm and help during the conference planning stage and later advised on the form and expanded content of the book. We all want to thank Margaret Pyle Hassert of the University Writing Center at the University of Delaware, who edited the conference transcripts and adjusted the delicate balance between the spoken and written word.

Special acknowledgment goes to Nicolas F. Veloz, who compiled the information submitted for a ''List of Outdoor Bronze Sculptures Recently Conserved'' (Appendix A); to Mark L. La Riviere, who created the drawings for Andrew Lins's article; and to Barbara Sosson, who designed this book.

Many of the sculptures used for illustrations are in Fairmount Park, Philadelphia. They are all owned by the Fairmount Park Commission of the City of Philadelphia, which kindly permitted their publication. All other photography credits and acknowledgments appear in the illustration captions.

V.N.N.

EvAngelos Frudakis, *The Fishing Bear*, Philadelphia Zoo.

SCULPTURAL MONUMENTS IN AN OUTDOOR ENVIRONMENT INTRODUCTION

Frank H. Goodyear, Jr.

This publication has evolved as the result of a conference held on November 2, 1983, at the Pennsylvania Academy of the Fine Arts and cosponsored by the Fairmount Park Art Association. The conference was initiated in response to interest generated by the Fairmount Park Association's sculpture conservation program of 1982-83. Unsolicited questions and comments demonstrated a growing concern about Philadelphia's public monuments in urban and park settings. The conference intended to address the general confusion about the desirability, effectiveness, and cost of conservation treatments.

Transcripts of the taped proceedings were edited by the various participants; illustrations, footnotes, a bibliography, a glossary, and appendixes were added to make this publication a clear record of information and ideas gathered here in 1983-84. Even in a field that is rapidly changing through advances in technology, this book will stand as a reliable reference for the documents and events that form the foundation of a new area of specialization. For professionals in various disciplines interested in public art, the collected papers will suggest a philosophy and a method of cooperation whose value cannot go out of date.

The conference was made possible through the generosity of Muriel and Philip Berman, who were also registrants at the meeting. The program was initiated by Penny Bach, Project Director of the Fairmount Park Art Association, and by Virginia Naudé, the Academy's sculpture conservator, who invited the speakers, worked out the logistics, and subsequently edited this publication. I am convinced that museums are principally known for three things: their great collections, their great curators, and their great conservators. The expertise of our conservator, Virginia Naudé, has enabled the Academy to become a major center for sculpture conservation in this country.

Some observations that I made when I opened the conference follow, recording a conviction that much more should and can be done to address successfully the issues presented at the conference. The publication of this book confirms the Academy's commitment to contribute.

November 2, 1983

Most of us in the museum profession and those of us like you who sit on association boards are usually more anxious to commit money and energy to acquiring new works of art than to conserving the works that are already in place in collections or around the city. I find that somewhat ironic. I am puzzled by the notion that it is easier to raise money to acquire something new than it is to take care of something old. I am also somewhat disturbed by the fact that many museum directors and curators, people of great distinction, are experts when it comes to acquisitions but know little or nothing about conservation. I cannot resolve that in my own mind. I think we need a generation of museum directors and curators and park administrators and supervisors and people like you who are committed to the notion of conservation at the highest level.

All of us who are in positions of responsibility to care for the artistic legacy of this country have a sacred trust, and I think we ought to know what the ethics and the procedures of conservation are. This conference intends to deal with some of the problems related to conservation and to the ethics of conservation of works in bronze in an outdoor environment. I have seen the list of attendees, and I am told that most of you in the audience are in decision-making positions that may affect the long-term well-being of bronze sculpture or other types of material sculpture. I feel sure that you approach such a responsibility with the utmost seriousness and seek the best information possible. If you do not, I would venture to say that the objects in your care are not getting what they deserve. Faced with a changing environment, we must learn how to treat outdoor monuments in the proper way.

We at the Academy are very much committed to the notion of conservation on the highest level, and it is out of such a belief that I enthusiastically endorse this conference.

Joseph P. Pollia, *General Thomas Jonathan (Stonewall) Jackson,* Manassas National Battlefield Park, Virginia. National Park Service photograph by Dan Riss.

OPENING REMARKS

Virginia Norton Naudé

This conference has been organized for the purpose of sharing professional experience in the preservation of outdoor sculpture. We hope the material presented will be useful to owners of outdoor monuments as well as to others who participate in making decisions about the structural stability and visual appearance of this special group of art objects. Although every sculpture has a unique set of requirements for successful preservation and although the plans for one sculpture may not be adequate for the needs of another, there are some common ways to identify and address the main issues.

Metal sculpture, specifically bronze, is the main topic today, but the approach to solving some of the particular problems with bronze may well be applicable to other kinds of material, such as stone. The reason we are not including discussions specifically about the deterioration and treatment of stone is that the problems are sufficiently complex and different from those of bronze to require a separate conference on that material alone. Moreover the long-term results of the methods presently advocated for preserving stone are not predictable at this time. However, in the area of bronze preservation, enough scientific evidence is currently available to approach the task of arresting bronze deterioration with the confidence that the time and money spent on the work will have positive long-term results.

The speakers this morning will discuss various technical, aesthetic, historical, and ethical issues. The speakers this afternoon will discuss concerns involved in conservation projects and will report on specific treatments. At the end of the conference the audience will be invited to ask questions or make statements for the record.

Before I introduce any of the speakers, I want to introduce the audience. Some of you are owners of sculptures that may be displayed in your own gardens or placed on loan on the grounds of an institution. Some of you are curators and care for outdoor sculptures that have been entrusted to you by individuals or institutions. Some of you are scholars of the history of sculpture and, along with the curators, concern yourselves with why monuments are created and what the sources are for the images used. Some of you are custodians of public collections that are owned by all the people of a city, state, or nation. Some of you commission new works. Some of you buy and sell sculpture. Some of you make sculpture—you are sculptors, casters, founders; you understand better than any of us the limitation and the potential of the material.

Some of you design or restore sites or buildings around which sculptures are displayed. Some of you move it and install it. Some of you repair and maintain it. I hope that none of you vandalizes it. Probably not, but, unfortunately, most of us take its presence in our outdoor environment for granted and we do not give much consideration to what is happening to it.

Most of the speakers today are conservators, the group of professionals who, in recent history, have played the leading role in the technical preservation of outdoor sculpture through examination, analysis, and treatment. At this point, conservators produce most of the documented work in the field. This documentation has provided a base for reliable data, making possible the responsible reporting and commentary you are about to hear.

Conservators' training in three separate areas—science, history of art, and the fine arts—has enabled us to begin to respond to the technical and aesthetic problems of outdoor art objects. But the treatments we perform and their relative merits and limitations, although often discussed among ourselves, are only one part of the dialogue that ought to take place on the subject of outdoor sculpture. A wider dialogue, which involves all of you whom I just introduced, should be encouraged. Some of you are already contributing; for others, this conference and its subsequent publication will provide the vocabulary and background to participate.

OUTDOOR BRONZES: Some Basic Metallurgical Considerations

Andrew Lins

The first speaker today is Andrew Lins, Conservator for Sculpture and Decorative Arts at the Philadelphia Museum of Art. He is also on the faculty of the University of Delaware, Winterthur Museum Art Conservation Program. He has advanced degrees from the Institute of Fine Arts, New York University, and from the London Polytechnic, where he studied engineering and corrosion science. For several years he was a student of sculpture here at the Pennsylvania Academy of the Fine Arts. V.N.N.

I am going to divide this talk concerning outdoor bronzes into four sections: (1) bronze casting, (2) structural problems, (3) surface deterioration, and (4) coatings. The material to cover in this short time is extensive, and we certainly will not be able to cover it all in more than a superficial way.

Bronze Casting

First, let me briefly review how bronzes are cast. Most of the sculptures that you will see in outdoor settings around this city are made by casting molten bronze into a mold. The various kinds of molds that can be used are numerous. Primary amongst these are sand-casting molds, lost-wax investment molds, and shell molds. Time allows us to discuss only one of these methods: sand casting. You will notice a number of bronzes made from sand-casting molds around this city, particularly bronzes cast before the turn of the century.

The sand-casting process begins with an artist's model, usually in clay. From the clay original, piece molds are used to make a plaster replica (figure 1: A and A'). After the replica has dried and been shellacked, it is half-buried in a bed of sand (B) held in a rigid metal frame (C and C'), usually cast iron or wrought iron.[1] The surface of the plaster is dusted with talc as a separator or release agent, and the sand is packed firmly in place, a process called ramming. The exposed top half of the sculpture is then covered with a series of small, carefully molded sand pieces (D and enlargement D'). The whole surface is covered with these pieces of fine molding sand, which are interlocked firmly together. The pieces of sand are held in place by a coarser outer bed of sand, supported in a second metal frame and again rammed to make the pieces firm (not illustrated). This same process is carried out for the other side of the plaster replica. The trick is then to extract the plaster replica without disturbing the very fine sand mold pieces.

When the two metal frames supporting the sand pieces are put back together, there is a large void formerly occupied by the plaster replica (E). In order to make the bronze casting hollow, a very desirable feature both for weight and for several other considerations, the void within the two halves of the mold is filled with what is called a core. The core (F and enlargement F') is constructed on an armature made of iron pipe, rod, and/or wire. Some rods, called core pins or chaplet pins, project out (G) and serve to steady the core in the mold

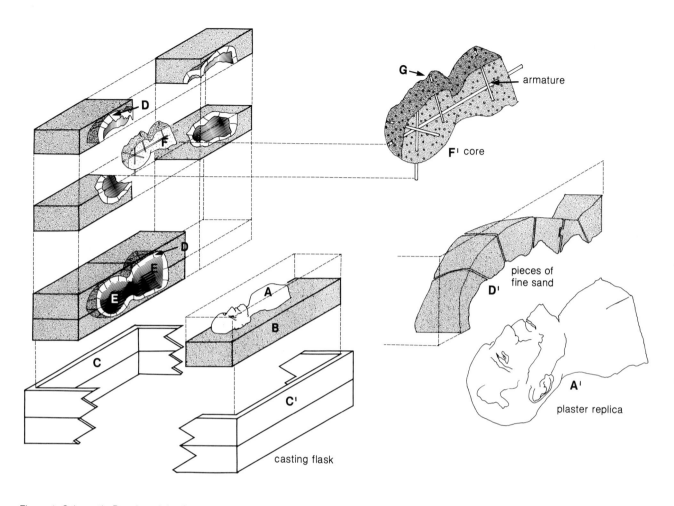

Figure 1: Schematic Drawing of the Sand-casting Process

during casting. The core material usually contains plaster, sand and wax rods, or organic material. The idea is to make this inner filling material, the core material, as porous as possible. Once this inner form is completed so that it nearly fills up the entire cavity formerly occupied by the replica, it is scraped back—normally from one-eighth to three-eighths of an inch—forming an empty space between the sand mold and the core[2]; see figure 2 (H), p. 10. Next, the surfaces of the halves of the mold are pierced in a number of places to provide channels that serve various purposes. Some channels, called gates (I and I'), allow hot metal to enter the empty space; others, called vents (J), permit gas to escape during the casting process. The metal is melted in a crucible and poured into the mold through sprue cups (K and K'). For large sculptures, the mold often is inverted when the molten metal is cast into it. The molten metal fills the space left when that one-eighth to three-eighths of an inch was scraped away from the core material (L). After the bronze has solidified in the mold, the object is removed from the mold, but there is still a great deal of work required

before the piece is finished. On the outside of the object are metal projections (M) formed during the casting process where metal solidified in the gates and vents. These have to be removed by grinding, sawing, or filing, as do the fins (N), metal that leaked out into cracks between the pieces of the mold. Once they are cut away, the surface is made smooth and even (O) by processes called chasing and finishing. Finally, the surface of the bronze is patinated. The raw bronze which is almost golden in color is often heated, and chemicals are brushed onto it, reacting with the metal to change its color. The artist usually specifies the color, and the founder chooses the chemicals that will produce the desired finished appearance. Sometimes a protective coating, such as wax or lacquer, is applied as well.

Now this, I hasten to add, is only one of a number of processes that can be used for creating a hollow casting of bronze. As you can see from the foregoing description, sand casting itself is a fairly complicated process. The number of steps, of course, affects the results; the skill with which each step is carried out affects the appear-

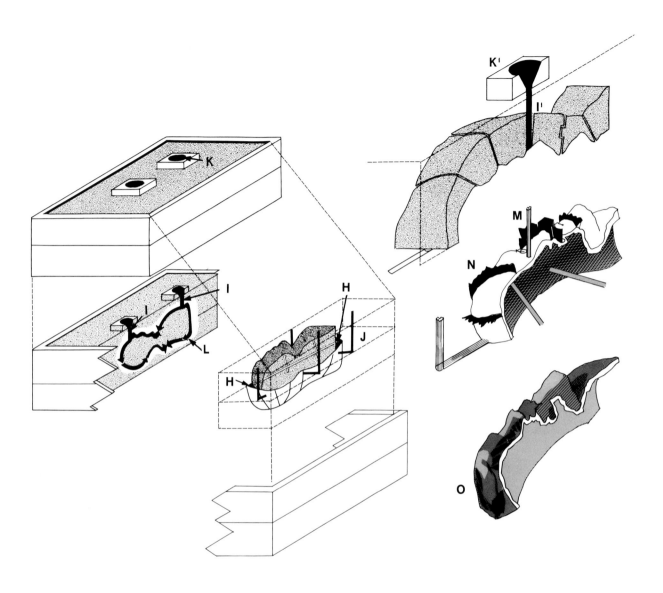

Figure 2: Schematic Drawing of the Sand-casting Process (continued)

ance, durability, and strength of the casting. The typical surface features of a sand casting are illustrated on a bronze head from the Rodin Museum, *Puvis de Chavannes,* the painter and a friend of Rodin (figure 3). Impressions of the sand mold and the remains of the fins, which were left after the casting of a multipiece mold and were not fully removed by chasing, are evident on the surface.

Structural Problems

Even though we have gone very quickly through one process for casting a bronze, you have been shown a number of steps, many of which can cause problems, particularly structural problems, for bronzes.

Many of the problems that occur on outdoor bronzes are due to core material or the remains of investment,

that is, the sand exterior support for the bronze during the casting. Lipchitz's *Prometheus Strangling the Vulture* (figure 4), in front of the Philadelphia Museum of Art, provides an example of problems caused by core materials. The white spots (figure 5) are plaster from the core; the plaster has migrated through the wall of the casting and now is appearing on the outside, resulting in an increase in the porosity of the walls, or a weakening of the walls of the cast. Some of these spots have brownish stains, probably rust, indicating that there is also iron armature left in this casting. Even though this is a very large casting and could well have been cleaned out at the foundry, it is not unusual to find this sort of material left inside in sloppy casting work, and it is often the cause of quite severe damage to the piece.

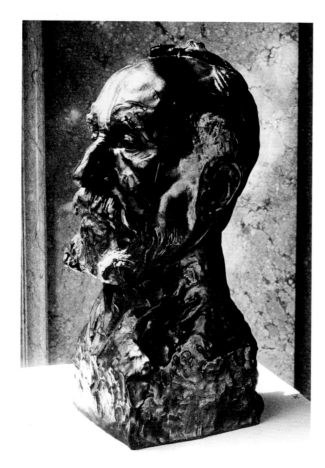

Figure 3: Auguste Rodin, *Puvis de Chavannes*. F 1929-7-12 Rodin Museum: Gift of Jules E. Mastbaum. Photograph by Rick Echelmeyer.

Structural problems with outdoor bronzes are often found at the attachment of the cast bronze to the base, regardless of how this is done. Let us look at the *William Penn* by Alexander Milne Calder (figure 8).[3] How is this sculpture, which is a fairly large and heavy one, held in place? If you look between and around his feet, you will see a number of whitish dots on the photograph. They are a series of wrought iron bolts used to hold the statue to the prepared base on Philadelphia's City Hall tower. Over time, in this environment, the wrought iron bolts severely corroded because of the juxtaposition of a noble metal and a baser metal. In fact, in the early 1970s the bolts were replaced because they were structurally so deteriorated that they could no longer provide adequate

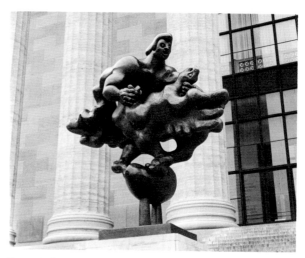

Figure 4: Jacques Lipchitz, *Prometheus Strangling the Vulture*. 1952-8-1 Philadelphia Museum of Art. Purchased: Lisa Norris Elkins Fund. Photograph by Rick Echelmeyer.

Let me illustrate the problem that occurs when castings with armatures show surface porosity due to shrinkage or gas formation in the mold. Figure 6 illustrates a detail from the *Washington Monument* by Rudolf Siemering, in front of the Philadelphia Museum of Art. There is considerable porosity in the casting of the extended foreleg on the stag. The armature in this rather thin section of the casting was not removed. The porosity of the casting allows water to come in contact with the armature whenever it rains or is very humid. The armature rusts and, in so doing, expands, thus splitting apart the bronze surface (figure 7).

Let me reiterate how this happens. If the armature sticking out into the wall of the sand pieces is not carefully finished off at the foundry, or if the plaster that constitutes most of the core material in many sand castings is not removed sufficiently, or if there is any kind of porosity in the surface that allows water to accumulate in the bronze, corrosion reactions will occur, such as the one seen in the *Washington Monument* or in the Lipchitz, causing the surface of the casting to deteriorate.

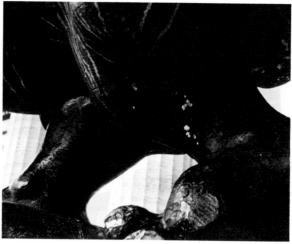

Figure 5: Detail of Figure 4. Photograph by Rick Echelmeyer.

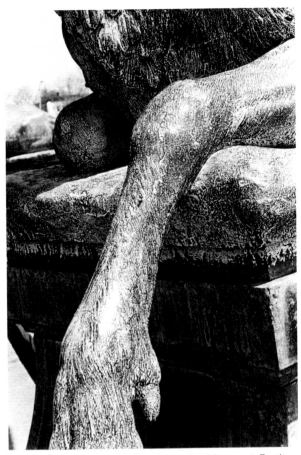

Figure 6: Rudolf Siemering, *The Washington Monument*. Foreleg of a stag. Photograph by Rick Echelmeyer.

Figure 7: Detail of Figure 6. Photograph by Rick Echelmeyer.

stability for the sculpture. Figure 9 illustrates this phenomenon, known as bimetallic or galvanic corrosion, a common cause of problems in many metals exposed to severe outdoor environments.

Other aspects of casting that lead to the ultimate deterioration of bronzes in outdoor environments include blowholes, gas porosity, shrinkage voids (4-8%), brittleness, and microsegregation—features often requiring magnification to see. Figure 10 is a simple schematic diagram of what a solid casting might look like, under some magnification, when a molten metal is cast into a mold. We might find planes of weakness or actual voids in the casting if the metal is poured when too hot into the mold or if the mold extracts the heat too rapidly from the molten liquid. When the metal hits the mold initially, it forms a layer called a chill layer, diagrammed in figure 10. Depending on how fast the heat is withdrawn by the mold, columnar grains may develop, creating a weak or brittle section. When the casting temperature is right, equiaxed grains, which tend to be stronger and which provide a more durable casting, develop in the

center of the casting. Typical of a cast section is the appearance of blowholes or porosity, seen under high magnification in figure 11. They are caused by the expulsion of gases from the solidifying metal and in some cases by a little bit of water on the mold wall. When molten metal is introduced into the mold, the water forms steam, the steam generates pressure, and the pressure results in holes in the casting. Dirt or imperfections in the mold materials can lead to similar problems.

Another common problem in sand casting is that the mold wall may not be able to withstand the temperature of the molten metal when it is first poured and may partially collapse. The little bit of dark material on the right-hand side of figure 10 represents this. When pieces of the sand mold are damaged, the finished appearance of the bronze surface is directly affected, as illustrated on the back of a female figure (figure 12) from the *Washington Monument*. The very bright spots in the middle, the squares and odd shapes, are repairs to the casting necessitated by flaws in various sections of the sand mold. Perhaps they are due to the mold wall

holes in the brazing. On a very fine microscopic level (on the order of a hundred times magnification), it can be seen that the cast bronze which appears homogeneous to the eye is, in fact, not at all homogeneous and that the edges of the grains of metal are often quite different in composition from the interior of those grains of metal. These differences in composition ("inhomogeneities") lead to corrosion on a subtle or microscopic level, which can nonetheless be very damaging in severely corrosive atmospheres.

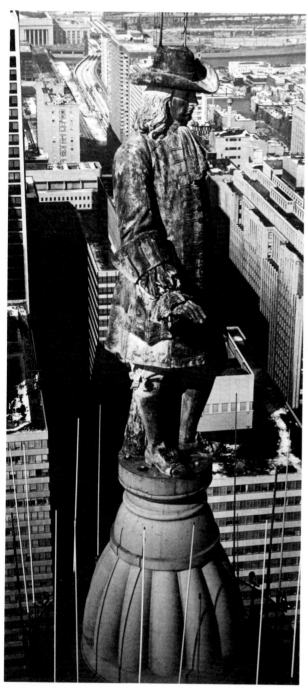

Figure 8: Alexander Milne Calder, *William Penn*. Photograph by Bernie Cleff.

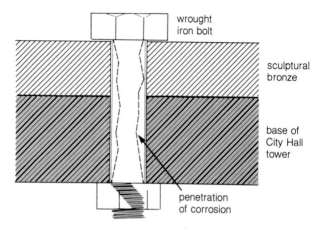

Figure 9: Schematic Drawing of Bimetallic Corrosion

wrought
iron bolt

sculptural
bronze

base of
City Hall
tower

penetration
of corrosion

Surface Deterioration

Now let us address the issue at hand: how bronzes in the environment deteriorate. I propose here a very brief and simplistic description of different stages of bronze deterioration in an aggressive urban environment:

1. induction period, dependent on acidity, abrasion, relative humidity
2. conversion of topmost surfaces to copper sulfate
3. runoff/streaking; black scab formation
4. spread of pitting; undermining of black scab
5. conversion of all exposed surfaces to sulfate

The rates at which the different stages appear and deterioration progresses depend on a great many variables. The aggressiveness of the environment is very important as is the positioning of the sculpture in a particular site. Every site has a specific level of pollution, with a specific orientation to the prevalent wind and rain conditions and to local pollution sources; in fact, even from one side of a

flaking off, as suggested in figure 10, upper right edge. These repairs are normally done by peening in new pieces of metal.

Figure 13 is an example of a brazed join under high magnification. The material in the middle is the brazing metal, and all the dark areas in the central section are

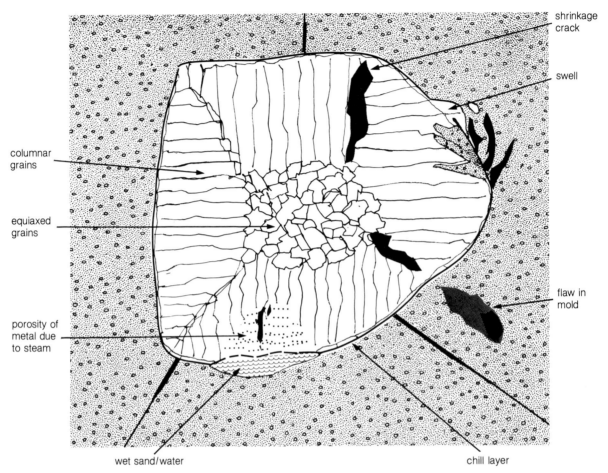

columnar grains

equiaxed grains

porosity of metal due to steam

shrinkage crack

swell

flaw in mold

wet sand/water

chill layer

Figure 10: Schematic Diagram of Solid Casting

sculpture to another, you can find quite different conditions of pollution. Moreover, the composition of pollutants in the air can often vary enormously from one time of the year to another. Sulfate is a particular worry for us in this area because the greens and blues that we see on the outside bronzes are mainly sulfates of copper. Here is an analysis of some of the solids that occur in the air:

COMMON AEROSOL PARTICLES
CONTAINING SULFATE

H_2SO_4	$MgSO_4$
NH_4HSO_4	$CaSO_4$
$(NH_4)_3H(SO_4)_2$	Na_2SO_4
$(NH_4)_2SO_4$	$ZnSO_4$

from AMOROSO AND FASSINA, 1983[4]

ANALYSIS OF PARTICULATES
LONDON, 1930

SAND	38%	Fe_2O_3	2.4%
CARBON	35%	$CaCO_3$	2.2%
ALUMINA	8.3%	TAR	1.5%
$(NH_4)_2SO_4$	5.8%	FIBER	0.9%
$CaSO_4$	5.1%	$MgCO_3$	0.3%
		NaCl	trace

from LEIDHEISER, p. 19[5]

Every outdoor sculpture, in urban areas in particular, is subject not only to a number of pollutants that are fairly noxious in terms of their chemical properties and corrosiveness to metal surfaces but also to some pollutants,

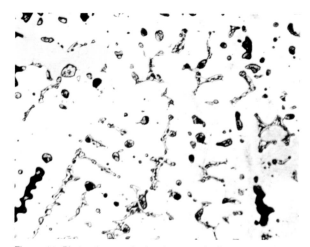

Figure 11: Photomicrograph showing porosity in cast metal. Reproduced through the courtesy of the Boston Museum of the Fine Arts, Research Laboratory.

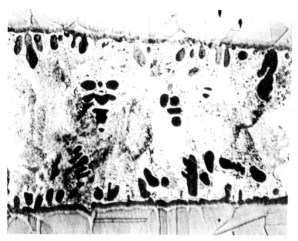

Figure 13: Photomicrograph of a brazed join. From *Art and Technology: A Symposium on Classical Bronzes,* edited by Suzannah Doeringer, David Gordon Mitten, and Arthur Steinberg, Cambridge, Mass.: The M.I.T. Press, 1970, Figure 11, p. 11. ©1970 by the Massachusetts Institute of Technology. Reprinted by permission of the publisher.

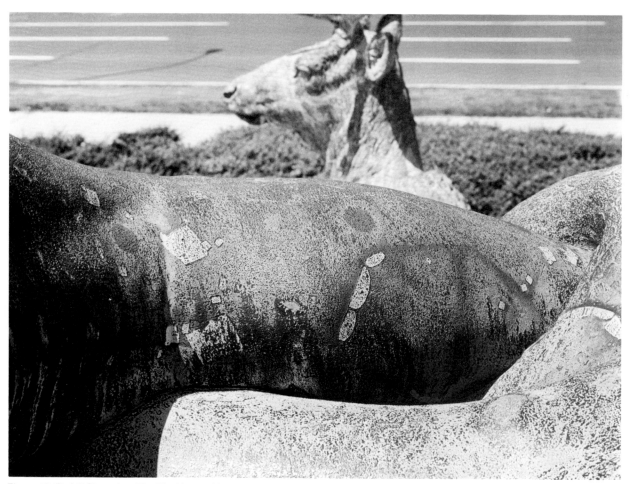

Figure 12: Rudolf Siemering, *The Washington Monument.* Detail of a female figure. Photograph by Rick Echelmeyer.

particularly silica and alumina, which in effect continuously sandblast the surfaces of the metal. Further, reactions can occur between different components of the airborne pollution. The following reaction suggests that hydrochloric acid can be generated:

$$2NaCl + H_2SO_4 \rightarrow 2HCl + Na_2SO_4$$

| SODIUM CHLORIDE | + | SULFURIC ACID | → | HYDRO-CHLORIC ACID | + | SODIUM SULFATE |

Even if generated in very small amounts, in parts per million, hydrochloric acid can be extremely detrimental to bronze sculpture and can accelerate corrosion processes enormously.

Let me also point out that on a given sculpture, in addition to pollution on one side perhaps being slightly different from on another, there may be temperature gradients. Last year in Rome, temperature sensors were placed on and in a sculpture of *Marcus Aurelius* to record the variations in temperature in different parts of the figure.[6] The temperature varied quite a bit from one pair of sensors to another; for instance, the difference between the area just in front of the tail of the horse on the upper surface and the belly of the horse was about twenty degrees. This large temperature gradient not only contributes to problems of stress but, more importantly, also affects the rate at which the corrosion reactions caused by pollution in the air may occur. Since these reactions are generally affected by temperature, the higher the temperature, the more rapid the corrosion rates.

In the 1930s an extremely able English corrosion scientist named Vernon did some careful studies on copper sheeting and the deterioration processes that it undergoes in the environment.[7] He described how a copper roofing material deteriorates: (1) brown film formation, (2) $CuSO_4$ crystals, after several months, (3) black skin, (4) copper sulfate: predominant corrosion product (7 mos.), (5) green patination.

Copper sheeting is made by rolling; in other words, it is a wrought structure. Figure 14 from the *Washington Monument* illustrates how a wrought structure differs from a cast structure in terms of corrosion reactions: to the right of the spear, a bright-green strip coming down beside the column with the acanthus leaf on it is a wrought piece that has formed a green barrier film of a copper sulfate known as brochantite. The covering is very even compared to the black, splotchy coating on the cast section of this part of the monument. A common distinction between cast and wrought bronzes in the outdoors is the ability of wrought bronzes to form a partially protective corrosion crust. There is some evidence that once the corrosion crust on a copper sheeting is fully formed over the whole of the surface, the sulfate, being almost insoluble, can form a barrier on the surface that slows

further corrosion attack. This copper sulfate has been analyzed as brochantite in Vernon's work and in some work subsequent to that. Of course, the green appearance is quite different from the original bright copper. Unfortunately, in our environment there is now some indication that this corrosion product, brochantite, is no longer the only major sulfate found on outdoor urban bronzes. In fact, what we are finding in some cases—for instance, on the *Statue of Liberty*—is a new corrosion product called antlerite:

$$\text{BROCHANTITE} \xrightarrow{\text{pH} < 4} \text{ANTLERITE}$$

$$CuSO_4 \cdot 3Cu(OH)_2 \rightarrow CuSO_4 \cdot 2Cu(OH)_2$$

You will notice that in this case, on the left-hand part of the formula, there are three copper hydroxide units, $Cu(OH)_2$, to one of copper sulfate, $CuSO_4$, for brochantite. Antlerite, which we are now seeing on a few sculptures in this region as well, has only two units of copper hydroxide to one of copper sulfate ($CuSO_4$). This means that a more acidic corrosion product, favored by conditions of substantial acidity in the environment, appears to be forming.

Figure 14: Rudolf Siemering, *The Washington Monument*. Detail of a frieze. Photograph by Rick Echelmeyer.

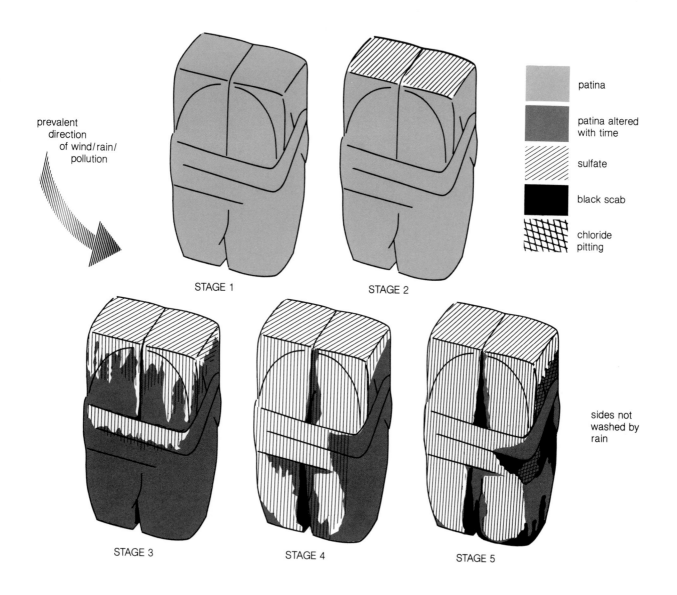

prevalent
direction
of wind/rain/
pollution

patina

patina altered
with time

sulfate

black scab

chloride
pitting

STAGE 1

STAGE 2

STAGE 3

STAGE 4

STAGE 5

sides not
washed by
rain

Figure 15: Schematic Drawing of Stages of Deterioration on a Sculptural Surface
(hypothetical bronze casting of Brancusi's *The Kiss*)

We do see substantial acidity in the rain in this environment; the pH in the rain is often under four.

Let me return now to the stages that we notice in outdoor bronzes in terms of their degradation. Figure 15 illustrates how the stages may appear on a sculpture. Figure 16 shows the corrosion stages in hypothetical cross sections that are highly magnified.

Initially, there is a patina applied to the clean surface of a bronze at the foundry. The patina may be dark; it may not be dark. It may have many layers; it may be a very simple coating. It is often applied with heat at the expense of some of the surface metal. The patina usually eats slightly into the metal during application, particularly in the case of higher temperature patinas. Artificial patinas are never completely neutral. They tend to change

and develop new mineral forms with time, so that during this initial phase of corrosion, or induction period, the patina on an outdoor bronze may grow slightly in thickness, assuming no protective coating has been applied over the patina.

Regardless of its structural complexity, the rate at which the patina will alter with time is determined by a number of factors—especially the acidity of local rain, the amount of abrasion from particulate material and other accumulated material on the surface, and the amount of water that rests on the surface over a long period of time, which is affected by the ambient relative humidity and temperature levels. In Philadelphia, for instance, relative humidity over 75%, which is enough to keep a metal surface pretty wet, seems to occur on many days,

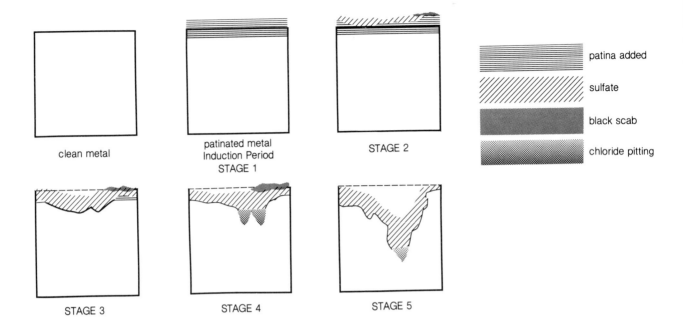

Figure 16: Schematic Drawings of Cross Sections of Metal During the Corrosion Process. The Y axis is greatly expanded for purposes of illustration.

perhaps three-quarters of the days of the year. So Philadelphia is a city where active corrosion may appear after a relatively short induction period.

The *second stage* of corrosion that we see on most outdoor bronzes is the conversion of the upper layers of a patinated cast bronze to a bright-green sulfate.

During the *third stage,* which occurs over a period of time in a severe environment, it becomes apparent that some of the sulfate is quite soluble and is not forming a coherent film, so that streaking and runoffs develop. It can be observed also that in the crevices where water does not wash the surface, the patina accumulates particulate matter and probably undergoes some growth in film thickness, forming what I am tentatively calling black scabs, which seem to contain not only copper, sulfur, and oxygen but which include other materials,[8] mostly carbon and iron-containing materials. The full analysis has yet to be made. The streaking of the sulfate down many figures on the *Washington Monument* has created etching more than a sixteenth of an inch deep, where the metal has been corroded away.

The *fourth stage* is the spreading of pitting in and around the black scab formations. The pits may and often do continue to grow underneath what may appear to be a fairly stable crust. Under certain conditions, if there is just a little bit of chloride underneath the crust, the penetration of corrosion under the black crust and even under the bright new green crust can go on insidiously with time, even though the surface may appear the same to the average viewer. A frieze from the *Washington Monument* shows some of the problem (figure 17). The drips on the bottom are from copper sulfate runoff, which colors the masonry green. In fact, if you look closely, you can see that they are not just sulfate runoffs but that deposits of copper sulfate are forming over soluble mortar nodules on the bottom of this piece; copper is being leached from the surface.

The *fifth* and *final stage* of corrosion would be the complete conversion of the rain-washed surface to a bright blue-green sulfate.

Coatings

Because of time constraints, I will have to close with a much too brief comment about coatings that are applied to outdoor bronzes to provide additional protection against corrosion. Many of the bronzes illustrated above had wax or shellac coatings when they left the foundry, coatings that have deteriorated with time. One of the reasons that a coating begins to deteriorate is that it is never perfectly applied. Figure 18 illustrates this. The coating has a small gap in it at the top. The little white nodules on the right suggest loose dust or perhaps loose particles of poorly applied patina. Any coating that is put on the top of such a surface can in time develop what we see on the bottom half of the illustration—blisters in the coating. Coatings can deteriorate in so many ways that we certainly cannot even list them all here, but I want to stress one critical

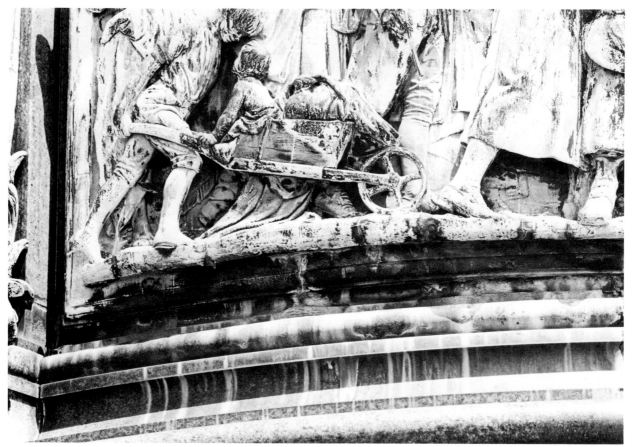

Figure 17: Rudolf Siemering, *The Washington Monument*. Detail of a frieze. Photograph by Rick Echelmeyer.

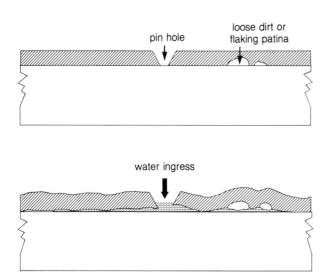

Figure 18:Schematic Drawing of the Deterioration of a Coating Film

phenomenon that usually causes the coating to fail: Wherever there is a gap or a particle that prevents the coating from adhering properly to the surface, water or pollution can make its way in. This means that with time the surface at that point will undergo corrosion as rapidly as the uncoated surfaces; in fact, in some cases the corrosion in the gaps in the coating occurs far more rapidly than if there were no coating there at all. The areas of active corrosion can then spread under the coating, undermining the coating mechanically and causing it to lose its protective value.

Further, virtually all organic coatings suffer degradation with time because of the effects of oxygen/ozone, ultraviolet light, and water, even in an unpolluted environment. In urban settings, when the effects of acid rain, auto emissions, and particulates are added, the rate of degradation of an organic coating increases dramatically. The useful lifetimes of present organic coatings are clearly limited, requiring careful inspection and renewal; this point must be carefully considered in all treatments of outdoor bronzes.

NOTES

1. The bottom section of a two-piece frame—or casting flask—
 is called the drag, and the top section is called the cope.
 Wood is another material commonly used in the construction
 of the flasks. There are many varieties of sands and additives
 used by different foundries, as well as a long list of different
 release agents that facilitate the removal of the plaster or
 other model once the molding process is completed.

2. The core materials vary widely from foundry to foundry.
 Frequently, the surface of the core is treated with charcoal or
 carbon black before the molten metal is poured. The thick-
 ness of the section is determined in part by the size of the
 sculpture and the strength required.

3. Alexander Milne Calder's sculpture stands 36′ 4″ high and
 weighs approximately 27 tons. It was cast at the Tacony Iron
 and Metal Works of Philadelphia in fourteen main sections,
 1890-91. *Sculpture of a City: Philadelphia's Treasures in
 Bronze and Stone.* New York: Walker Publishing Co., for
 Fairmount Park Art Association, 1974, pp. 104-09.

4. Amoroso, Giovanni G., and Fassina, Vasco. *Stone Decay and
 Conservation.* Amsterdam: 1983, pp. 89-90 and pp. 127-32.

5. Leidheiser, Henry, Jr. *The Corrosion of Copper, Tin, and Their
 Alloys.* The Electrochemical Society Corrosion Monograph
 Series. New York: John Wiley and Sons, 1971.

6. Accardo, Giorgio; Caneva, Claudio; and Massa, Sandro.
 "Stress Monitoring by Temperature Mapping and Acoustic
 Emission Analysis: A Case Study of Marcus Aurelius." *Studies
 in Conservation* 28, no. 2 (May 1983): 67-74.

7. Vernon, W.H.J., and Whitby, L. "The Open-Air Corrosion of
 Copper: A Chemical Study of the Surface Patina." *Journal of
 the Institute of Metals* 42 (1929):181; 44 (1930):389.

8. Block, Ira, and Sommer, Sheldon. "The Corrosion and Protec-
 tion of Outdoor Bronzes." In *Preprints of Papers Presented at
 the Tenth Annual Meeting, Milwaukee, Wisconsin, 26-30 May,
 1982.* Washington, D.C.: American Institute for Conservation
 of Historic and Artistic Works, 1982, pp. 22-26.

Rudolf Siemering, *The Washington Monument,* Philadelphia.
Detail. Photograph by Franko Khoury.

PATINA: Historical Perspective on Artistic Intent and Subsequent Effects of Time, Nature, and Man

Phoebe Dent Weil

The next speaker is Phoebe Dent Weil, who has a B.A. from Wellesley College and an M.A. from the Institute of Fine Arts, New York University. She has also studied extensively in Europe and is a Fellow of the International Institute for Conservation, as well as of the American Institute for Conservation. As Conservator at the Washington University Center for Archeometry and now as Chief Conservator of the Washington University Technology Associates, Mrs. Weil has been a leader in outdoor sculpture preservation through her laboratory work, site work, publications, and lectures. She will address us now as a historian in a field to which she has contributed several distinguished publications, the technical history of art.

V.N.N.

With a topic so vast and so rich, my task is not unlike an attempt to relate the history of sculpture, the history of scientific thought, the development of Western philosophical and aesthetic ideas, and the history of technology in the space of half an hour. It is surely an impossible task, but I hope to present some guideposts in an expansive and complex landscape and, in so doing, provide some new avenues of access, awareness, and enjoyment to these infinitely marvelous objects generally known as bronze sculpture.[1]

The Paragone: A Fresh Look at Theoretical Problems

In the apparent current revival of interest in sculpture, it is instructive to take a fresh look at our old friend the *Paragone,* or "Comparison of the Arts," primarily a philosophical discussion between connoisseurs and artists of the Renaissance in which the relative merits and specific characteristics of painting and sculpture were defined and debated. Leonardo da Vinci was a major contributor to the defense of painting, condemning sculpture as a "most mechanical exercise" and the sculptor as a "lowly laborer who works by the strength of his arm."[2] Michelangelo's famous reply to Benedetto Varchi, written in 1549, defends the special qualities of sculpture, stating: "I now consider painting and sculpture are one and the same thing [that is, equally valuable] unless greater nobility be imparted [to sculpture] by necessity for keener judgment, greater difficulties of execution, stricter limitations, and harder work."[3]

We might continue the discussion, as an aid to reconditioning eyes accustomed to studying and responding to painted images, by noting that:

1. It is still instructive for the beholder to consider the extraordinary difficulties of execution of sculpture, and the resulting necessity for the sculptor's work often to be the result of multiple collaboration. Collaborative effort is particularly required for bronze casting, but it has also been traditionally typical for stone carving as well. In both cases, the role of the sculptor can vary considerably, even to the point of no participation at all in the final work.

2. The beholder's visual experience in sculpture is fundamentally different from that required for painting. In order to be seen and experienced, sculpture requires change and physical movement on the part of the viewer. Further, there is a subtle but vibrant life imparted to the sculptural surfaces by the constantly changing quality, direction, and character of the light that falls on them.

3. Patina on the surfaces of bronze sculpture is not merely a color but contains a multiplicity of qualities, of which color is merely one element. The peculiar character of surface finish of the metal, of color variations, of transparency or opacity, of superimposition of colors as translucent glazes, of degree of matteness or reflectance, and a host of other variants all enter into a complex interplay.

These qualities are normally perceived as secondary characteristics of sculpture; that is, we first focus on form and content and then secondarily on the qualities of surface characteristics. As Josef Albers has pointed out, we have no memory for color, so that it is impossible to carry in our memory a great deal of precision about color and surface qualities.[4] Whatever we can carry requires a particular effort and interest, from whence comes an exceptional difficulty in communication. One man's "green" or "brown" will not be the same as another's, and if we describe a patina as "green" or "brown," we have said very little.

4. Further, an important aspect of a general consideration of the problem of color in sculpture is a phenomenon that seems to have originated during the Roman period and later became a particular concern of sculptors like Bernini and Houdon—namely, a separation between what Rudolph Wittkower has called "high-class" and "low-class" art, where greater sophistication of taste demands sculpture in a pure, more-or-less monochromatic medium, such as marble or bronze, and where the more naive prefer polychromy, or painted, "naturalistic" coloration.[5] The "pure," monochromatic medium demands the use of form and texture to imply a sense of color. Some sculptors have shunned coloristic effects for pure untextured forms. Others, like Bernini, have been deeply preoccupied with the problem of using form to imply color. Bernini pointed out that the problem particularly concerned him in portrait busts. He stated that if a live person were to paint his face, hair, beard, and, if possible, his eyeballs white like a marble bust, needless to say, he would not resemble himself at all.[6]

5. A final point in looking at sculpture, particularly bronzes, is to remember that sculpture is a medium of translation, or metamorphoses (to use the title word of the superb Fogg Museum exhibition of a few years ago).[7] Artistic ideas normally originate and evolve in noncolored media—the grays, blacks, and whites of clay, wax, and plaster—and are then translated into bronze or stone. This fact will influence in one way or another the sculptor's basic theoretical concept, which normally is dominated by either the so-called *glyptic* approach of carving technique or the *plastic* approach of modeling; or, as Leon Battista Alberti made the distinction, those sculptors who work *"per via di levare"* (by taking away) or *"per via di porre"* (by adding).[8]

To sum up, comprehension of artistic intent requires a deep intellectual and experiential understanding of problems of technique, technical manipulation, and materials as well as of historical changes in the theoretical foundations of sculpture. While the basic techniques of stone carving and bronze casting have remained relatively constant, dramatic developments have occurred in surface treatments and patina.

Patina: Natural and Artificial, Noble and Virulent

Let us now focus on the characteristics of patina on bronzes, but first let us make an attempt to fine-tune our descriptive vocabulary. There are four basic attributes of a patina on bronze sculpture that are to be found in the literature from ancient to modern times; these are typically paired as "natural" or "artificial" (*natürliche* and *künstliche* in the German literature) and as "noble" and "vile."

Natural patina, here represented by Hogarth's *Time Smoking a Picture* (figure 19), shows Father Time seated upon the ruins of the *Belvedere Torso,* his scythe piercing a canvas painting, while he exhales blackening fumes upon the picture surface. The Limet brothers, Père and Jean (figure 20), represent the late nineteenth-/early twentieth-century flourishing in Paris of the artful practice of artificial patination by patina specialists called master *patineurs.*

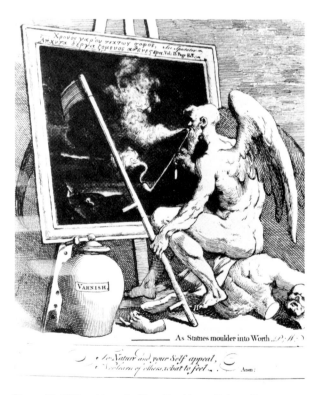

Figure 19: William Hogarth, *Time Smoking a Picture.* From *Hogarth to Cruikshank, Social Change in Graphic Satire,* by Dorothy George. ©1967 by Dorothy George. Reprinted by permission of Walker & Company.

Figure 20: *Père and Jean Limet, 'Master Patineurs', in Their Paris Studio, 1938. Blowtorch Heating the Bronze Before Applying Acids with Brush.* Photograph by Malvina Hoffman. Reprinted by permission of Malvina Hoffman Properties.

A natural patina is hard to find these days, but perhaps the closest we can come to it is found on the arm of Cellini's *Medusa* beneath the feet of the *Perseus* in the Loggia dei Lanzi, Florence, whose glossy, translucent, stable, and protective oxide patina is maintained by the caresses of passers-by. An exemplar of a small Degas *Horse* in a private collection in St. Louis, cast after Degas's death by Hébrard, is an unusually appealing example of an artificial patina.

"Noble" and "vile" are terms that appear in Pliny's first-century A.D. *Historia Naturalis,* or *Natural History,* where a distinction is made between two kinds of *aerugo* (*aerugo* derived from *aes* [bronze] and *robigine* [rust], that is, the rust, or corrosion, of bronze).[9] The first, *aerugo nobilis,* may be translated "noble patina"; the second, *virus aerugo,* has been called "vile patina" but might better be translated "virulent patina" to distinguish between corrosion products that are attractive, enhancing, and stable and those that serve as virulent destructive agents. These latter two distinctions are represented by the handsome, glossy, compact, tin-rich, noble patina often found on excavated Etruscan mirrors (figure 21) and

by the face of a typical outdoor urban bronze (figure 22), a virulent patina of modern origin, namely, industrial pollution.

The literature in which these various qualities—artificial/natural and noble/virulent—are discussed is rich, fascinating, and highly entertaining; occasionally downright hilarious and sometimes highly ironic. A.H. Hiorns, whose book appeared in 1892, is one of the most articulate writers in English on the subject of patination, and perhaps the most sophisticated and observant. He typically demonstrates great admiration for the effects of "Nature" on metals, stating that it is a good thing to attempt to imitate those effects with the important condition: "always provided that the colours aimed at are strictly in keeping with the metallic character."[10] Elsewhere he states, "a metallic article is not like a

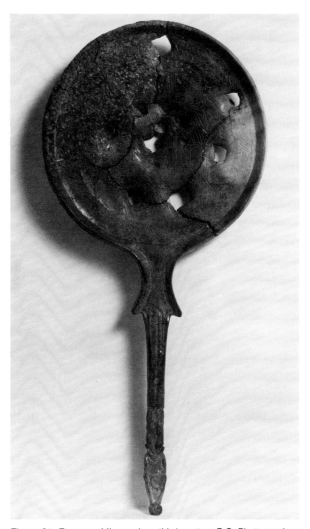

Figure 21: Etruscan Mirror, circa third century B.C. Photograph courtesy of the Fogg Art Museum, Harvard University. Transfer from the Department of Classics, Harvard University, Haynes Bequest.

canvas or paper, which has to be completely covered with paint of all colours . . . but a material which must always assert its peculiar metallic character, so that there is never any doubt as to its real nature."[11]

A German contemporary of Hiorns describes a noble-natural patina (*schöne Patina,* or *Edelrost*) on outdoor bronze sculpture as a

> green or brown, polished, peculiarly attractive, translucent, almost greasy [surface] which leaves no doubt that metal lies beneath. The translucent surface does not come from treatment but is simply a result of patina formation and owes its beauty not only to a green color, but rather it means that the warm, red-brown tones are displayed as well.[12]

Friedrich Rathgen, founder of the first museum laboratory in Berlin in the 1890s, describes noble and virulent patinas on excavated bronzes:

> If a patina is to deserve the name of a good, sound, or, as it is termed, a "noble" patina (edel-patina), the original contours of the bronze with all its markings must be distinctly visible. For this the patina must not be too thick, must be of moderate hardness, and above all must have an enamel-like surface.

He postulates a scientific explanation:

> Apart from chemical influences, such a patina can only have been formed in those cases in which the alloy has been homogeneous, fine-grained, dense and not porous, and when its surface has been so smooth that oxidation has taken place very slowly More frequently met with than these varieties, or than the so-called noble patina, is that in which the bronze presents a more or less rough and pitted surface, light or dark green, or even grey in colour if there is a large proportion of lead present. More rarely the tint is blue or brown.[13]

Before we proceed to a quick look at historical attitudes and methods from ancient to modern times, I need to mention just a word about the problems of photo-graphing patinas and about having any confidence at all that the photographed and projected image comes anywhere close to the actual object. It simply does *not,* and you must not fool yourselves into thinking that it does. Luckily, accompanying this conference there is an exhibition mounted by Linda Bantel, where you may have your eyes refreshed by the real thing; and, of course, not too far away are the Philadelphia Museum of Art and the Rodin Museum, where you may look further.

Patina: A Brief Survey of Historical Attitudes from Antiquity to the Twentieth Century

There is good evidence that in ancient times the com-monly accepted appearance appropriate for artistic metal-work was the brilliant, reflective, and polished or burnished state. Wherever a descriptive word or phrase is used in connection with bronze in the writings of Homer, it is invariably "resplendent," "polished," "gleaming," "brilliant," and the like. Telemachus removed his father's arms and armor from the banqueting hall, out of reach of

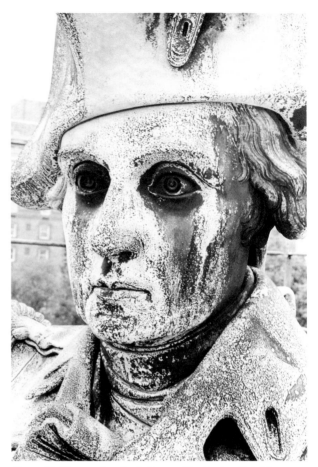

Figure 22: Thomas Crawford, *George Washington,* Detail from the *Washington Monument,* Richmond, Virginia. Before-treatment photograph by WUTA/SCL.

his mother's suitors, with an excuse he knew would be understood by all: They were becoming tarnished from excessive exposure to the smoky fumes of the cooking fires.[14]

That evidence lies in the bronze sculptures themselves has been convincingly pointed out in studies by Erich Pernice (1910)[15] and Gisela Richter (1915),[16] who conclude that the ancients finished their bronze work with a high polish. That is not to say that sculpture and other bronze artifacts were not without a variety of coloristic and textural effects. They were, in fact, resplendent with variety, as the *Charioteer of Delphi* or the recently dis-covered Riace bronzes demonstrate, with their inlaid colored eyes made of semiprecious stones, their long bronze eyelashes, their copper lips and nipples, and their gleaming silver teeth. Coloration was achieved in ancient times with a variety of means, all of which were entirely dependent upon the bright and untarnished appearance of the whole. These brilliant effects were maintained with a coating of pine tar pitch, periodically removed, surfaces repolished, and the coating reapplied.

Parallel to the admiration, in ancient times, of the resplendent, polished surface was a fascination with the colored corrosion products of copper. Cyril Smith has cited this development as a particularly good example, among many, of scientific discovery motivated by aesthetic curiosity, for the results served to form the foundations of alchemy and thereby of chemistry itself.[17] Edward Forbes has noted that the origin of the word "chemistry" is to be found in the ancient Greek *chyma,* meaning "casting," as a result of the experimentation with properties and color-producing reactions of metals by the ancient metal workers.[18] Documents such as Pliny's *Historia* and the early ninth-century *Mappae Clavicula*[19] describe the artificial production of corrosion products on copper, using vinegar and other reagents. The colored powders that resulted were used for pigments, cosmetics, and various medicinal purposes, such as the healing of sores and ulcers; but they were not in any way related to the finishing or coloration of bronze statuary.

The overall gilding of large-scale outdoor sculptures was a comparatively late arrival in Roman times and was looked upon by Pliny as redundant, since the golden condition could be maintained using coatings and occasional repolishing. The visual effects of the gold surfaces formed by a mercury-amalgam technique on large-scale, outdoor Roman statuary appear to have been modified by using a scratching technique to enhance the reading of the sculptural forms and to counteract the blinding reflections of the surface.[20]

During the Renaissance, coloristic effects were still achieved primarily through gilding or by the use of contrasting alloys on small objects. The most popular and most common finish for bronzes large and small was the application of a dark lacquer, such as on Donatello's *David,* the first free-standing, full-length bronze figure cast since antiquity. The use of this dark lacquer may have been the result of a misinterpretation of Pliny's mention of a bituminous coating used on ancient bronzes, presuming it was dark and semiopaque rather than essentially transparent. More than likely, the dark lacquer served the important purpose of providing visual uniformity by concealing the casting flaws and numerous repairs that were characteristics of Florentine fifteenth-century bronzes. Giambologna's exquisite attention to finishing and the use of translucent lacquers in a variety of colors were characteristic of Florentine work of the late sixteenth century.

Translucent, lustrous brown, that is, the "natural" color of copper oxide, combined with gilded elements, predominated on the large-scale works of the seventeenth century, such as Bernini's *Baldacchino* for the crossing of St. Peter's basilica in Rome. Bernini said that he preferred the "natural" color of bronze for his work, by which he meant the lustrous, translucent copper-oxide brown. We have no specific documentation regarding how it was achieved, but it was probably a simple method involving a high polish followed by heating and rubbing with oil, with, perhaps, exposure to a smoky straw fire and additional polishing.

It is toward the end of the seventeenth century that the first known printed reference to patina appears. Filippo Baldinucci's *Vocabolario,* published in Florence in 1681, defines *patena* as follows: "a term used by painters, called by others a skin (*pelle*), namely that general, dark tone which time causes to appear on paintings, that can occasionally be flattering to them."[21] The most likely origin of the word is the old Italian word *patena,* used to refer to a shiny dark varnish applied to shoes. From paintings, then, the word was adapted to refer to the much-admired colored corrosion products found on archaeological bronzes. But the leap from darkened varnish to the corrosion products of bronze antiquities appears to have occurred only toward the mid-eighteenth century.

The topic of the flowering of bronze foundries during the nineteenth century is material in itself for at least one, if not several, lectures. Early development can be found first in Munich at the Royal Foundry, directed by Ferdinand von Miller. It was von Miller who supervised the casting of the eighteen-meter-high statue of Schwanthaler's *Bavaria* between 1837-48. This foundry, using the sand-casting technique, was preeminent in Europe until around 1880 and was used by most American sculptors working in Europe during this period—for example, by Harriet Hosmer and by Thomas Crawford for the bronzes on the *Washington Monument* in Richmond, Virginia, cast between 1849-69. Between 1880 and the outbreak of World War I, Paris became the "bronze capital" of the world, producing during this period perhaps a greater number of bronzes than had ever been cast in any other time in history.

Documents in the Valentine Museum in Richmond, Virginia, tell us that von Miller used an alloy intentionally selected to give "luster and malleability" and "to prevent the statues from turning green by years of exposure." Von Miller's letters provide specific instructions for cleaning, maintenance, and protection, "for," as he stated, "the color of the metal imparts a peculiar beauty to works of art." The fame of the so-called "gold bronze" of Munich was widespread by the 1870s, according to an article in the *New York Tribune* in 1874, in which it was compared with the predominantly brown tones of contemporary bronzes from other foundries.[22]

The revolution in sculptural aesthetics that paralleled the technical revolution in the revival of the lost-wax process reached a climax during the 1880s. *Cire perdue* (lost wax) eventually came to eclipse sand casting as the quintessential artistic casting method. It had numerous artistic advantages, but crucial for sculptural surfaces was the exceptional precision of reproduction it afforded and the minimized need for chasing and mechanically reworking the surfaces. This faithfulness in surface replication went hand in hand with an increased interest

in surface finishing and coloration, and it was from the 1880s into the early decades of the twentieth century that experimentation with artificial patination reached its height and the master *patineurs* reached their zenith.[23] The Limet brothers, for example, not only executed patinas for various foundries and artists, including Rodin, but also frequently suggested the tonality for them.[24]

The new interest in textural differentiation and detail and in manipulations of color typifies the Beaux-Arts style of the latter decades of the nineteenth century. The American sculptors Paul Bartlett and Augustus Saint-Gaudens are two American sculptors working in Paris during this period who demonstrated a deep preoccupation with the possibilities of finishing and patination. They played an active role in this aspect of their work, demanding absolute control of casting, finishing, and patination.[25]

It is not surprising, then, that Saint-Gaudens was among the first sculptors to be aware that modern urban atmospheres contained a potential for distorting and damaging the finishes that he so carefully produced. Saint-Gaudens gilded the *Sherman* monument at his own expense and wished to do the same for the *Garfield* monument in Philadelphia, for he had a fear that his sculptures would end up "looking like old stove pipes."[26] (What might he have said to the idea, recently expressed, that the blackened face of the *Adams Memorial* was original patina!) Saint-Gaudens's *Farragut* was originally described as a deep, rich-brown bronze with gilded accents on the uniform, sword, and belt.[27]

Patina in Modern Times: Virulence and Aesthetic Irony

The past sixty years or so present a sad chapter for bronze sculpture. The virulent effects of the industrial phenomenon of sulfur pollution are now all too plainly visible on urban bronzes. Perhaps it was partially the disruption and upheaval of two world wars that made bronze sculpture somehow less important, less noticed. The piebald, speckled appearance of the corrosion products themselves tended to serve as camouflage, making the sculptures less visible, less noticeable. Most likely, it appears that new, destructive phenomena, particularly those that, like sulfur pollution, appear slowly, may be only slowly recognized for what they truly are. Virulent patina caused by sulfur pollution, though identified as a problem as early as the 1860s in Berlin, has become so familiar a sight in the United States and elsewhere that it is even today commonly described as "natural." As a result, fashion has followed common perception, with bright, matte, opaque green coming into vogue in the Art Deco world of the 1930s and '40s. There is the further irony that the scientist who identified this new green as basic copper sulfate, not verdigris or copper carbonate as previously thought, described it as "natural, protective and having aesthetic value."[28] Vernon, whose interest focused on copper roofs and not on statues, was quoted as gospel, and no one has looked, really looked, at bronze

surfaces until very recently. Sadly enough, it is too late for many of these sculptures, and it is a sobering thought indeed that during our lifetime the *Horses of San Marco* in Venice and the *Marcus Aurelius* in Rome have come indoors, probably for good.

NOTES

1. See the author's previous study on this topic: P. Weil, "A Review of the History and Practice of Patination." In *Corrosion and Metal Artifacts—A Dialogue Between Conservators and Archaeologists and Corrosion Scientists.* Washington, D.C.: National Bureau of Standards, Special Publication 479, 1977, pp. 77-92.

2. Richter, J.P., and I.A. *The Literary Works of Leonardo da Vinci,* I. London: 1939, p. 91.

3. Ramsden, E.H., ed. *The Letters of Michelangelo,* II. Stanford University Press, 1963, p. 75, #280.

4. Lecture at Harvard University, Autumn 1958.

5. Wittkower, Rudolph. *Bernini: The Bust of Louis XIV.* London: 1951, pp. 9-11.

6. Wittkower, p. 9. Quoted from Chantelou.

7. *Metamorphoses in Nineteenth-Century Sculpture.* November 19, 1975-January 7, 1976, Fogg Art Museum, Harvard University. Exhibition publication edited by Jeanne L. Wasserman.

8. Alberti, Leon Battista. *On Painting and On Sculpture.* For Latin text of *De Pictura* and *De Statua* see C. Grayson, ed. London: Phaidon Press, 1972, pp. 120-21.

9. Pliny. *Natural History,* 9. Translated by H. Rackham. London: Loeb Library, 1958, Book 34 (XXXIV.xlvii).

10. Hiorns, Arthur H. *Metal-Colouring and Bronzing.* London: 1892; 2nd ed., Macmillan and Co., 1911, p. 5.

11. Hiorns, p. 67.

12. Hausding, A. "Ueber echte Bronzen und Patina." *Zeitschrift des Vereins zur Beförderung des Gewerbefleisses* 72 (1893): 226-27. "Diese sogenannte 'schöne Patina' oder der Edelrost einer Bronze ist die durch Zeit und äussere Einflüsse eintretende chemische und physikalische Veränderung der reinen Metalloberfläche unter Uebergehen des ursprünglichen gelbroten reinen Metall-Bronzetons ins Grüne oder Braune, bei gleichzeitiger allmählicher Entstehung einer glatten, eigentümlich reizvollen, mattglänzenden, durchscheinenden, fast speckigen Oberfläche, welche über das darunter befindliche echte Metall keinerlei Zweifel lässt" (author's translation).

13. Rathgen, F. *The Preservation of Antiquities.* Cambridge: 1905, pp. 34-36.

14. Homer. *Odyssey.* Translated by E.V. Rieu. Harmondsworth and New York: Penguin, 1982, p. 252.

15. Pernice, Erich. "Untersuchungen zur antiken Toreutik, V. Natürliche und Künstliche Patina im Altertum." *Jahreshefte des Oesterreichischen Archäologischen Institutes in Wien* 13 (1910): 102-07; "Bronze Patina und Bronze Technik in Altertum." *Zeitschrift für Bildende Kunst* 21 (1910): 219-24.

16. Richter, G.M.A. *The Metropolitan Museum of Art: Greek, Etruscan, and Roman Bronzes.* New York: 1915.

17. Smith, Cyril. "Materials and the Development of Civilization and Science." *Science* 148 (April-June 1965): 908.

18. Forbes, Edward. "The Origins of Alchemy." *Studies in Ancient Technology* I. 2nd ed. Leiden: 1964.

19. Smith, C.S., and Hawthorne, J. *Mappae Clavicula: A Little Key to Medieval Techniques.* Philadelphia: 1974.

20. Vittori, O., and Mestitz, A. "Artistic Purpose of Some Features of Corrosion on the Golden Horses of Venice." *Burlington Magazine.* 1975, pp. 136-38.

21. Baldinucci, Filippo. *Vocabolario Toscano dell 'Arte del Disegno.* Florence: 1681.

22. Cook, Clarence. "Palmer's Statue of Livingston." *New York Tribune,* July 8, 1874, pp. 4-5. I am grateful to Michael Shapiro for this reference.

23. Shapiro, Michael Edward. "The Development of American Bronze Foundries 1850-1900." Ph.D. dissertation, Harvard University, May 1980, Chapter V. The aesthetic impact of the rediscovery of lost-wax casting and an immense amount of information pertaining to patination are discussed in a forthcoming book by Mr. Shapiro based on his dissertation. *Bronze Casting and American Sculpture: 1850-1900.* Newark, Delaware: University of Delaware Press, 1985.

24. Shapiro.

25. Shapiro.

26. Dryfhout, John. "Augustus Saint-Gaudens." *Metamorphoses in Nineteenth-Century Sculpture.* Edited by Jeanne L. Wasserman. Cambridge, Massachusetts: 1975, p. 183.

27. Tharp, Louis Hall. *Saint-Gaudens and the Gilded Era.* Boston: 1969, p. 157.

28. Vernon, W.H.J., and Whitby, L. "The Open-Air Corrosion of Copper: A Chemical Study of the Surface Patina." *Journal of the Institute of Metals* 42(1929): 181-95 (Part I); 44(1930): 389-96 (Part II); 49(1932): 153-61 (Part III). See also: P. D. Weil et al. "The Corrosive Deterioration of Outdoor Bronze Sculpture." In *Preprints of the Contributions to the Washington Congress, 3-9 September 1982: Science and Technology in the Service of Conservation.* London: International Institute for Conservation, 1982, pp. 130-34.

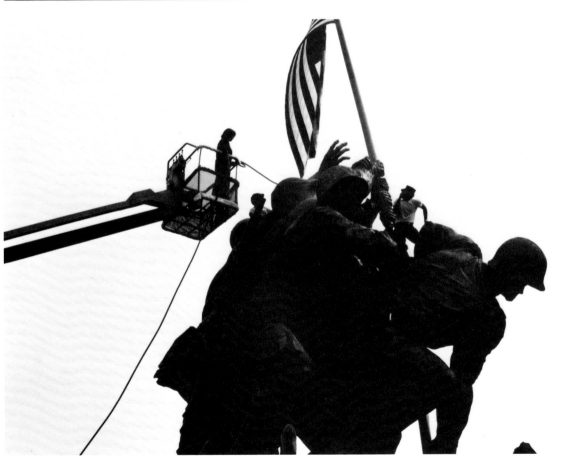

Felix de Weldon, *Marine Corps War Memorial (Iwo Jima),* Arlington, Virginia. National Park Service photograph.

MANAGING THE CARE OF OUTDOOR METAL MONUMENTS BY THE NATIONAL PARK SERVICE: Some Past Experience and Future Direction. An Unofficial View by an NPS Conservator

Dan Riss

The next speaker is Dan Riss. He has a B.A. in Anthropology/Archaeology and also professional training in photography. For the past ten years, he has been a conservator at the National Park Service's central laboratory in Harpers Ferry, West Virginia. He has served as advisor to the Washington Office on preservation and policy matters for outdoor metal sculptures. Mr. Riss has led programs within the Park Service as well as for outside audiences on preservation awareness and techniques.

V.N.N.

My title may sound as if it were drafted by a Philadelphia lawyer, but I want to phrase it that way because I am really not here as an official spokesman for the Park Service. I am more of an intimate observer or an involved actor. You might say that I am reporting from the belly of the beast of the bureaucracy.[1]

I would like to divide this talk into two parts. First, I would like to get at some of the sources of confusion that cause so much misunderstanding between art historians, conservators, owners, maintenance people, and members of the public when talking about outdoor bronzes and their preservation needs. This will include some general philosophical considerations, as well as a clarification (I hope) of some of the detailed technical preservation issues. Second, I will discuss what is being done to preserve outdoor bronzes at various Park Service sites and I will also discuss the evolution of policy at the Washington level.

PART I: Sources of Confusion

If the answer to the question "What shall we do to preserve outdoor bronzes?" were clear and evident, we would not find it necessary to hold a conference such as this. As it is, managers who must take action, as well as other novices in the field, have been getting answers that are diverse and sometimes conflicting. This diversity and conflict lead to confusion and to problems in communication. The confusion is due both to the inherent intricacies of bronze preservation and to fundamental gaps in the knowledge of the conservation and art-historical professions.

Differing Perspectives

Much of the confusing intricacy arises from the fact that statues can be viewed from many perspectives, and our view of the problems of preservation becomes colored by the point of view chosen. For example, statues are, at the same time:

> symbols
> and industrial products
> and artistic works.

Insofar as statues are symbols, they are communication devices, sending messages of "honor," "liberty," "delight-in-form," and the like. The harmonies of meaning resonate in the minds of viewers, while the specific manifestations are patterned by the culture. But these statues are also industrial products: physical things. They are the end result of a chain of industrial-scale operations: ore extraction, concentration, melting and casting, chasing and finishing, patination, transportation, and erection. They represent a distilled essence of work and teamwork: works of work. These pieces of shaped metal then are exposed outdoors and are further shaped by the corrosive physical and chemical forces of man (vandalism, war, pollution) and nature (moisture, wind, birds). And, of course, these statues are also works of art, products of particular talents and sensitivities. From this point of view, a statue is a particular realization of intangible mental templates via the unique prism of the artist.

When we talk about the preservation of a bronze, then, we are really talking about the preservation of a constellation of interrelated and interdependent attributes. But an art historian is mostly talking about the preservation of the touch of the artist; a metallurgist is mostly talking about the preservation of a mass of frozen metal; and a social anthropologist/historian is mostly talking about the preservation of a cultural symbol complex. Each will approach the preservation needs of an outdoor bronze from a different angle. What is especially confusing is that the preservation needs for one aspect may not be relevant or compatible with the needs of other aspects. For instance, the requirements for the best preservation of the metal may be incompatible with the need for the bronze to have a certain aesthetic. A metallurgist's suggestion of a thick epoxy coating or of plating with another metal would certainly preserve the bronze, but the artist or curator might find the resulting appearance unacceptable. In another example, we may find that the gross iconography may still be evocative, even with loss of surface detail or with streaks of green corrosion. In fact, the artist may even have intended the work to weather and decay. And this, of course, is incompatible with the desire for survival of the metal structure and of the pristine appearance of the piece as it first came from the artist.

When, instead, we take a more holistic view, we can integrate these various perspectives and try to balance each to meet as many requirements as possible. The perspective of another specialist, the conservator, is important here. Conservators are more than mere practitioners of preservation techniques. By training and inclination they have an attitude, an approach to looking at problems, that brings together the artistic/historical/anthropological/scientific aspects. It looks to me as if decision makers, to keep from getting confused, are going to have to start thinking like conservators.

Many Actors

Now, on to another and different set of confusing factors. If we consider the viewing of a work of art as a communication transaction—the artist speaking to others via the art—then we have as factors: first, the art itself; and second, the actors in the transaction—the artist, the public, and the owner or custodian. Each of these actors has a different set of interests, requirements, and responsibilities vis-à-vis the art and its preservation. Again, we have a balancing act. Who decides? Whose opinions count? Should the artist decide the fate of his or her work alone? What if the artist is not available for consultation? What if the artist is dead? Should we take a vote among the general public as to how a statue should look? Ask art historians or curators? Should the owner call all the shots? Actually, our economic system gives an owner, through his financial interest, the principal claim to make decisions about the fate of his possession. When the owner is the public in general, through government, agencies then become custodians, but with responsibilities beyond the institution itself. We can only hope that the institution acts more on behalf of the artist/art/public and less in deference to bureaucratic priorities, such as the convenience of the maintenance department or the bottom line of the budget office. We need to remember that the preservation of outdoor bronzes is a public art form itself, like a Christo happening. To avoid becoming confused, then, we need to keep the cast of characters straight.

Aesthetic History

A third source of confusion arises from the many environments of opinions, attitudes, understandings, and scholarship in which a work of art exists. Each member of the public brings a more-or-less unique background of education, sensitivities, and experience to the viewing of a bronze and will come to certain conclusions and interpretations concerning aesthetics, his view of the artist's intent, how it should change with time, and the like. Professionals, such as art historians, curators, and conservators, can often come to a consensus on technical issues, but the question of the pleasure or pain of the aesthetics is for each person to decide. This means that where preservation decisions have aesthetic impact, everyone will have an opinion as to whether or not he likes the result. The artist and informed scholars can help by clarifying original intentions, but I am convinced that otherwise there is no one right opinion as to pleasing results.

Furthermore, not only do we have a multiplicity of opinions and attitudes today, but there was a different environment of opinions and attitudes at the time the bronze was made and there will be another and different environment in the future. With this ever-changing climate of attitudes, it is important to keep our discussions clear

and specify just whose opinions we are using and what period they refer to. And if we make an aesthetic judgment today, we need to remember that the taste of today may or may not reflect accurately the taste of the past and may be subject to revision in the future.

Language

A fourth source of confusion arises from the way we use the words "conservation," "restoration," and "preservation." Their interrelated meanings confuse the layman no end. Part of the trouble is that these are words that are in common use and have multiple meanings, resonances, and overtones. When we talk to each other, we need to use the words in pretty much the same way or else we are not really communicating.

One set of definitions is that provided by the National Conservation Advisory Council (now the National Institute for Conservation, Inc.), which uses the word "conservation" to refer to the broad concept, while using the terms "preservation" and "restoration" in specific narrow senses.[2] In this somewhat arbitrary scheme, "conservation" is seen as an activity that encompasses three kinds of operations: first, a preliminary examination; second, "preservation," defined to encompass a passive phase (for example, storage and environment) and an active phase (intervention, that is, treatment); third, "restoration," a re-creation of something as it was at a particular point in the past. These are subtleties of expression that are difficult to convey to, say, a park superintendent or a magazine writer, for whom the word "preservation" means the same as "restoration." The distinction that some conservators are now trying to draw, though, is that it seems to be possible to "preserve" (in the common sense of the word) a bronze outdoors without necessarily "restoring" it to approximate what it might have looked like when new.

Treatment Possibilities

This leads into the fifth set of confusing factors: all the varieties of possible treatments. But we need to disabuse ourselves of the notion that there is a "best method." Each bronze exists in its own particular circumstances and thus requires an individual evaluation and plan for treatment. However, the options we have to choose from are not unlimited and can be simplified down to three broad choices:

A. We can protect our bronzes by bringing them in out of the weather. This is the best method from many points of view, but usually impractical. We might bring in the four horses of San Marco in Venice or the *Marcus Aurelius,* bronzes of exceptional value, but I doubt that any of our street-corner generals-on-horseback will be inside anytime soon. (Not that there aren't inquiries. I was recently talking with a young lady who used to give tours

at Gettysburg, and she said that people have actually asked her, "What do you do with the monuments in the winter?" She also said that other people have asked, "How did they shoot around the monuments in the war?")

This leaves two broad choices of practical treatment options, two broad schools of thought, if you will:

B. We can strip corrosion, recolor, then protect by a coating, or

C. We can clean without stripping, then protect with a coating.

Basically what it boils down to is that some people believe that it is absolutely necessary to strip off all previous corrosion, and some people say that a sufficient degree of protection can be obtained without removing corrosion. Both schools believe in the application of a protective barrier coating. Further treatment options are available after one has decided which of these major approaches to take. A taped talk by Tom Chase of the Freer Gallery provides valuable assistance in clarifying the choices that every owner has to consider and in explaining treatment options.[3]

It should be noted that the option of stripping off all the corrosion is a very controversial one. A portion of the argument against stripping would state that it is not needed because major corrosion processes are moisture-dependent and that wax or lacquer barriers suffice since they deprive the corrosive fires of an essential component. (Some treatments, generally referred to as "hot-wax" treatments, include driving off moisture by heating the metal before applying wax at ambient temperature to the hot surface.) A portion of the argument for stripping would state that corrosion proceeds under coatings unless removed and that accelerated corrosion can occur at breaks and pinholes in poor coatings. We have little time for a full presentation of the arguments pro and con; they are subtle and many. What we also do not have is published scientific comparative studies of the qualities and effectiveness of the various treatment options. Perhaps, in time, relevant studies will be made and published. For now, many of our decisions must be made in the face of uncertainty.

Visual Effects

The sixth source of confusion arises from the variety of visual effects the various treatments are responsible for. Washing, cold waxing, and the application of benzotriazole can be virtually invisible treatments. Lacquer can make the surface look plastic or glossy but can be toned down with a matting agent. Wax applied to the heated metal tends to make the surface darker and is especially useful in toning down the contrast differences between the various shades of light and dark green usually found on exposed bronzes. Some people, though, find that the "hot-wax" treatment can give a "mud-pack"

appearance. Cleaning with walnut shells removes surface green and leaves a surface of dark green, gray-green, brown, or red-brown. Then, of course, if stripped to bare metal, bronze can be colored to an endless variety of shades, usually some sort of green, gray-green, or brown.

Beyond color, there is the question of surface quality: the metallic luster of polished bronze which becomes more matte with corrosion and, in time, pitted and coarse. Art conservators generally do not advocate a total foundry refinishing to "restore" a lost surface, for that would be too great an intervention. (But see the statue of *Jefferson* in the U.S. Capitol for an example of this.[4]) If a bronze is not too corroded, rubbing can bring up some luster. However, cleaning with walnut shells has little or no effect on luster; peening with glass beads can render some surfaces more matte and cause some pitted surfaces to become apparently more coarse (by removing corrosion from pits, thus increasing the visible relief). Waxes and lacquers can be more or less transparent to allow the surface below to shine through or can be made darker and more opaque with pigments, if necessary.

The question of how an outdoor bronze is supposed to look is not an easy one. Artists have sometimes wanted their work to be maintained like new; others do not mind a certain amount of weathering and may even prefer their work to change with time. The choice of treatment will have to take into account these matters of art history and public attitudes and balance them with present concerns.

PART II: Preserving Outdoor Bronzes in the NPS

We normally think of the Park Service in terms of the beautiful vistas, ecosystems, and natural scientific wonders of places like Yellowstone, Yosemite, the Everglades, and the Great Smokies. But there is much more. The Park Service is also an amazing and wonder-ful agglutination of other kinds of places: battlefields (Gettysburg, Saratoga); historic houses associated with famous people (Vanderbilt, Carl Sandburg, Robert E. Lee); old forts (Ft. McHenry, Ft. Larned, Ft. Sumter); archaeological remains of ancient Native American settlements (Gran Quivira, Chaco Canyon); old ships (Boston, San Francisco); not to mention Jamestown, Ellis Island, Mount Rushmore, Independence Hall, and other familiar places. In all, there are over 330 major units in the NPS; and that doesn't even count the over 700 bits of land in Washington, D.C.: from the Mall and the White House, to the circles, squares, and triangles which put the NPS in the urban park business. So the Park Service must manage land, houses, museums, trees, grass, and visitors, as well as statues.

Where are the statues in the NPS? Most are either in Washington, D.C., or out on the field in a few Civil War battlefields. A national census is, so far, incomplete, but a rough count of monuments with bronze statues or figurative reliefs would number roughly 80 in Washing-ton, 180 at Vicksburg (many bas-reliefs), about 100 at

Gettysburg; in all, at least 400 nationwide. The reason it is difficult to count what we have is that our usual management records system refers to a "monument" as a single unit, whether it has one statue or many. Nevertheless, by any measure, the Park Service has a lot of outdoor bronzes.

Of what quality and importance are the Park Service bronzes? While an overall evaluation has yet to be made, we do know that some bronzes have attained a national symbolic value, like French's *Minute Man* and de Weldon's Iwo Jima memorial. Mills's *Jackson* equestrian of 1853 was an important milestone in American bronze sculpture and an object of national pride at the time. Park Service equestrian monuments are some of the best of their time, and some represent the sculptor's finest work. Just about every prominent nineteenth- and twentieth-century sculptor of works to be cast in bronze is represented in parks: Ward, French, Rhind, Lowrie, Buberl, Dallin, Bush-Brown, Shrady, De Lue, Borglum, Elwell, Potter, Jennewein, A.S. Calder, Aitken, Story, Ball, MacMonnies, Saint-Gaudens, Manship, Fraser, and so on. And some are objects of controversy and generate heated letters to the editor, as did (and still does) the proposed bronze of sculptor Frederick Hart, to be placed on the grounds of the Vietnam Memorial.

The condition of Park Service bronzes covers virtually the entire spectrum of possibilities, from highly eroded to pristine. As might be expected, the urban bronzes (Washington, New York, Baltimore, Philadelphia) have in general been more strongly affected by exposure than the more rural bronzes (Vicksburg, Gettysburg, etc.). Mills's *Jackson* has been exposed longer than any major bronze still standing in America. And White's *Pershing* was only very recently put up (fall 1983), so the artist's intended finish is still readily apparent.

What have been the past treatment and maintenance practices for these outdoor bronzes? As far as I know, there has been little previous central direction from Washington in regard to maintenance techniques for statues.[5] For administrative convenience, outdoor monuments, however much they may be works of art, are considered "structures" and usually are attended to, if at all, by historic architect/historic preservation staff or the general park maintenance staff. For many purposes, the individual parks can be considered independent fiefdoms, going very much their own way, loosely overseen by ten regional offices, with Washington setting overall policy and representing the ultimate source of funds and staff. As a result, each superintendent is generally quite free to set the agenda for matters needing attention in the park. Since popular mythology holds that bronzes form protec-tive coatings naturally, superintendents in the past probably saw little need to do anything except wash away bird droppings, replace missing parts, and remove graffiti.

A systematic search of park files relating to mainte-nance is yet to be made, so we do not have a clear picture of all past practices, but preliminary inquiries have

turned up some interesting information. The battlefield parks did not come under the custody of the Park Service until the 1930s, having previously been under the War Department. In the files at Gettysburg is a prescription for the "Treatment of Bronze Tablets," presumably dating from that time, which recommends a coating of beeswax and turpentine.[6] Gettysburg also has a letter from the Bureau Brothers foundry, dated June 1931, giving advice on how to match the color of some new repair work with the old color and how to protect everything. Polysulphide was to color the metal, while Johnson's Liquid Floor Wax or turpentine and beeswax, perhaps with pigments if needed, was recommended as protection.[7] Remains of what appears to be pigment can still be found on Gettysburg bronzes, though whether from War Department application or from some later time is not yet known.

The monuments of Washington, D.C., likewise did not come to the Park Service until the 1930s. In the files of a previous agency (which had responsibility from 1862 to 1924[8]), I found a piece of paper cut from a printed government document of about 1913-14 which contained the following report: "*Statues.* Attention has been given to all the completed statues during the year, and the pedestals and bronze figures have been maintained in a cleanly [sic] condition as far as possible." Although the document lacks details, at least we have an indication that someone has been actually doing something, and perhaps with a little more research we may find out what was done.

A fine example of the treasures awaiting in the files for the intrepid researcher is the information I turned up in just a few hours at the National Archives. I was on an exploratory foray to see if anything useful to present needs in regard to treatment, maintenance, appearance, repairs, and the like could be found. I used the papers of the Grant Memorial Commission for my search and managed to get through about 40% of them. In 1911 the architect of the memorial, Mr. Casey, responding to a complaint about green stains on the marble pedestal, replied that he and others have "always regarded this as not so great a misfortune as might appear and have rather welcomed it as tending to harmonize the marble with the bronze as it prevents in a measure the sudden jump from black to white."[9] Today we find the staining to be disturbing and a sign of neglect. Actually, this staining of the *Grant Memorial* was poulticed in the 1920s, and the marble still looked fairly good even up to 1965. But by 1983 the staining became more disfiguring than enhancing.

Also in the files was an offer from 1916 by a private manufacturing firm to apply its commercial protective formulation for metal (Metalol) and stone (Lithol) to the *Grant Memorial* groups. Samples were sent to the National Bureau of Standards for analysis and their reply of three weeks later (!) showed the Metalol to be a "very thin Chinese wood oil-rosin varnish with mineral spirit thinner," and Lithol a solution of "treated Chinese wood

oil in a volatile solvent of mineral spirits."[10] Since the stone preservative darkened marble, the Memorial Commission declined to use it but allowed the use of Metalol on the Cavalry group.[11] Further correspondence from 1916 indicated that spots on the Artillery group were touched up with Minwax.[12] Additional research should provide a more complete treatment and maintenance record for the life of the memorial, and this same kind of record needs to be compiled for each of the Park Service monuments.

More recently there have been some treatments beyond routine maintenance that have been rather better documented. In 1972, in conjunction with the National Bureau of Standards (an old connection, we now see), four large gilded pieces in Washington, D.C., were stripped, regilded, and coated with Incralac (an acrylic lacquer incorporating a corrosion inhibitor).[13] Ten years later the lacquer had become cloudy in places, and it was decided to strip off the old lacquer and apply a new coat. George Washington Parkway Cultural Resource Manager Nicolas Veloz was in charge of the project.[14] He and his crew had an extremely difficult time removing the old Incralac, which was supposed to come off easily with toluene.[15] The lacquer was particularly stubborn on two figures which were poorly cast and whose very irregular and porous surfaces had required, presumably, an especially thick lacquer coat to form a seal. Lacquer removal was somewhat easier from the two figures that had been better cast, whose smooth surfaces could be sealed by a thinner coat. To avoid a repeat of the lacquer experience in the future, it was decided not to relacquer but instead to coat with wax (incorporating a corrosion inhibitor). This mixture was sprayed on, with expectations of future maintenance of washing and rewaxing about every two years and with estimations of total replacement for the wax being needed perhaps every four to six years.[16]

Manship's *Theodore Roosevelt* in Washington, D.C., was treated three times recently, in 1978, 1979, and 1983 by Nick Veloz (with the initial collaboration of Lynda Zycherman).[17] First the old wax had to be removed; the piece was then washed, corrosion inhibitor applied, and microcrystalline wax wiped on and buffed. In 1983 corrosion inhibitor was added to both the detergent solution and the wax, which this time was sprayed on rather than wiped on with rags.

Further work by Nick Veloz on Park Service bronzes in Washington (*Admiral Byrd, The Hiker*) and on a non-Park Service bronze in Indianapolis, Indiana (*Benjamin Harrison*), involved the removal of green corrosion products by the use of low-pressure grit-blasting, using the soft abrasive of ground walnut shells.[18] The use of walnut shells in the finest size available, 60/100 or 60/200 mesh, appears to do the metal no harm at all, while removing surface accretions, down to the oxide layer if desired. Nick's treatment also involved degreasing, washing, and waxing, with corrosion inhibitor added to

both wax and wash as well as sprayed directly on. Before treatment, the *Harrison* appeared the usual light green with darker patches where protected. After treatment, the *Harrison* appeared a dark green which virtually matched the painted plaster model, without the need to strip the bronze to bare metal and recolor.

In New York City, Ward's *Washington* at the NPS site, Federal Hall, was treated by Phoebe Weil several years ago. At Saint-Gaudens's New Hampshire studio, now a Park Service site, outdoor bronzes were recently treated under contract with the Fogg Art Museum. A very conservative washing and waxing were all that was called for here. And in Concord, Massachusetts, French's *Minute Man* was to be washed and waxed in the fall of 1983.

Finally, at Gettysburg National Military Park are a number of bronzes treated by a variety of methods over the last several years. Some have been stripped to bare metal, recolored, then lacquered with Incralac. Six equestrians have been washed, then "hot waxed." And a few have been "restored" by a sculptor/founder/restorer who prefers not to provide details of his processes or the composition of his protective coating (patent pending). Except for a small figure treated by Harpers Ferry Center as an experiment, all of the above treatments at Gettysburg were accomplished by an outside contractor.

So, at one Park Service site or another, we have a wide variety of treatments and aesthetic options that have been tried, some with more success than others. Our task now is to look at what has been done in the parks and at what the conservation community is doing, then develop guidelines at the Central Office level to help park superintendents manage the preservation of this resource. Each park should not have to reinvent the wheel.

The locus of activity for monument preservation in the NPS is the Park Historic Architecture Division of the Office of the Associate Director for Cultural Resources (remember that for management purposes, statues, being generally immobile, are considered structures). The Chief Historic Architect is now Hugh Miller. He will be coordinating NPS policy, providing file space to act as a central data bank for maintenance histories and art-historical studies, and acting as custodian of the List of Classified Structures (a computerized management tool which provides a basic inventory of NPS properties, including monuments).

Policies and guidelines will not emerge out of thin air but will derive as a logical result from an already existing document called *Management Policies of the NPS*. These policies, generally unknown outside the Park Service, derive from legislation, Executive Orders, and other high-level guidelines.[19] They will need to be interpreted in the light of the practical experience in bronze preservation we and others have had in the last few years. What we have seen is that there are differences of approach which have consequences for aesthetics, manpower, task time, and preservation effectiveness. We have also seen that there is still much unknown, still much research lacking, in terms of the relative merits of the various treatment possibilities and our knowledge of attitudes and understandings of artists, art historians, and the public.

So what, then, are the implications of all this for the future of bronze preservation in the Park Service?

1. The Office of Park Historic Architecture is working on some guidelines, to be issued by the Director of the Park Service, which will provide that certain procedures and approvals will be required before any treatment is performed on bronzes that will result in an irreversible change in appearance. Parks will need to document the history of the bronze, its maintenance, artist's wishes, public attitudes, etc. They will have to show that drastic treatment is absolutely needed for the survival of the metal or that restoration is needed to interpret the piece properly. Review and approval will be needed from, at least, Washington, and perhaps from us at Harpers Ferry or from other professionals. This process will ensure that the decision to proceed is made with knowledge of all the consequences by all concerned. However, present thinking in Washington is that, because of all the uncertainties in the present state of the art of bronze preservation, we have an obligation to proceed conservatively for the time being and that, until the waters clear, approvals for irreversible treatments will probably be few. The directive will, on the other hand, encourage regular attention, such as frequent washing and waxing.[20]

2. The Park Service is sponsoring research into the effects of acid rain on park resources, some of which will be relevant to outdoor monuments. In one project, the Building Materials Division of the National Bureau of Standards is identifying "significant long-term atmospheric corrosion and weathering data for metals, masonry, and coatings taken at active exposure sites," then "developing relationships between the deterioration rates and the environmental conditions at the exposure sites." These results will be used to help make an assessment in fiscal year 1985 of the effects of acid rain on building materials.[21]

A second project, also by the Bureau of Standards, involves the development of an electrical sensor element to monitor the corrosion rate of bronze in the field on a continuous basis. Another part of this project is the modification of ultrasonic and eddy-current nondestructive testing technology to monitor changes in corrosion thickness and corrosion pit depth. A third project involves the development of color patches to be used when photographing bronze, which will aid in a computer-image analysis of the extent of corrosion. A fourth project, through Washington University in Saint Louis, involves a study of the deterioration of bronze plaques of uniform specifications (National Historic Landmark Plaques) to provide retrospective estimates of deterioration and of variations in rates.[22]

3. The Office of Park Historic Architecture, the Division of Conservation at Harpers Ferry Center, and other NPS professionals are collaborating to develop guidelines for managers of parks in establishing programs relating to

bronze preservation. These will include development of programs and approved procedures for inventory, condition evaluation, preservation techniques, and treatment reporting.[23]

4. In addition to the above, I hope to devise a questionnaire or survey, with photographs, to submit to artists, foundrymen, art historians, members of the public, and so on, regarding questions of desired/intended appearance, attitudes to the effects of weathering, attitudes to restoration, maintenance, and the like, on bronzes in general (and the artist's work in particular). I also hope to be able to outline further research needs in treatment effectiveness, art history, and past park maintenance to be carried out somehow, some way, when we can find the money and people to do it. (Art-history professors, take note!)

CONCLUSION

The purpose of the National Parks "is to conserve the scenery and the natural and historic objects and the wild life therein and to provide for the enjoyment of the same in such manner and by such means as will leave them unimpaired for the enjoyment of future generations."[24] It is only in the past seven years or so that it has become apparent that outdoor monuments, especially bronzes, are in need of the specific kinds of attention the Park Service devotes to its other natural and cultural resources. We are really just beginning this effort and so are taking a "look-before-you-leap" approach. While this may seem timid to some, in the long run I think that more informed decisions will be the result, and all the values embodied by outdoor bronzes will be better conveyed unimpaired to the future.

NOTES

1. The author is a conservator at the Division of Conservation at the National Park Service's Harpers Ferry Center. There are only about a dozen card-carrying conservators in the NPS, and most of them are at the Division of Conservation. We do conservation on objects for exhibits as well as advise parks on conservation, storage, and environmental conditions for their collections. The rest of the Center produces the interpretive media (booklets, maps, exhibits, and audio-visual programs) for the whole Park Service. The National Park Service is an agency of the Department of the Interior.

2. See Appendix 1, p. 31, of *Conservation of Cultural Property in the United States,* Washington, D.C., National Conservation Advisory Council, 1976:

 "*Conservation* encompasses three explicit functions: examination, preservation, and restoration.

 • *Examination* is the preliminary procedure taken to determine the original structure and materials comprising an artifact and the extent of its deterioration, alteration, and loss.

 • *Preservation* is action taken to retard or prevent deterioration or damage in cultural properties by control of their environment and/or treatment of their structure in order to maintain them as nearly as possible in an unchanging state.

• *Restoration* is action taken to return a deteriorated or damaged artifact as nearly as is feasible to its original form, design, color, and function with minimal further sacrifice of aesthetic and historic integrity."

See also below, footnote #19, for NPS definitions.

3. Tom Chase has nicely outlined the steps to go through in choosing a treatment in a talk before the Workshop on the Conservation of Outdoor Sculpture at the Johnson Atelier in Princeton, New Jersey, in October 1981. This talk is available on audiocassette. Order NJS 4 & 5, "Effects of the Environment on Non-Ferrous Metals" (includes other talks as well) from Audio Archives of Canada, 7449 Victoria Park Avenue, Markham, Ontario, Canada L3R2Y7, at $18 for the two. See also papers in *Bronze and Masonry in the Park Environment,* Preprints. Center for Building Conservation and Central Park Conservancy, New York, October 1983.

An outline of my notes from a portion of Tom's talk in Princeton may prove helpful here.

Overall considerations—need to take into account
• present state (new, old, how long outside)
• original state (if known)
• sculptor's intentions (allow to weather, maintain pristine, etc.)
• aesthetics of treatment (treatment choices affect appearance differently)
• possibilities of treatment (repertoire of choices)
• possibilities of maintenance (frequency of attention possible, available manpower, money)

Objectives of treatment—goals
• structural soundness
• stabilization of corrosion
• improvement of aesthetics
• restoration of original state (or not; sometimes not possible or desirable)

Major classes of treatment
• take out of corrosive environment (isolate from ground, take indoors, roof over)
• remove corrosion, apply barrier coat
• clean without removal of corrosion, apply barrier coat

Coatings
• lacquer (for example, Incralac, an acrylic lacquer incorporating benzotriazole as a corrosion inhibitor)
• waxes
 –applied at ambient temperature ("cold wax")
 –applied to heated metal ("hot wax")
 –applied cold as a top coat over a "hot-wax" treatment or over a lacquer
• lanolin, fats, animal oils
• benzotriazole, corrosion inhibitor, can be used alone or under lacquers or waxes or *in* lacquers and waxes
• repatination—conversion of corrosion

Divestment—stripping off corrosion
• peening
 –glass beads (to bare metal)
• chemical
 –alkaline (e.g., rochelle salts)
 –acid (sulfuric plus inhibitor)
• electrochemical, electrolytic
• mechanical (rubbing, etc.)
• laser (maybe in future)

Partial divestment
• washing (remove soot, bird droppings, etc., with or without soap, detergents)
 –water
 –solvents

- walnut shell cleaning (removes green only, down to oxide layer)
- mechanical (light rubbing)

Examples of some treatment strategies
- wash with fiberbrush and nonionic detergent in water, rinse, degrease with solvent, heat with torch, brush on wax blend (maybe two or three applications), buff, top coat of wax applied cold, buff, touch up once or twice a year, or as needed
- strip with glass bead peening, degrease with solvents, apply benzotriazole in water/alcohol solution, spray lacquer (thin coats, maybe one with matting agent to reduce gloss), top coat of wax, touch up once a year, touch up lacquer as needed
- wash and degrease as above, apply wax to cold metal, or slightly warmed metal (two or three coats), buff, maintain three or four times a year
- wash and degrease as above, apply benzotriazole in water/alcohol solution, apply wax or lacquer, maintain once a year

Note: examples not exhaustive of possible treatments one should consider.

4. The statue of *Jefferson* by Pierre Jean David d'Angers was cast in France in 1833, placed in the Rotunda in 1834 but then placed outside in front of the White House in 1847. It was left out until 1874, a total of twenty-seven years. A newspaper in 1874 describes the statue's fate thus: "Exposed to the elements, and lost to inspection or appreciation, it became covered with verdigris, and was allowed to practically rot without the slightest effort or attempt at preservation." A report submitted to the Senate (Report #138, 43rd Congress, 1st Session, Feb. 25, 1874) comments: "The bronze of which it was made, judging from present appearances, cannot have been of the best quality, and from recent exposure in the open air to the weather has received some injury which will be likely to be increased if it should so remain. If placed under cover, with a small expenditure for cleaning and the repair of some defects, it would at least be restored to a position where it would not be seemingly an object of neglect and reproach." In June 1874 an appropriation was made for the sum of $1013, "For repairing and finishing in a thorough and complete manner the bronze statue of Jefferson, placing the same in the National Statuary Hall, and procuring a suitable marble base therefor." Moved from Statuary Hall in 1900, the statue may now be seen back in the Rotunda, where the metal glows richly as if it had never been exposed outside. (Quotations are from documents in the files of the Office of the Curator for the Architect of the Capitol.)

5. See NPS *Museum Handbook,* 1969, Appendix C, for discussion of maintenance of metal sculptures. The basic recommendation is for washing and waxing. This is the only Park Service-wide guideline we know about so far.

6. The full text is as follows: "Treatment of Bronze Tablets— First scrub bronze with grease solvent, a combination of abrasive, soap, etc., which can be purchased from almost any plumber, using a stiff bristle brush, then remove grease solvent with warm water and Old Dutch Cleanser or some other good soap powder, being sure all the grease solvent has been removed. Then apply a preparation made of 4 oz. common beeswax dissolved in 1 qt. of pure turpentine, mixing in sufficient dry burnt umber to obtain the color desired."

7. Relevant portion of letter: "It is necessary to keep the Polysulphide sealed and dry and when wanted—a teaspoonful will make about a quart of liquid. When dis-

solved in water if kept in a closed fruit jar it can be used as wanted—if too strong add water and if weak add a pinch of Polysulphide. It is sometimes necessary to make the bronze a trifle darker than wanted—then brush up slightly until you get an approximate color you want—then when dry apply Johnsons Liquid Floor Wax or Turpentine & Beeswax with a small amount of dry umber—lamp black or red sienna and apply with a paint brush and dry with another brush—then leave it dry for a half day or so—then you can rub it dry.

"The dry color with the wax is to match the rest of the work you are repairing"

8. Office of Public Buildings and Grounds. These files are in the National Archives in Record Group 42. The fragment referred to is in the papers of the Grant Memorial Commission, associated with Document 4/749.

9. Record Group 42, Grant Memorial Commission, Office of Public Buildings and Grounds Document 4/507, 31 January 1911.

10. Document 4/889, 24 July 1916. The letter by the director of the National Bureau of Standards goes on to say: "This material is, in short, a metal lacquer, and as such will give reasonable protection to bronze against weathering. If applied to a new piece of bronze work, it will prevent the formation of the 'platina' [sic] effect which is usually considered desirable. If it is applied after the proper 'platina' coat has formed, it will require frequent renewal to preserve it."

11. For a comparison by the company's sales manager, see Document 4/893 of 4 Oct. 1916: ". . . in comparison it now looks as if the Artillery Group was not a bronze group at all, but one made of cast iron. The lions also look like cast iron along side of the Cavalry Group which shows the reflection of bronze when the sun is shining on it, while the rest of the bronze work has a dead appearance and does not do justice to the sculptor."

12. Document 4/894, 12 Oct. 1916.

13. See Ogburn, Fielding, et al. "Restoration of Large Gilded Statues Using Various Electrochemical and Metallurgical Techniques." In *Corrosion and Metal Artifacts—A Dialogue Between Conservators and Archaeologists and Corrosion Scientists.* Washington, D.C.: National Bureau of Standards Special Publication 479, 1977.

14. See Veloz, Nicolas F. "Selected Problems in the Preservation of Outdoor Sculpture." In *Bronze and Masonry in the Park Environment.* Preprints, Center for Building Conservation and Central Park Conservancy, New York, 1983. See also Veloz, Nicolas F. "An Ounce of Prevention: The Preservation Maintenance of Outdoor Sculpture and Monuments." Master's thesis, George Washington University, 1983.

15. "Toluene, xylene, DMF, MEK, acetone, lacquer thinner, and several methylene chloride paint removers were tried in an attempt to remove the Incralac. Most successful. . . was a marine methylene chloride paint remover and approximately 900 psi water pressure. The paint remover did not emulsify the lacquer, but repeated applications did soften it, and weaken the surface bond sufficiently to enable 'blowing off' the slightly softened lacquer with the water jet. . . ." Veloz. "Selected Problems," p. 8.

16. Veloz. "Selected Problems," pp. 8-9. Before waxing, the gilded figures were washed with water and nonionic detergent, Igepal CO-630, with the addition of about 2.5% of the corro-

sion inhibitor benzotriazole. This was followed by additional spray applications of benzotriazole solution alone.

17. For 1978 and 1979 treatment, see Zycherman, Lynda A., and Veloz, Nicolas F. "Conservation of a Monumental Outdoor Bronze Sculpture: *Theodore Roosevelt* by Paul Manship." *Journal of the American Institute for Conservation* 19, no. 1 (Fall 1979): 24-33. See also Veloz thesis and "Selected Problems."

18. See Veloz thesis for background on soft abrasives and his "Selected Problems" for details of the *Harrison* treatment.

19. Extracts from *Management Policies of the National Park Service,* dated 1978:

PROPOSAL FORMULATION AFFECTING CULTURAL RESOURCES

Proposals for the restoration, reconstruction, removal, or neglect of historic sites and structures shall be advanced only as part of the planning process.

Proposals for any park purpose affecting cultural resources shall be implemented only when consistent with the following criteria.

1. The proposed action is consistent with the purposes for which the park was established, and there is no prudent or feasible alternative to a proposal that will affect cultural resources adversely.
2. The proposal has been formulated with the active participation of professional specialists in history, archeology, and historic architecture, as appropriate.
3. Sufficient historical, archeological, and/or architectural data have been gathered to permit a professional judgment of the validity of the proposal. If such data have not been gathered, proposals shall be conditioned on their subsequent acquisition.
4. The proposal is so conceived and defined that it is consistent with the applicable Service policy and criteria.
5. The effects of the proposal on all historic resources and other elements of the human environment have been assessed through interdisciplinary analysis, and all reasonable measures to minimize harm and avoid adverse effects have been incorporated in the proposal, including salvage of data and materials.
6. The Advisory Council on Historic Preservation and the appropriate State Historic Preservation Officer(s) have been presented an opportunity to comment on the proposal in accordance with the Council's Procedures for the Protection of Historic and Cultural Properties established under Section 106 of the National Historic Preservation Act and Section 2(b) of Executive Order 11593; compliance shall be documented by letter or memorandum of agreement as applicable. . . .

TREATMENT OF CULTURAL RESOURCES

For purposes of preservation treatment, the Service recognizes three classes of cultural resources: historic sites, historic structures, and historic objects (which differ from structures in being generally movable). Perpetuation of these resources will be accomplished by one or more of the following methods: preservation, restoration, or reconstruction.

Preservation—involves the application of measures to sustain the existing terrain and vegetative cover of a site and the existing form, integrity, and material of an object or structure. It includes initial stabilization work, where necessary, as well as ongoing maintenance.

Restoration—is the process of recovering the general historic appearance of a site or the form and details of an object or structure by the removal of incompatible natural or human-caused accretions and the replacement of missing elements as appropriate. For structures, restoration may be for exteriors and interiors and may be partial or complete.

Reconstruction—involves the accurate reproduction of an object or structure, in whole or in part.

All cultural resources shall be preserved (except where a determination is reached in accordance with the procedures of the Advisory Council on Historic Preservation that a particular resource need not be preserved). Consequently, prior to any other approved treatment, or following restoration or reconstruction, preservation treatment is required.

All forms of treatment described above shall be carried out only by, or under the direction of, competent Service professionals in conformance with approved supplemental criteria, standards, guidelines, and technical instructions.

All forms of treatment may be carried out in an area as applicable. Significance of the resource, its condition, its interpretive value, and the cost of treatment are all factors that must be weighed in determining the appropriate treatment. . . .

HISTORIC OBJECTS

Preservation—All historic objects that come into the possession of the National Park Service shall be accessioned, cataloged, given appropriate preservation treatment, and stored or exhibited in ways that will insure their continued survival with minimal deterioration. Such storage or exhibit shall include periodic inspection, cleaning and preservation treatment as necessary, and such conditions of atmospheric control as are most conducive to the survival of the objects.

Restoration—When needed to interpret properly the historical values of an area, a historic object may be fully or partially restored by the removal of nonhistoric additions and the replacement of missing members. In no case shall restoration include the removal of elements of the object such as integral parts or original finishes, except where such removal is necessary for the survival of the object as a whole. In such a case, removed elements shall not be discarded unless their removal occasioned their total destruction. To the extent possible, work accomplished in the restoration shall be reversible. Restoration of a historic object may be authorized on the basis of the following criteria:

1. Restoration is necessary for the survival of the object as a whole; or
2. The object is necessary for display purposes but cannot be properly understood without restoration, and sufficient data exist to permit an accurate restoration with a minimum of conjecture. In such a case the nonhistoric elements shall be distinguishable from the historic and removable. . . .

HISTORIC STRUCTURES

In its treatment of historic structures, the National Park Service shall heed the following internationally accepted maxims, adopted in 1936 by the Advisory Board on National Parks, Historic Sites, Buildings, and Monuments (now the National Park System Advisory Board):

- "Better preserve than repair, better repair than restore, better restore than reconstruct."

– "It is ordinarily better to retain genuine old work of several periods, rather than arbitrarily to 'restore' the whole, by new work, to its aspect at a single period."

The restoration of a historic structure to reflect an earlier period of its existence usually involves the impairment or destruction of some of its original fabric and a degree of conjecture in the replacement of missing fabric. Alterations to a structure are often of historical or architectural value in themselves and convey a desirable sense of evolution over time. No matter how well conceived and executed, a restoration will be an artificial modern interpretation of the past rather than an authentic survival from it. Accordingly, the preservation of a historic structure in its existing form shall always be given first consideration.

A historic structure, whether preserved in existing form, restored, or reconstructed, may be subject to adaptive use. Adaptive use may be appropriate for structures that are visually important in the historic scene but do not otherwise qualify for exhibition purposes. In such cases the facade, or so much of the exterior as is necessary, is treated to achieve the management purpose so that it will be properly understood from the public view. The interior is usually converted to modern functional use, but original fabric is retained wherever practicable.

Preservation—A historic structure shall be preserved in its existing form on the basis of the following criteria:

1. The structure, upon acquisition, already possesses the integrity and authenticity required; *or*

2. Restoration is indicated but must, for reasons of cost or the lack of sufficient data, be postponed; *or*

3. The structure has been restored or reconstructed and now must be preserved.

Restoration—Full restoration of a historic structure may be undertaken when essential for public understanding and appreciation of the historical or cultural associations of the park. Partial restoration (usually for adaptive use) may be undertaken when necessary to insure preservation of the structure or to restore the historic scene, or when desirable for interpretive purposes. In all cases, sufficient historical, architectural, and archeological data must exist to permit accurate restoration, with a minimum of conjecture.

Every restoration shall be preceded by detailed documentation of the structure, and any changes made during restoration shall be carefully documented. Original historic fabric shall be safeguarded to the extent possible during and after restoration. Important structural features, samples of surviving historic paint, and other elements of the structure removed during restoration and important to a technical understanding of the structure shall be preserved.

20. For a preliminary statement of current thinking, see Chief Historic Architect Hugh Miller's "The Three-Dimensionality of Statues, Monuments and Memorials," in *Cultural Resources Management Bulletin.* Washington, D.C., National Park Service, September, 1983.

21. *1982-1983 Building Technology Project Summaries.* Washington, D.C.: US Dept of Commerce, National Bureau of Standards, Special Publication, pp. 446-47, 1983.

22. Susan Sherwood, of the Preservation Assistance Division under the Associate Director for Cultural Resources in Washington, D.C., is coordinating National Park Service acid rain research and should be contacted for details at (202) 343-1055.

23. Nick Veloz suggests that a preservation program should include the following elements:
 • *inspection/inventory:* document condition, environment, site, etc.
 • *proposed maintenance/treatment plan:* evaluate and review
 • *schedule:* wise use of time, money, people
 • *implementation:* carry out work
 • *evaluation:* report treatment, monitor effectiveness, modify procedures if necessary

He has developed three forms for statuary/monument inventory, inspection, and record work completed.

24. From the Act of Congress establishing NPS, 25 August 1916.

THE VARYING ROLE OF THE CONSERVATOR IN THE CARE OF OUTDOOR MONUMENTS: Ethical Dilemmas

Arthur Beale

The next speaker is Arthur Beale, Director of the Center for Conservation and Technical Studies at the Fogg Art Museum, Harvard University. The Center is one of eleven cooperative conservation centers in the U.S. Mr. Beale is also the conservator of objects and sculpture and a senior lecturer on Fine Arts at Harvard, where he has been a conservator for eighteen years. He is currently chairman of the board and council of the National Institute for Conservation.
V.N.N.

Nineteen hundred and eighty-three is beginning to look like a milestone year in conservation, both in the level of activity in the actual conservation of outdoor sculptural monuments and in the number of conferences and articles addressing issues related to the techniques of conserving these monuments. There have now been three significant conferences within the span of a month.[1] Those responsible for the care of historic and artistic material who have followed these debates must at this point be very confused. Because of the high visibility of the type of cultural objects under consideration, the public itself is now more than just curious as to what is happening, as illustrated by the growing number of newspaper articles on the conservation of outdoor sculpture that are appearing in various U.S. cities. Before the issues become further confused and misinformation broadly disseminated, it is incumbent upon all of us directly concerned to focus our efforts toward common understanding. It is to this end that I have developed the following discussion. Beginning with a brief historical perspective, I will define some basic terms, explore in some detail the actual reasons for the ethical dilemmas we face, and conclude by pointing to areas of common agreement.

Conservation is a young and growing profession. The second generation is only now beginning to assume leadership roles. The American group of the International Institute for Conservation was formed twenty years ago. The American Institute for Conservation (AIC) was incorporated only a decade ago. The National Conservation Advisory Council (NCAC), which became the National Institute for Conservation (NIC), is just ten years old this year. It is also noteworthy that the American conservator who has done the most in the area of outdoor sculpture conservation, Phoebe Dent Weil, is marking the eleventh year of her work. It is significant that these milestones are being reached at the same time.

AIC membership is now in excess of 2000; approximately 300 of those individuals are Fellows, who have had at least five years or more of experience beyond professional training, often at the Master's degree level. There is also a growing number of Professional Associates, a relatively new membership category in the organization. These two groups, in assuming their professional standing, sign a pledge to abide by the AIC "Code of Ethics and Standards of Practice." The "Standards of Practice" was originally drafted in 1963; the "Code of Ethics" in 1967. Both these documents

were revised in 1979. In the first publication of the revised version, a historical note in reference to the "Standards of Practice" is made: "The primary purpose of this document was to provide accepted criteria against which a specific procedure or operation can be measured when a question as to its adequacy has been raised."[2] Although there is some repetition in the two documents, for the most part they complement one another (see Appendix B for the complete texts). The "Code of Ethics" directly concerns the actions of the individual conservator, while the "Standards of Practice" relates more to the conservator and his or her relations with colleagues and with users of conservation services.

Before looking at the documents further, it would be useful to define some terms. In the 1976 NCAC publication, *Conservation of Cultural Property in the United States,* an elaboration of the term "conservation" is presented:

Conservation encompasses three explicit functions: examination, preservation, and restoration.

Examination is the preliminary procedure taken to determine the original structure and materials comprising an artifact and the extent of its deterioration, alteration, and loss.

Preservation is action taken to retard or prevent deterioration or damage in cultural properties by control of their environment and/or treatment of their structure in order to maintain them as nearly as possible in an unchanging state.

Restoration is action taken to return a deteriorated or damaged artifact as nearly as is feasible to its original form, design, color, and function with minimal further sacrifice of aesthetic and historic integrity.

Every user of conservation services should have a copy of and be familiar with the AIC "Code of Ethics and Standards of Practice." The following discussion will only attempt to highlight some areas of the document, particularly as they relate to the treatment of outdoor sculptural monuments.

Of first importance is a preamble to the "Code of Ethics," which reads as follows:

Conservation of historic and artistic works is a pursuit requiring extensive training and special aptitudes. It places in the hands of the conservator cultural holdings which are of great value and historical significance. To be worthy of this special trust requires a high sense of moral responsibility. Whether in private practice or on the staff of an institution or regional center, the conservator has obligations not only to the historic and artistic works with which he is entrusted, but also to their owners and custodians, to his colleagues and trainees, to his profession, to the public and to posterity. The following code expresses principles and practices which will guide the conservator in the ethical practice of his profession.

The first topic heading after the "Preamble" is "Obligations to Historic and Artistic Works," which affirms the primacy of the object itself. It starts off with "A. Respect for Integrity of Object," stating that "all professional actions of the conservator are governed by unswerving respect for the esthetic, historic and physical integrity of the object." There are a number of other items. I will not go through all of them here but will list the topic headings: "B. Competence and Facilities"; "C. Single Standard," which instructs the conservator not to let value judgments influence treatments; and "D. Suitability of Treatment." "E. Principle of Reversibility" deserves more attention and is particularly controversial when strictly applied to the treatment of outdoor works:

The conservator is guided by and endeavors to apply the "principle of reversibility" in his treatments. He should avoid the use of materials which may become so intractable that their future removal could endanger the physical safety of the object. He also should avoid the use of techniques the results of which cannot be undone if that should become desirable.

The next item, "F. Limitations of Esthetic Reintegration," is also particularly relevant to our discussion:

In compensating for damage or loss, a conservator may supply little or much restoration, according to a firm previous understanding with the owner or custodian and the artist, if living. It is equally clear that he cannot ethically carry compensation to a point of modifying the known character of the original.

The last two items are "G. Continued Self-Education" and "H. Auxiliary Personnel," which is particularly important with outdoor sculpture, where a treatment is often a team effort involving technicians of varying skills and training. Next in the document is a whole section devoted to "Responsibilities to the Owner or Custodian," covering contracts, reports, and fees. The last sections are "Relations with Colleagues, Trainees and the Profession" and "Obligations to the Public."

Part Two, "Standards of Practice," also has a preamble which begins: "The following standards and procedures are approved by AIC as detailed guidelines to professional practice by conservators in the examination and treatment of historic and artistic works." Some of the general areas covered in this part of the document are policy questions, procedures for initiating and conducting and reporting scientific studies of works, and a very important section on procedures for engaging in and reporting on examinations and treatments. This reporting is generally called documentation. The "Standards of Practice" is very specific about what is expected of the conservator in the way of documentation, that is, condition and treatment reports, photographs, and so forth. Users of conservation services should be aware of these things so that they know what to expect prior to and at the conclusion of a treatment.

There are a number of reasons why documentation is considered so important. First, it is the written and photographic evidence that records exactly how the tenets set down in the Code have been met by the conservator in a specific treatment. Visual changes that occur in the course of the treatment are usually recorded in black and white photography; color prints and negatives are considered substantially less durable. Before-, mid-, and after-treatment photographic shots (see figures 26-28)

are considered a minimum for documentary purposes; multiple views are necessary with three-dimensional objects. Written reports list all of the specific materials and techniques used in the course of a treatment. These reports are an invaluable reference for any subsequent treatment that may need to be performed on an object; collectively, treatment records serve as the touchstone for further research for improving the materials and techniques of conservation. Finally, observations made by conservators about objects and their construction, recorded as documentation, are an important art-historical resource.

Although the accreditation for conservators is not yet a reality, AIC revised the "Code of Ethics and Standards of Practice" in 1979, partially to make them more legally enforceable. In short, if those who signed the pledge were proven to have violated the Code, they could be disciplined by the organization. There is an AIC Committee on Ethics and Standards that considers complaints and makes recommendations to that organization's board of directors. The AIC board has already taken some actions, and I believe we can expect more in the future. Ethics are becoming a serious matter with the rapid growth and the competition in the profession of conservation today. The profession wants to avoid state or federal intervention in licensing or accreditation; it would rather police itself, as many older professions now do.

When the "Code of Ethics" and "Standards of Practice" were first adopted, there was not very much going on in the way of treatment of outdoor monuments. Although some might argue that for this reason the documents are, at least in part, not relevant to the treatment of outdoor works, I find little to support this argument. The principal reason for the 1979 revision was to ensure that these standards would be applicable to the full range of cultural materials. A series of examples may help us better understand traditional views of what is intended by the documents so that the issues surrounding applicability can be more clearly considered.

All materials of art change with the passage of time. Environment, of course, plays a large role in how quickly and in what manner this happens. When combinations of materials are used to make a work of art, as they are in a majority of cases, structural and visual distinctions are created by the varying rates of decay of these different materials. For instance, some pigments in a painting will fade or discolor more rapidly than others. Similarly, certain metals in an alloy will corrode more readily than those with which they have been combined. Changes of this sort, as well as errors in the technique of the artist, are often referred to by conservators as "inherent vice." In addition to these natural changes, the modern conservator often has to contend with abuses of the past, which occurred to the work in the act of "restoration." An understanding of and a frustration with these abuses were what gave rise to the development of a written code for conservators.

Irrespective of whether the changes are natural or unnatural, the Code states that the integrity of the object must be respected and that the known character of the original must not be modified. In the first illustrations (figures 23 and 24), which show a painting by the fifteenth-century Italian artist Carlo Crivelli, compensation in severely damaged areas has been carried well beyond ethical bounds. Although for the most part the restorations in this example have been confined to the areas of

Figure 23: Carlo Crivelli, *Pietà,* Italian, 15th century. Condition of the painting in 1901. Courtesy of the Fogg Art Museum, Harvard University. Gift of Arthur Sachs.

Figure 24: Painting shown in Figure 23, after 1909, before being acquired by the Fogg Art Museum in 1924.

loss, my next example (figure 25) shows a painting from the same period from the school of Giovanni Bellini that has been almost entirely overpainted in an attempt to restore a badly damaged surface.

Let us consider whether it is reasonable to apply the rules governing the treatment of these two-dimensional examples to three-dimensional sculptures. Does surface treatment become less important than form when dealing with sculpture? Should we bend the rules when the original surface was ostensibly monochromatic and therefore more easily re-created? If we answer in the affirmative and the sculpture is in an outdoor environment, we next come head to head with the question of reversibility.

To illustrate the importance of reversibility, I have chosen the example of the treatment of a Greek vessel called a *skyphos*, circa 500 B.C. (figures 26-28). The vessel was acquired by the Fogg Art Museum in 1960. Additional pieces of the vessel were found in 1975 at the University of Mississippi. The vessel had to be disassembled and reconstructed, incorporating the additional sherds. If we could not have dissolved and removed the adhesives and fill materials used in the former treatment without damaging the fabric of the original vessel, we would have faced a serious dilemma.

Figure 26: Theseus Painter, *Attic Skyphos,* circa 500 B.C. As displayed at the Fogg Art Museum prior to 1975. Courtesy of the Fogg Art Museum, Harvard University. Bequest of David M. Robinson. Photograph by Michael Nedzweski.

Figure 27: Skyphos shown in Figure 26 during reconstruction to incorporate newly discovered sherds. Photograph by Michael Nedzweski.

Figure 25: Giovanni Bellini (school of), *Madonna and Child,* Italian, 15th century. Areas cleaned of former restoration show how little of the original surface is present. Courtesy of the Fogg Art Museum, Harvard University. Bequest of Grenville L. Winthrop.

Figure 28: Skyphos shown in Figures 26 and 27 after completion of 1978 conservation treatment. Photograph by Michael Nedzweski.

The cosmetic solution in this treatment is also worth noting in that it was arrived at with curatorial consultation, and it illustrates the range of possibilities. Remaining losses have been filled and monochromatically treated in orange and black, slightly off color from the vessel, so that the restorations can be discerned by the viewer, while there has been a minimal amount of design reconstruction. The intent is to allow us to appreciate the general shape of the vessel and its decoration without finding the restorations disconcerting or deceiving.

Another area of conservation where reversibility plays a major role is coatings. Natural resin and wax materials have been with us as protective coatings almost as long as painting and sculpture themselves. The removal of aged and discolored coatings typically occupies much of the time of a paintings conservator. Although to a lesser extent, it is also the concern of sculpture and objects conservators. With so many outdoor sculptures now having protective coatings applied, removal of these coating materials in the future will become a major task.

Debates persist to this day on the appropriate cleaning and coatings for paintings. At the heart of these controversies are issues of the reversibility and the stability of coating materials versus their optical properties, a matter of aesthetics. Because of the severity of environmental conditions, extremes of temperature, high ultraviolet light exposure, etc., stability is of major importance for coatings outdoors. Whether or not to sacrifice reversibility and aesthetic qualities for durability is obviously an ethical dilemma for the outdoor sculpture conservator.

The word "patina" has been used to describe discolored varnishes and accretions on paintings. It has even more relevance when used to describe both the artificial and the natural alteration of sculptural surfaces. The cleaning of sculpture and the possible removal of patina are today no less controversial than the cleaning of pictures. Even the simple removal of accumulated grime from a three-dimensional object can cause a rather dramatic change in a color or in surface quality (figure 29). Ancient objects, such as classical or Chinese bronzes, are often revered for their patinas, which are in fact corrosion products. Unless these metal alterations are particularly malignant or disfiguring, they are generally not removed. However, the attitude toward the treatment of the surfaces of other ancient metallic objects, such as those made of silver, is quite different. Corrosion products from silver objects are often removed electrolytically.

There are several specific technical considerations that enter into the decision making of whether or not to remove a metallic corrosion on an ancient object. First, there is the possibility that fine sculptural details, even including inlays or platings or precious metals, exist in the corrosion crust and would be irretrievably lost if the corrosion were removed. Next, there is frequently the possibility that the object has developed a form of on-going corrosion called "bronze disease." This condition results from burial in saline soil where chlorine reacts with

the surface of the bronze to produce an unstable form of copper chloride which, in the presence of moisture, acts to change sound metal underneath to more unstable copper chloride. While treatments have been developed that are at least partially successful in arresting the condition, the only guarantee of complete copper chloride removal is stripping by electrochemical or electrolytic means. Incidentally, chloride compounds are not usually found on outdoor bronzes unless they are located near the ocean or if there is a salt residual from a chemical patination process. The last and most difficult technical consideration is the fact that corrosion products are altered original metal. One or more specific metals—copper, for example—in an alloy have combined chemically with elements from the environment to form a new material that contains part of the original object. Complicating matters further is the situation in which alteration products become physically mixed with accretions, usually from the soil. Although the accretions are foreign material, it is not always technically possible to separate and remove them from an altered surface without removing the "patina" itself.

Figure 29: Amedeo Modigliani, *Carved Stone Head*. Mid-treatment photograph shows that the appearance of a sculpture's surface can be changed considerably simply by the removal of superficial grime. Photograph by Arthur Beale.

Several corrosion or alteration products that are relatively modern phenomena are caused by sulfur in the environment. When sulfide tarnishing forms on antiquities or other metal objects housed indoors, it is usually a brown or a black color and is quite disfiguring. If caught at an early stage, conservators can chemically remove the alteration without seriously affecting other corrosion or the original patina on a surface. Although in practice this particular treatment does not present major ethical dilemmas, when extended to outdoor bronzes, real problems do arise. Sulfur-related corrosion is severe because of acid precipitation. In many instances, sulfides and sulfates are the only patinas to be found on the sculptures.

Figure 30: Daniel Chester French, *John Harvard*. Harvard University. Photograph by Arthur Beale.

The degree to which an outdoor sculpture has been affected by acid rain or snow is a function of its geographic or site location and its configuration, as well as whether or not it has protective coating. The five examples I have chosen are all bronzes in the Boston-Cambridge, Massachusetts, area and represent five stages in the development of predominantly sulfide and sulfate patinas caused by their environments. The first example, *John Harvard* by Daniel Chester French (figure 30), was erected on the site of Harvard University in 1884. Because it has been the object of acts of vandalism by students of rival schools, such as Yale and Dartmouth, and the site of student protests, it has long received a biannual coating of protective wax. As a result, its original, chemically induced brown patina is largely unchanged despite exposure to the elements. The next example, also on the Harvard campus, *Rhinos* by Katharine Lane (figure 31), was installed in 1937. Because these sculptures are surrounded on four sides by multi-story buildings, rain and snowfall come straight down on them. In the winter, they are shaded and dry slowly. This exposure results in the disfiguring effects of acid

precipitation, with an overall black copper-sulfide patina streaked with bright-green copper sulfate. The next example is the *Robert Gould Shaw/54th Regiment Memorial* by Augustus Saint-Gaudens (figure 32), erected on Boston's Beacon Hill in 1897. Because this sculpture is in high relief, partially sheltered by its cut-stone setting, the protruding elements are the ones most altered by the rain and snow. The original brown background patina is for the most part still intact. The fourth example is a work by Olin Warner of *William Lloyd Garrison* (figure 33), dedicated in 1885. Islands of original surface now converted to copper sulfide tenuously remain above etched valleys of copper-sulfate corrosion. The final example is a heroic-size bronze by Thomas Ball of *George Washington* (figure 34), astride his horse, which has faced the elements in Boston Garden since 1864. This work has lost most of its original surface and now has an overall thin green sulfate patina.

My main point in showing these examples is to emphasize how different the condition of outdoor works made of

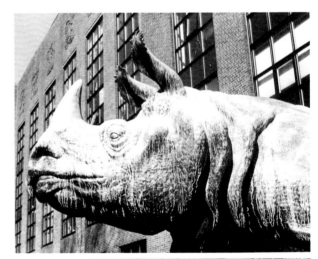

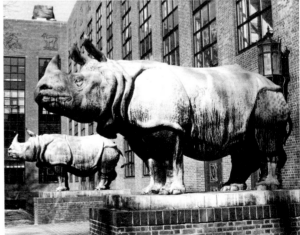

Figure 31: Katharine Lane, *Rhinos*. Harvard University. Photograph by Arthur Beale.

Figure 32: Augustus Saint-Gaudens, *Robert Gould Shaw/54th Regiment Memorial*. Boston Common. In 1981, before treatment. Photograph by Rick Stafford.

the same material can be. The dilemma for the conservator is to find appropriate and ethical treatments that address a common problem, while remaining sensitive to the aesthetic needs of each individual sculpture.

Several of my colleagues have focused on these issues. In 1972 Paul Philippot, in an article entitled "Historic Preservation: Philosophy, Criteria, Guidelines," offered the following:

> If the conservation of an object or building requires an intervention or substitution, the intervention should be recognized as a modern, critical action. How to integrate the modern intervention without faking the original object is an essential question of conservation, and the way in which the modern intervention is handled makes the difference between the restorer or conservator and the traditional craftsman.[3]

In the preprints from the October 1983 conference in New York, *Bronze and Masonry in the Park Environment,*[4] three of the participants also use the word "intervention." Tom Chase discusses "minimum intervention"; Phoebe

Dent Weil talks about "appropriate intervention"; and Nicolas Veloz in his paper presents the term "minimal intervention" in discussing his treatments with walnut shell cleaning and with benzotriazole and wax coatings. In the same publication, Tom Chase summarizes the problems surrounding the minimalist philosophy:

> In an ideal world, the conservator would like to preserve for all time the object in its original condition. But the real world is not ideal. Often we first see the object in a deteriorated or an aged state. Practical considerations enter in.[5]

And then he asks a series of questions: "Should we attempt to return the object to its original appearance? What was its original appearance? Is there evidence of age that must (should) be preserved? Is the surface corrosion or patina?" And, finally, he asks: "Who has the final say on what the object will look like?" This is a question that has come up again and again. I believe that the answer, especially in regard to outdoor monuments, is

Figure 33: Olin Warner, *William Lloyd Garrison.* Commonwealth Avenue, Boston. Photograph by Damon Beale.

that there should be collective responsibility. Certainly the conservator cannot be responsible for all the aesthetic decisions, nor should he be.

One example of this type of cooperative approach occurred in 1981 during the conservation of the *Shaw/ 54th Regiment Memorial* in Boston (see figure 32). Before work began on the monument, a committee made up of a scholar, a museum curator, and a National Park Service site director, all of whom were very familiar with the sculpture of Augustus Saint-Gaudens, was constituted to monitor the work in progress and especially to consider the aesthetic treatment of the monument. Through this process, a dialogue between the conservator, the curator, and the scholar was established. Not only did each member contribute particular expertise, but all learned from each other. Ultimately, they became collectively responsible for the aesthetic results. One of the more difficult decisions reached was to chemically repatinate corroded surfaces of the sculpture. For the conservator, this meant a process that was essentially irreversible. For the committee as a whole, it meant a decision that would

result in a dramatic change in the overall appearance of the sculpture. This particular monument is highly visible and socially significant. There was the risk that public opinion on the visual change would be negative. As it turned out, reaction was not adverse; but had it been, the members of the committee, all respected professionals, were prepared to defend their decision in the press. The mechanism worked well and could serve as a model for helping define the role of the conservator by providing an informed basis for decision making where ethical dilemmas exist.

In considering appropriate degrees of intervention, other alternatives should be mentioned. Relocation of an outdoor sculpture indoors will usually stop corrosion. Although not often a practical solution, sometimes objects are of such importance and high value as to warrant a move to a more stable environment. Familiar examples are the four *Golden Horses* of the basilica of San Marco in Venice and the caryatid architectural sculptures of the Erechtheum on the Acropolis in Athens. Serving in the role of conservation consultant, I have frequently found myself suggesting relocation as a solution to outdoor corrosion problems, especially for smaller contemporary works. Recently, I recommended to the mayor and City Commission on Arts and History of Charleston, South Carolina, that a marble sculpture of *William Pitt* by Joseph Wilton be moved indoors. It has been outdoors for 214 years and is now showing the serious effects of acid rain. It was my feeling that the state of our present technology is not such that we can guarantee the preservation of this, one of the oldest and most historic monuments in the United States, on its present site. After full consid-eration of the implications of the move, a decision has been reached to put the *William Pitt* statue in a Charleston museum. In addition to the conservation questions was the concern for the historic relationship of the monument to its site. The decision was made easier by the fact that the work was not presently on its original site and had been relocated several times already.

With other monuments, however, relocation presents real dilemmas. As Philippot has said: "The recognition of the value on the whole and the object's context leads logically to the principle that every object should, whenever possible, be conserved in situ if one wants to save the full value of the whole and of the parts."[6]

When a decision is made that a monument must remain where it is, as in the majority of cases, we are faced, either individually or collectively, with the question of how much intervention is appropriate. Philippot notes that environmental alterations of original materials are not only unavoidable but usually themselves irreversible. He states:

> The point when such alterations are felt to be distortions of the object's value and not enhancements of its aes-thetic quality cannot be defined objectively and is, therefore, a matter of critical interpretation and cultural responsibility. It should be clear, in any case, that simple

removal of the patina on a bronze or a painting will not recover the object's original appearance, but only uncover the present state of the original material.[7]

If patina removal is as serious a matter as Philippot suggests, then what are the alternatives in seeking the least interventionist approach? Obviously, the first general

Figure 34: Thomas Ball, *George Washington*. Boston Garden. Photograph by Damon Beale.

approach is the application of a protective coating. But even this step is a serious matter for the conservator. In a recent article, van Zelst and Lachevre, in discussing the application of "barrier" coatings, explain:

> . . . this . . . approach brings the conservator face-to-face with the necessity of tampering with the object in order to protect it from influences created by ourselves! It is only because the other solutions are in most cases not feasible, and the majority of the sculptures therefore would be left unprotected and undergo rapid fatal deterioration, that this last remedy can be considered partially acceptable.[8]

Protection or barrier coatings are also called "sacrificial coatings." The inference is that what a conservator puts on, nature or man can remove without harm to the original sculpture. Although in theory it is the coating that is intended to be sacrificial, in practice unmaintained coatings often cause differential corrosion which can be damaging to the sculpture. Similarly, if a break occurs in a coating and is not repaired, electro-chemical corrosion is accelerated in the exposed area. Both these causes of differential corrosion result in arbitrary disfigurement. The ethical dilemma for the conservator is whether to get involved with the application of coatings without a guarantee that they will be maintained. Funding uncertainties are a particular hazard with the treatment of outdoor sculpture. Treatment programs, especially those financed with "soft" moneys, are often thought of as one-time efforts. Endowments such as the one established for the conservation maintenance of the *Shaw/54th Regiment Memorial* in Boston, discussed before, are one way to address the problem.

Another difficulty with sacrifical coatings, often related to the lack of maintenance, is reversibility. Potentially, the surface of a sculpture can be damaged during the process of removing an insoluble coating. Nicolas Veloz has outlined the difficulty encountered in removing an eleven-year-old plastic coating called Incralac from the gilded monuments *The Arts of War* and *The Arts of Peace* in Washington, D.C.[9] Incralac, used as a sacrificial coating, is thought to have durability and reversibility for five years or longer. In the particular case of the Washington pieces, I believe that the gilded surfaces, because of their reflective properties, double the ultraviolet exposure received by the coating. This equivalent of more than twenty years of ultraviolet exposure in turn may have caused the change in solubility of the coating. Examples like this are warnings that more product testing needs to be done and, most of all, that regular maintenance schedules for removal and reapplication of coatings be established. Selection of protective coating materials in the future will not only be based on how effective they are but also on how easily and safely they can be removed.

One of the leading proponents of wax coatings for outdoor sculptures, particularly the "hot-wax" treatment, is Steven Tatti.[10] He also takes a preservation approach in his work, feeling that removal of any surface material other than surface dirt and grime seriously interferes with

Figure 35: William Wetmore Story, *Edward Everett*. Photograph by Arthur Beale.

the sculptor's work. A difference in kind rather than in degree exists between Mr. Tatti's method and the use of low-pressure, soft-abrasive (for example, walnut shells) cleaning methods. Hand cleaning and corrosion removal with bronze wool and water probably achieve results similar to those of the walnut shell cleaning. At the other end of the spectrum is the total removal of corrosion crusts, most commonly with low-pressure, air-driven glass microspheres. Phoebe Dent Weil has done the most work with this technique.

The major point of our discussions is that any corrosion removal is an irreversible process. The most succinct, yet comprehensive, justification of the total removal of corrosion products is to be found in a recent paper by Mrs. Weil entitled "Toward Ethical, Adequately Researched, Adequately Documented, Appropriate, and Maintainable Treatments for the Conservation of Outdoor Bronze Sculpture." She describes the following three advantages:

1. greatly increased chemical stability and resistance to corrosive attack through uniform surface treatment and uniformly re-reacting the metal surfaces thereby "defusing" the established local-action corrosion cells

2. minimal thickness of patina layer allowing for more effective and longer protection by the protective coating
3. the possibility of achieving a "classic" artificial patination that can be modulated to suit the specific demands of each sculpture and that may utilize the specific lustrous qualities of the metal beneath the "glazes" of color.[11]

Virtually all the individuals I have quoted or paraphrased agree on one thing: Each sculpture presents unique treatment problems that must be individually addressed. I believe that they would also agree that the principles set down in the AIC "Code of Ethics and Standards of Practice" play a substantial role in the design and execution of any given treatment. The users of conservation services can also play a substantial role in seeing that treatments are adequately documented and ethically and responsibly carried out. This can be accomplished by greater user awareness of the details found in the Code. Then, in drawing up contracts with conservators, users can stipulate adherence to the Code. I have seen this happening with National Park Service contracts as well as with grants for conservation treatments at both the federal and the state level. For example, for some time the National Endowment for the Arts has required both written and photographic treatment documentation as part of final grant reports. It is particularly important and useful to include the Code as part of bid documents and specifications, especially when potential contractors are not AIC members and are therefore unfamiliar with its tenets. I know of several instances in which state and city contracts for the conservation of outdoor bronzes were successfully carried out by metals craftsmen working within the Code and within the specifications drawn up by professional conservators.

An essential part of the self-education process for the user of conservation services goes beyond the Code, the literature, or the lecture hall. There is no substitute for what is to be gained from seeing treated objects. It is particularly useful for a client to go with the practitioner and to have the work and the aesthetic treatment described and justified (see Appendix A). In the same way that each treatment must fit the need of the object, the user must judge whether the treatment option proposed meets the long-term responsibilities held by the custodian. In at least one instance, I have had a client, a committee representing a city project in a neighboring state, consider all the treatment options, including seeing other treated sculpture, and decide on the ultimate—nonintervention. They decided that they would do absolutely nothing with the monument because they felt they could not guarantee a maintenance program and were afraid that the actions that they might take in regard to the monument might in the long run be detrimental.

The concern expressed by this group was twofold but commonly rooted in their perceived view that they had no control over the future. Tax funding for annual coating maintenance was uncertain, and they felt that our nation's ability to clean up air pollution was equally unsure. This

Figure 36: Chinese Stele, Harvard University. Photograph c.1936.

Figure 37: Stele shown in Figure 36, after almost fifty years outdoors. Photograph by Arthur Beale.

is certainly a problem that is tied to funding priorities. Philippot concludes:

> Any long-term conservation policy must be concerned more with fighting causes of deterioration than with repairing its effects.[12]

With outdoor monuments today there are two principal causes of deterioration: vandalism and acid precipitation. Both are environmental problems that are man-made and therefore have solutions. Finding the answers is a responsibility to be shared among all those concerned with the care and preservation of cultural property.

A neglected monument is an invitation for vandalism. Broken parts, graffiti, unmaintained lighting, and other symptoms of neglect, if left unaddressed, encourage further vandalism. The example illustrated here shows a nineteenth-century bronze of the orator Edward Everett raising a modern beer can to the sky, perhaps toasting the tattered symbol of our country seen flying above him (figure 35).

The pH readings of rainfall in the Northeast average 4.2 to 4.3 and during certain "events" even reach 3.6. Neutral is 7. Normal acidity in rainfall is 5.6. The rate of deterioration of outdoor bronzes and stone monuments from acid precipitation has not yet been accurately quantified. For conservators who work intimately with this

material, the quantification research is an unnecessary step. They are all too familiar with cause and effect. The once noble materials of the classical world, bronze and marble, are ironically falling victim to modern air pollution. One of the best examples of this is a marble monument found on the Harvard campus (figures 36 and 37). When this twenty-ton Chinese stele was given to Harvard in celebration of the University's tercentenary in 1936, the monument was already over one hundred years old. The area of inscription had been recut with an appropriate dedication and painted for contrast. Today this inscription and many sculptural details are nearly illegible because of the deleterious effect of acid precipitation.

The role of the conservator today in regard to outdoor monuments is a frustrating one. Methods for treating bronzes are largely stop-gap measures that require ongoing maintenance. Treatments for stone monuments are largely experimental, principally because of the extremely difficult nature of the problems. We need a concerted national effort, first to raise consciousness and then to find means to reverse the environmental air pollution that is destroying our cultural heritage. While continuing to concern ourselves with the treatment of individual outdoor monuments and larger scale preser-

vation programs as a first line of defense, we all must assume a greater role in addressing the causes of deterioration. This means that we will have to become voices with the media and with legislators. In addition, we will have to encourage and support greater efforts in the research and development of conservation methods and materials. It is through a cooperative and collective approach that we will see the greatest progress made in the care of sculptural monuments in an outdoor environment.

NOTES

1. *Preservation of Monuments and Historic Structures.* Sponsored by the Cultural Resources Management Section of the Mid-Atlantic Region of the National Park Service. Gettysburg, Pennsylvania, October 17-21, 1983.

 Bronze and Masonry in the Park Environment. Cosponsored by the Center for Building Conservation, the Central Park Conservancy and the New York City Department of Parks and Recreation. New York, October 20-21, 1983.

 Sculptural Monuments in an Outdoor Environment. Cosponsored by the Pennsylvania Academy of the Fine Arts and the Fairmount Park Art Association. Philadelphia, Pennsylvania, November 2, 1983.

2. *Conservation Treatment Facilities in the United States.* Washington, D.C.: National Conservation Advisory Council, 1980, Appendix B, p. 28.

3. Timmons, Sharon, ed. *Preservation and Conservation: Principles and Practices.* Washington, D.C.: 1976, p. 369.

4. *Bronze and Masonry in the Park Environment.* Preprints, Center for Building Conservation and Central Park Conservancy, New York, October 1983.

5. Chase, W.T. "An Introduction to Outdoor Bronze Corrosion and Treatment." In *Bronze and Masonry,* p. 1.

6. Timmons, p. 371.

7. Timmons, p. 374.

8. van Zelst, Lambertus, and Lachevre, Jean-Louis. "Outdoor Bronze Sculpture: Problems & Procedures of Protective Treatment." *Technology and Conservation Magazine* 8, no. 1 (Spring 1983), p. 19.

9. Veloz, Nicolas F. "Selected Problems in the Preservation of Outdoor Sculpture." In *Bronze and Masonry,* p. 7.

10. Tatti, Steven. "General Considerations Pertaining to the Conservation of Outdoor Bronze." In *Bronze and Masonry.*

11. Weil, Phoebe Dent. "Toward Ethical, Adequately Researched, Adequately Documented, Appropriate, and Maintainable Treatments for the Conservation of Outdoor Bronze Sculpture." In *Bronze and Masonry,* pp. 14-15.

12. Timmons, p. 381.

CHOREOGRAPHY AND CAUTION:
The Organization of a Conservation Program
Penny Balkin Bach

The first speaker of the afternoon is Penny Balkin Bach, Project Director for the Fairmount Park Art Association. She is also an artist, curator, educator, and administrator and was formerly head of the Department of Community Programs at the Philadelphia Museum of Art. A graduate of Tyler School of Art, she has a Master's degree from Goddard College in Visual Communications and Social Organization. Penny has presented exhibitions, workshops, lectures, and written material addressing art and the environment, museums and communities, and art education programs. Well-known for her work with artists, she was responsible for the Fairmount Park Art Association's tricentennial exhibition, Form and Function: Proposals for Public Art in Philadelphia, *which was held here at the Pennsylvania Academy of the Fine Arts.*
V.N.N.

One might wonder why a person whose primary interest is contemporary art would be so much involved with a conservation program that attends to nineteenth- and early twentieth-century sculpture. It is certainly a question that I have asked myself over the past two years. I will share my conclusions with you as I discuss the development of the Fairmount Park Art Association's Sculpture Conservation Program—why it was initiated, how it was formulated, and what we learned in the process.

The formal establishment of Philadelphia's outdoor sculpture tradition began in 1871. Two neighbors, Henry Fox and Charles Howell, young men in their early twenties, were determined that something was to be done to redeem Philadelphia from what they called the "reproach of excessive industrialism." Only a few years before, the city had established the Fairmount Park Commission and was proceeding to buy land to extend the city's holdings to the northern Wissahickon and the city's watershed. At the same time, Philadelphia had just been confirmed as the site for the 1876 Centennial Fair. One can imagine the great enthusiasm and youthful idealism of these men when in 1872 they established the Fairmount Park Art Association. By charter, the Art Association was designed to "promote and foster the beautiful in Philadelphia, in its architecture, improvement and general plan."

Herein lies the key, in my opinion, to Philadelphia's great tradition of public art; for over a century, the Association has been concerned not only with the commission of public sculpture but also with the placement and relationship of the sculpture to the plan of the city and to the spirit of the city. According to the Association's archives, this tradition has been characterized by innovation and agitation, followed by cooperative efforts with other civic bodies. It is this same process, I believe, that we have established while developing the conservation program, and it is this process that brings us together here today.

Over the years, the Association has initiated some of the most important concepts related to the physical and artistic growth of Philadelphia. For example, in 1907, the Association commissioned the plan for the Benjamin Franklin Parkway by Jacques Gréber, the noted French landscape designer. That same year, it established the "Committee on a Municipal Art Gallery," which urged the placement of a public art gallery (Philadelphia Museum of Art) at the end of the Parkway. In 1911 the Association successfully lobbied for the creation of a Municipal Art

Jury to approve and to recommend works of art that would become the property of the city. This established an early prototype for the city's Art Commission. In 1944 the Association commissioned plans for the area now known as Independence National Historic Park. Board members have also supported the creation of the city's Planning Commission and the city's "one percent for art" ordinance.

The Association has traditionally stirred public interest by initiating projects that have been "worthy of the public good." Then it has cooperated with existing institutions, often establishing new ones, to follow through with the original concept. Clearly there has been a time-honored practice of "filling in the gaps," and the care of works of art in Philadelphia certainly falls into this category. I would also like to fill in the gaps by addressing the questions that owners and custodians of works of art may have.

In this context, a conservation program was initiated three years ago, when the Association simultaneously began an ambitious program to commission contemporary sculpture. The Association recognized the need to preserve Philadelphia's existing sculptural history, even as we explored new directions and approaches to public art. As we looked toward the future, we were equally concerned with the treasures of the past. Because I had already been invited by the Association to direct its public art programs, the administration of the Conservation Program also became my responsibility. From my point of view, the issues of care, maintenance, artistic intent, and environmental concerns are the business of all public art, no matter when the work is created. And since, in one way or another, public art ultimately reflects civic values, I would like to examine these issues.

The notion of care and maintenance is glorified in the ritualistic attention given to the Cerne Giant (figure 38), a 180-foot-long chalk-cut hill figure in Dorset, England. Originating in the first or second century, the Giant has been maintained by ritual scourings on a lunar schedule, over sixty-six generations. These series of maintenance processes involve following the paths of the marks cut into the chalk hillside. It is truly astonishing that the Giant survived Puritan backlash, Victorian prudery, and other societal influences that could have interrupted the care devoted to this environmental work over the years despite its overtly sexual imagery.[1] Another example of ritual care is exemplified by the stone gardens of Ryoan-Ji Temple in Kyoto, Japan. There at sunrise the tradition of maintaining the rippled effect of raked stones continues as a daily spiritual responsibility.

The antithesis of ritual care and domination of the effects of nature can be seen in selected works of contemporary sculpture. Robert Smithson's *Spiral Jetty* (figure 39), of 1970, is located in a remote area of the Great Salt Lake in Utah. Smithson selected this specific site because microbacteria gave the water surface a red color. In this case, the effect was intended as part of the work. Smithson wrote about the process:

Figure 38: *Cerne Giant,* Dorset, England. After 1983 restoration. Photograph courtesy of the National Trust.

During the months of June and July, the *Jetty* was under 2 or 3 inches of water. . . . Around mid-August it was beginning to surface and the entire *Jetty* looked like a kind of archipelago of white islands because of heavy salt concentrations. . . . Two weeks later . . . the *Jetty* was almost entirely surfaced and . . . encrusted with salt crystals. There were various types of salt crystal growth. . . . Then, at other times, there is a different kind of mineral that looks like wax dripping on the rocks[Then,] some huge thunderstorms came in and completely dissolved all the crystals and turned the *Jetty* back to naked rock.[2]

Smithson described the coexistence of his sculpture with nature and the environment. The changes that took place were celebrated and were not meant to be dominated by any conservation process. If anything, the *Jetty* signifies the ultimate corrosion process: from earth returning to earth.

Michael Singer, in his *First Gate Ritual Series* of 1979, creates bamboo structures in remote park locations. These he envisions as private studies of the relationships of form, nature, and time. Each structure has a life of its own. As the constructions decompose, Singer returns to the locations, collects the remains, and is quite content to

Figure 39: Robert Smithson, *Spiral Jetty*. Photograph ©1984 Gianfranco Gorgoni. Reproduced by permission of the Contact Press, N.Y.

examine the formal aspects of his work through documentation and photography.

I refer to these last two works, not because they reflect all conditions in contemporary art but because they recognize and celebrate the relationship between art and nature, an important concept in contemporary art. In the context of this discussion, they confront the idea of decomposition, returning the materials of the artist to their natural form. While a small number of artists share this particular concern, acts of nature upon sculptural monuments in an outdoor environment are of concern to a wider community of artists, curators, conservators, owners, custodians, and administrators.

Last month I received some photographs and a note which said, "Behold vandalism and neglect!" A sculpture of Stephen Girard stood hidden by trees and defaced by graffiti. A recent inspection revealed that the trees had been pruned and the graffiti removed. However, given the vast holdings of the city and the park, it is not uncommon to see works that are in serious need of attention. By the establishment of a Sculpture Conservation Program, the Association has attempted to raise public consciousness. The fact that this seminar brings us together points to the growing local and regional concern for the care of public art. Through the news media, we have also been able to stimulate general public awareness of sculpture in today's environment.

I have been asked to focus on the "nuts-and-bolts" issues of conservation. When the Association began to explore the idea of a conservation program, members of the board first consulted with knowledgeable professionals in the field. The board itself is composed of museum directors, museum curators, lawyers, architects, business people, and concerned citizens; in effect, the board is a microcosm of people who have a vested interest in conservation. Various treatments were explored, and treatment proposals were elicited from several conservators. This was a complex endeavor, particularly because at that time there did not seem to be conclusive data available from the conservation profession. The Association examined the available data concerning environmental problems, the methods of conservation, and the controversies surrounding these issues. Simultaneously, sixteen works of particular artistic and historic importance to the city of Philadelphia were identified for treatment. Very soon it was concluded that a program had to be initiated immediately because serious deterioration had already occurred.

After careful deliberation, Steven Tatti was selected as the principal conservator for our project. It is important to recognize that the client engages (and purchases) not only the hand of the conservator but his/her critical eye and years of experience in the examination of works of art and the understanding of their scientific treatment. Tatti had broad experience in the treatment of outdoor sculpture; the board was very impressed with his work for

Figure 40: J. Otto Schweizer, *All Wars Memorial to Colored Soldiers and Sailors,* Fairmount Park, Philadelphia. Detail of three figures before treatment. Photograph by Franko Khoury.

the city of Baltimore, which similarly had embarked on a methodical conservation program.

The selected treatment is based on the application of a hard paste wax to a clean and heated bronze surface. First, the sculpture is cleaned of all surface dirt, grime, and other foreign matter. After cleaning, the sculpture is heated with propane torches; this heating process drives out any entrapped moisture and opens the metal to receive the first of a series of wax applications. This treatment does not remove any surface materials or current patinas. Rather, the sculpture is cleaned, protected, and stabilized, as the wax fills in the pitting and arrests the uneven deterioration of the work. As a result, the treatment also improves the appearance of the sculpture. It produces a cohesive physical and visual surface on which, in most cases, the modeling as intended by the artist becomes visible. The surface of J. Otto Schweizer's *All Wars Memorial to Colored Soldiers and Sailors* prior to treatment presented an image that was less than heroic; there was so much pitting, uneven corrosion, and visual activity that the actual rendering of the sculpture was obscured (figure 40). To be able to look

Figure 41: Detail shown in Figure 40, after treatment. Photograph by Franko Khoury.

at the forms as the artist intended, with gestures, expressions and details, is very exciting indeed (figure 41).

It is important to understand why the Association, its board, and its committees selected this particular conservation treatment. At that time, we were not considering a single work with a single owner. Rather, we found ourselves in a rather unusual situation. Although the Art Association originally had commissioned many of the works, they had been donated over a period of time to the city of Philadelphia, under the jurisdiction of the Fairmount Park Commission. Considering the many and growing responsibilities of the city and the park, it is not difficult to understand why conservation was not a priority.

This particular treatment was cost effective in that it enabled us to attend a larger number of neglected sculptures than any comparable method, protecting the sculptures against further deterioration. With this method, no original metal is removed. Further, the materials used for stabilization are reversible; the sculpture is retreatable. If and when other treatments become proven or desirable or if a benefactor is willing to give a large amount of money for a more thorough investigation of individual works, other treatments may

still be pursued. However, choosing this system enabled the Association to "buy time" and to protect the sculpture from further deterioration.

Once the treatment, the conservator, and the estimated costs were established, the Association looked for funding for this project. We found ourselves with an unanticipated dilemma. Because the Association had donated the works to the city, we discovered that we were ineligible for funding from most sources because we were not the "owners" of the works of art. For example, the National Endowment for the Arts, through the Museum Program, does fund conservation projects for organizations other than museums; however, it will only fund projects when the owner is also the grantee. (In the future, we can anticipate working with the city to apply for funds from the Endowment.) After considerable discussion and application to a number of funding sources, we found that we really "fell between the cracks." However, in April 1982 the Mabel Pew Myrin Trust generously granted $200,000 for a two-year conservation program. The trust acknowledged the critical need for initiating a program and for establishing a dialogue among those agencies that are ultimately responsible for the care of Philadelphia's sculpture.

This raises the issues of the responsibilities of maintenance and ownership. To this end, I have examined the early documents of the Association to determine if there was any thought or consideration given to the notion of maintenance. I could find none. What did our predecessors think about this? What I did discover was that the spirit of the time (1871-1921, the first fifty years of the Association's growth) was based upon a reaction to "the effect of a mechanical civilization upon human character and the human soul."[3] It was a very romantic, idealized view of the city. Most of the sculpture commissioned at that time glorified the idea of the beautiful or commemorated a particular person for having done a particular deed. Absorbed by beautification and commemoration, our city fathers never gave much thought at all to what was to become of these works with the passage of time. James M. Beck, a trustee since 1902, made some amusing statements in 1921 on the occasion of the fiftieth anniversary of the Art Association. He mused that if he could suspend animation and return in a hundred years, he would walk up to the Parkway, up the steps of the Art Museum, which he helped initiate, to look over Philadelphia, which would then have become the Athens of America. He never imagined that the ravages of time, nature, and vandalism would affect our lives so dramatically that, in fact, we would share with Athens not only our vast holdings of public monuments but also the pollutants that threaten our environment and our sculpture.

After the funding was confirmed, we began a yearlong process of work, which included approvals by the city's Art Commission and by the Fairmount Park Commission,

both granted in June 1982. During the following fall and winter, we proceeded to establish procedures for permits with the Fairmount Park Commission. We established a working process to solve logistical problems, such as access to water, storage of supplies, and examination of insurance, and to draft an agreement which would address the issues of cost, responsibilities, and record keeping.

Such an agreement is probably the most important conservation document. It describes and specifies the nature of the work and the documentation that is expected. Properly written, it allows for inspection and intervention, if necessary, at various stages of the working process. In this case, we requested at least three points in time when staff and board would have the opportunity to inspect the work prior to continuation of the working process. It is crucial to establish a working process that allows for the possibility to intercede and to intervene, if necessary, during the course of the treatment. We did not always feel the need to exercise this privilege, but the opportunity was available to us.

The agreement sets forth a payment process as well. In this case, the cost of individual treatments varied from two thousand dollars to eleven thousand dollars, with a total sum that was not to be exceeded. This allowed for fluctuations in the cost for any particular work; we realized that once the conservator was on the site, he might discover something that would make a treatment more or less expensive. Payments were made in accordance with the submission of conservation proposals (which evaluated conditions and proposed treatments) and conservation reports (which were submitted upon completion). At every stage, these written submissions were signed and authorized for payment by various board members. As a result, there were a number of different people who saw the reports along the way.

The agreement also outlines the responsibilities of the conservator and the client. Who pays for transportation? Who pays for equipment? Who pays for scaffolding? Who is responsible for photographic services? Who is responsible for water? What about repair of adjacent property, if for any reason it is disturbed in the course of the work? And who secures permits? These are all questions that must be answered and responsibilities that must be defined. Liability, insurance, and indemnity also must be addressed in the agreement. The client, for example, ought to request listing as an additional named insured on the conservator's policy. Certificates of insurance ought to be submitted to the client for review and carefully examined by the client's agent. Dispensing free insurance advice would be foolhardy; however, the agent will probably recommend bodily injury and property damage with excess umbrella coverage, independent contractors' coverage with completed operations, broad form comprehensive, general liability, and worker's compensation coverage. This may seem overwhelming, but working in

an outdoor environment carries unanticipated risks and is quite different from working within the protection of the artist's studio or the conservator's laboratory. Dealing with all of these problems creates a working relationship between the client and the conservator. The end result is therefore improved, because one anticipates problems and guards against them. By the time the work is initiated, it ought to flow fairly smoothly—which it did in our case.

The agreement also can establish a time schedule, and it provides a working document which clarifies responsibilities. The format for proposals and treatments can be designed at this time, taking into consideration the immediate and long-range documentation needs of the organization. In this case, we designed treatment forms jointly with the conservator—forms that would work for him on site and that would add to our archives as documentation for the sculpture.

Now, what are the results of this effort? Through the time and effort of the Academy, this conference is addressing the issues about which we all are concerned. While I present a rather cursory review of what the Art Association has accomplished, I really do believe that having the opportunity to bring people together to share these concerns is something quite extraordinary. Last spring, for example, the Art Association sponsored a seminar for artists which dealt with the fabrication process and its effect on the long-term care of large-scale outdoor sculpture. Philadelphia's Clean Air Council and the Commonwealth of Pennsylvania's Department of Environmental Resources have both acknowledged the work of the Association and the need to call attention to the condition of sculpture in the environment. The very slow decay of cultural property is close, tangible, and important to the quality of daily life. Convincing the public and public officials of the devastating effects of acid rain has been accomplished dramatically by a photograph of the corrosion on Remington's *Cowboy*. Corrosion was no longer seen as a romantic reflection of the past. Articles in local newspapers stirred a great deal of public interest and debate. Despite broad and accurate media coverage, we received telephone calls from uninformed people who wanted to know why we were painting all the sculptures with black tar! One wonders where they got their information but one applauds their general concern.

What are the implications? We must pay attention to all the issues raised today. We must set up a system that will establish a survey and maintenance program for this city's holdings. We must engage artists in an ongoing dialogue. Artists who are creating contemporary outdoor works must be made aware of the problems of the environment and the problems of maintenance. We must think about problems we can only imagine. As I reflect upon our predecessors, I realize they could not have imagined what the effects of pollution would be in today's world. We must provide careful documentation of the conservation process. Information concerning the fabri-

cation of new sculptures as well as documentation of the artist's intent will prove useful to future generations.

We also must watch the results of our efforts over a period of time. We need to examine these different treatments at regular intervals. When one takes a dog to a veterinarian, the doctor keeps a series of records, and one can tell from year to year what is happening to the dog's coat and vital functions; our doctors do the same for our bodies. A similar method of record keeping must be initiated for sculpture so that we can look at it over a period of time. Many of our assumptions are based on things we have just recently discovered.

Finally, we must work cooperatively to see that these goals are addressed. Why "Choreography and Caution," the topic of this paper? The choreographer plans the movements of others so that they can perform in harmony. I suggest that the role of the administrator is to keep all aspects of a program—in this case, a conservation program—in harmony. I will guarantee that one performer or another is going to get out of step, and it is the role of the administrator somehow to get everybody moving together and working together again. Caution? I can only reflect that we have proceeded very, very carefully in order to serve the best interest of the sculpture. Time, on the one hand, is not on our side because of the rapid deterioration that we have observed. On the other hand, we ought not to make quick decisions that we cannot reverse.

I have one final thought for the future. Earlier I referred to the ritual care of Japanese gardens, and I would like to mention the Japanese again. An innovative installation was recently initiated in downtown Osaka. This innovation solves public-health needs with an urban amenity. In 1979 the city government installed twenty-four illuminated aeration fountains along a 300-meter stretch of the canal in the downtown theater district which had become heavily polluted, evidenced by the disappearance of fish. Environmental checks disclosed a rise in the canal's biological oxygen demand above the available level. The installation of the twenty-four aeration fountains made possible increased amounts of oxygen in the stream and in the area. These fountains, in five different changing colors, illuminated the whole area at night and also pumped oxygen into the canal.[4] Thus, the environment was protected through a creative approach to art and urban planning. We need this kind of creative problem solving; the answers to our problems may not appear before us in ordinary fashion. We will be called upon to employ all of our resources to face the challenge of maintaining the past and protecting the future.

NOTES

1. Lippard, Lucy R. *Overlay: Contemporary Art and the Art of Prehistory.* New York: Pantheon Books, 1983, p. 221.

2. Holt, Nancy, ed. *The Writings of Robert Smithson.* New York: New York University Press, 1979, p. 183.

3. Beck, James Montgomery, LL.D. "The Utility of Civil Beauty." *Fiftieth Anniversary Publication No. 59.* Philadelphia: Fairmount Park Art Association, 1922, p. 20.

4. "Revived Canal Becomes Tourist Attraction." *Urban Innovation Abroad.* September 1979, p. 8.

BRONZE CONSERVATION:
Fairmount Park, 1983
Steven A. Tatti

Steven Tatti, the next speaker, has a nation-wide reputation for his work in outdoor sculpture conservation—from Mt. Rushmore to Philadelphia, where he is known to many of us either personally or through newspaper articles about his work for the Fairmount Park Art Association during the summer of 1983. He was with the Smithsonian Institution for eight years, primarily as sculpture conservator at the Hirshhorn Museum and Sculpture Garden, and is now in private practice.
V.N.N.

After listening to Penny Bach's presentation, *Choreography and Caution,* I suppose I am the dancer who performs for the public. I promise to take you on a walk through the park, but first I would like to make a few observations. Philadelphia's Fairmount Park has a remarkable collection of sculptures by some of America's greatest artists. These pieces were commissioned with the highest sense of national and local pride. They are monuments to the country's leaders and celebrate our history in a manner deemed appropriate by those who commissioned them. Bronze was the ideal and traditional material to employ when glorifying the past for future generations. Along with its inherent technical possibilities bronze also had the supposed advantage of being stable in an exposed environment. Just as we gained much information about past civilizations from their bronze artifacts and statues, so, too, we expected our bronzes to carry our story to generations in the future. This, unfortunately, is not what we are experiencing. After less than a hundred years, we are finding our sculptures to be in serious trouble. They have clearly not developed stable protective corrosion layers but have, instead, developed uneven pitted surfaces, disfiguring the sculpture and compromising the artistic integrity of the work.

It is not surprising to me that no serious attempt had been made to care for these monuments in the past. Given the history of bronze's durability, one certainly would not have expected such serious deterioration so soon. It is only recently that attitudes have changed toward monuments in public spaces as it has become increasingly clear that our environment is changing, and generally not in a positive direction. Each year, more ancient bronzes and marble statues are being moved inside to preserve what remains. I do not feel that the situation for outdoor statuary in this country has come to such a point or that moving sculpture indoors is a realistic solution for us. It is absolutely evident, however, that no piece can be left outside very long, untreated. In 1983 we have enough experience and information to find ourselves in a good position for establishing systematic care and maintenance for monuments. This is what we have started and hope to continue in Philadelphia. With the Fairmount Park Art Association, we undertook a project to treat the sculptures in the Park with the primary goals of arresting further deterioration and of improving aesthetic appearance. In so doing, we believe we are clarifying the original artistic intent.

The treatment I use in most cases—after initial examination and photography—begins by cleaning off all surface dirt, grime, and foreign matter, using water under low pressure and a nonionic detergent. The sculpture is then thoroughly rinsed clean of all detergent and loose particles. After cleaning, the piece is heated with propane torches, working all around the sculpture, driving out the entrapped moisture, and opening the metal to receive the first in a series of wax applications.

Wax is prepared in the studio ahead of time in the following proportions:

85% Bareco Victory microcrystalline wax
10% Bareco 2000 polyethylene wax
5% Cosmoloid 80 H wax

Generally, I use a clear wax, which saturates the metal and brings out the existing color, so that the final appearance will be similar to the sculpture saturated with rain water. The light-green corrosion particles absorb light so that none of the color underneath can be seen, and the contrast between light-green corrosion and darker areas that usually contain some original patina becomes very distinct. Saturation of the metal with water or wax minimizes the color contrasts that have developed over the surface. Each sculpture has a unique surface and color, requiring special treatment. If an object has a green patina, the clear wax will be used. This only slightly deepens the green. If the original patina is very dark brown or black, the use of brown wax helps to unify the piece.

Concentrating on one area at a time, the wax is worked into the bronze surface with large, coarse hair brushes, using additional heat to flow the wax into cavities. The initial coat is allowed to solidify overnight. The next day, after the solvent has evaporated, we can see how the various areas of the sculpture have received the wax. Certain porous areas will appear not to have been treated at all, while the burnished areas will have wax lying on the surface.

The procedure for application of wax is similar the second day, but work is concentrated on the more porous areas; the intention is to harmonize the wax saturation and the color differentials. When the second application has dried overnight, we can evaluate how successful the previous day's treatment has been. If the surface looks coherent, the third and final layer of wax is applied evenly. This layer is applied with less heat and is flowed onto the surface to create a homogeneous film.

During all three stages, evaluations are being made as to the amount of wax required to bring out the quality of the metal but not to make the object look like wax itself. Aesthetic decisions about this effect, as well as surface continuity and the overall unity of the piece, are made throughout the treatment process. An understanding of sculpture and a sensitivity to three-dimensional qualities are essential. The mechanical task of applying the wax with heat can easily be taught, but haphazard and unsatisfactory results can occur if the ongoing aesthetic decisions are not appropriate to the particular sculpture and site.

The last stage of the treatment takes place after the final coat has dried overnight. The surface is buffed by hand with brushes and cloths, and cold wax is applied in areas that show imperfections in color and gloss. It is important to buff by hand, to be able to work the highlights so that each one is meaningful to the overall artistic integrity of the piece. An overzealous working of the surface or the creation of polished accents for dramatic effect can result in a misleading surface appearance, one that is not true to the original artistic intent.

This treatment has the desired effect of sealing the bronze from atmospheric attack and humidity problems. A positive aspect of the method is that no original material is removed; whatever remains of the original patina is retained. In working with different colors of wax during the third stage of treatment, we try to bring back as much surface color and definition as possible. The success of this treatment over time, as with all treatments, relies heavily on a commitment to continual maintenance to keep the pieces protected and looking their best. This upkeep involves close inspection on an annual basis and re-treatment of the surface with cold wax. These treatments have been designed so that a sculpture can be maintained by skilled, careful craftsmen, but it is in the best interest of the sculpture if the conservator reinspects the sculpture routinely and specifies the nature and extent of the annual maintenance.

Twelve illustrations follow with explanations of many of the issues we addressed in the summer of 1983.

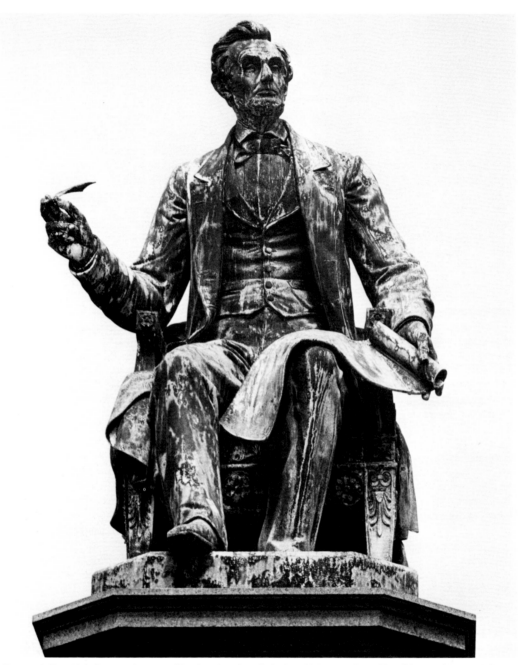

Figure 42: Randolph Rogers, *Abraham Lincoln,* 1871. Installed 1871. Fairmount Park, East River and Lemon Hill Drives. Condition May 1983, before conservation treatment. Photograph by Franko Khoury.

The appearance of the surface is typical of bronze sculpture that has been outdoors for extended periods of time without any protection. The dark areas are generally original surface, darkened chemically in the foundry to the artist's specifications, plus dirt and dark corrosion products. The light areas are generally bright-green corrosion products that have formed in areas where surface metal has been washed away by rain. The vertical streaks, such as those on the right side of Lincoln's face and along his left trouser leg, show the paths of the rain water. The depressions in the surface where metal has been lost can easily be felt with the fingertips. Small sculptural details can become obscured by the artificial pattern of lights and darks, and small sculptural ornaments can be destroyed, such as the plume in the right hand, which is now almost paper thin.

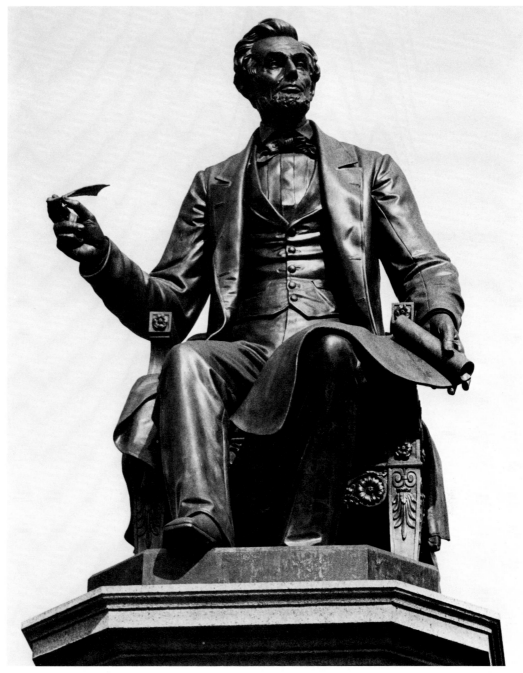

Figure 43: Sculpture shown in Figure 42, July 1983, after conservation treatment. Photograph by Franko Khoury.

The surface appearance has been greatly unified by the application of a hard paste wax onto heated bronze. On close inspection, the darker areas of original surface are still distinguishable from the lighter areas of loss, but the difference has been minimized to such an extent that details such as folds on the shirt can be seen and the textural juxtaposition of shirt, coat, and beard can be appreciated. With proper maintenance of the wax coating, the sculpture will be protected from further deterioration.

Figure 44: Sculpture shown in Figure 42, March 1984, after conservation treatment. Photograph by Franko Khoury.

The granite base of *Abraham Lincoln* was originally embellished with bronze plaques on four sides. The plaque on the front has been missing for some time and will eventually be replaced because the void that has been created disturbs the total effect. This work was not carried out in 1983 because protection of the bronze sculptures was the highest priority in the first year of the Fairmount Park Art Association's conservation project.

Figure 45: John J. Boyle, *Stone Age in America,* 1887. Installed 1888. West Fairmount Park, near Sweetbriar Mansion. Detail of child's face, May 1983, before conservation treatment. Photograph by Franko Khoury.

This detail shows fairly typical destruction of a bronze surface that has been outdoors, unprotected for almost a century. The differential corrosion of the metal is described in the caption for figure 42. Here, the severe pitting gives the child's face a diseased and tortured appearance.

Figure 46: Detail shown in Figure 45, March 1984, after conservation treatment. Photograph by Franko Khoury.

The wax has saturated the pits in the bronze, protecting the metal, bringing out the natural color, and unifying the surface. The expression of fear and helplessness suitable to the interpretation of the piece has been re-created.

Figure 47: Alexander Milne Calder, *Major General George Gordon Meade,* 1887. Installed 1887. West Fairmount Park, north of Memorial Hall. Condition May 1983, before conservation treatment. Photograph by Franko Khoury.

This sculpture sits in the middle of an open field away from main traffic arteries. The sculptural planes are generally large and smooth, and there are not a lot of small crevices in the modeling. Because of the design and because the monument gets the full force of weather from all directions, the loss of original surface has been extraordinarily even. Almost the entire surface is covered with a light-green sulfate.

Figure 48: Frederic Remington, *Cowboy*, 1908. Installed 1908. Fairmount Park, East River Drive. Condition July 1983, after conservation treatment. Photograph by Franko Khoury.

Figure 49: Detail of cowboy's right boot from sculpture shown in Figure 48, May 1983, before conservation treatment. Photograph by Franko Khoury.

This sculpture was missing a number of design elements, such as the reins on the left side, a lasso on the right side, and the spurs on the left boot. Their absence was so disturbing that it was decided to replace them during the initial phase of work. We modeled them in wax, using counterparts on the opposite side of the figure for reference. They were cast in bronze, chemically patinated to match in color the waxed surface of the sculpture, and welded to the piece.

Public attention directed toward conservation of this sculpture in the summer of 1983 sparked some new interest in the landscaping of the site, which had been chosen specifically by Remington. Grasses were cut back from the base of the monument, and trees were pruned to afford a full view of the whole sculpture from all approaches.

A fairly common problem on outdoor bronzes is seen here. The large white spot on the back of the pant cuff is investment material that has come through a porous area of bronze because of pressure from water trapped inside the hollow casting. Weep holes drilled in the bottom of casts to facilitate water drainage often become clogged with grime over the years; sometimes the foundry has not drilled as many as are necessary. In this case, we drilled out the core material, releasing water from the internal cavity. A new weep hole was drilled underneath. The porous area on the cuff was sealed as part of the wax treatment.

Figure 50: Antoine-Louis Barye, *Lion Crushing a Serpent,* 1832. Installed 1893. Rittenhouse Square. Condition May 1983, before conservation treatment. Photograph by Franko Khoury.

Figure 51: Detail of sculpture shown in Figure 50. May 1983, before conservation treatment. Photograph by Franko Khoury.

Although the appearance of this piece suggests that it has been severely attacked by its environment, the damage is fairly superficial. Rain has washed the sculpture along composition lines. The metal itself does not show any pitting or serious corrosion problems. This may be due to the fact that Barye is known to have worked over the entire surface of his pieces very thoroughly after the bronze was cast. The sculptor's tools compressed the metal, forming a hard, uniform surface. In this case, the major purpose of the minimal wax treatment was aesthetic.

This sculpture is often touched by children playing around it; their attention to the head of the serpent, for example, has caused the patina to be rubbed off and the exposed bronze to be polished to a bright gold-brown. This contrast against the deep-brown chemical patina is part of the history and the continual use of the piece, and we chose not to alter that. If the object were in a more protected place, I might have considered chemically repatinating the areas of loss.

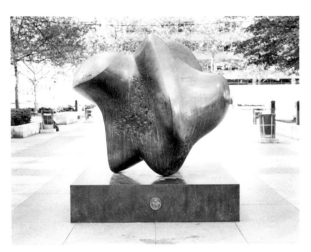

Figure 52: Henry Moore, *Three Way Piece Number One: Points,* 1964. Installed 1967. John F. Kennedy Plaza. Condition May 1983, before conservation treatment. Photograph by Franko Khoury.

Figure 53: Detail of sculpture shown in Figure 52, May 1983, before conservation treatment. Photograph by Franko Khoury.

On the lower part of the sculpture, the streaky pattern of surface loss is clear, although on close inspection one cannot yet see with the naked eye that depressions have been formed in the metal. Photographs from 1977 suggest that there was little visible alteration in surface appearance during the first ten years the piece was outside. However, the cumulative effect of outdoor exposure has become more obvious after fifteen years.

Graffiti is a problem, particularly in this busy plaza in Philadelphia, on a sculpture that is so easily accessible. Graffiti is most often applied with spray paint, although felt-tip markers are commonly used; paint is sometimes poured into balloons and thrown on high monuments. Public property is never really safe from vandalism. Once graffiti appears on a piece, it encourages more graffiti, so that it is wise to remove markings as soon as they appear. The protective wax coating applied to this piece in the summer of 1983 offers an excellent barrier, facilitating the removal of paints. After removal, new wax can be applied to the clean area and buffed to regain the former surface appearance.

CONSERVATION OF BRONZE SCULPTURE: A Series of Case Studies

Phoebe Dent Weil

It is a pleasure to introduce again Phoebe Dent Weil, who spoke to you this morning as a historian. This afternoon she is wearing the hat of conservator. Out of the St. Louis center have come an impressive number and variety of treatments for outdoor bronze sculpture. Many kinds of challenges and a range of possibilities for meeting them will be discussed.
V. N.N.

The problems of bronze sculpture conservation are complex; they do not admit simple solutions. Each piece has its own unique characteristics from the point of view of fabrication, materials, structure, history, aesthetics, purpose, significance, function, location, environment, and deterioration. Each of these, and other aspects, must be carefully documented and considered in forming judgments regarding an appropriate conservation treatment. Formulating "a method" and proceeding on the *"et cetera* principle" are not what we may call conservation.

There is a basic and serious flaw to thinking in terms of the development of an ideal "treatment" or "method" or "process" to be "applied to" sculptural works of art. It is always the other way around; that is, the conditions and specific problems posed by the object, in this case bronze sculpture, dictate the application of solutions most appropriate to those problems. The conservator must, then, be prepared with the most diverse and broadly based skill, knowledge, experience, and judgment to meet these diverse needs in conservation applications.

By "conservation" we understand the inclusion of the activities of examination, restoration, and preservation. Sheldon Keck has defined restoration as an operation "completed when the structure has been returned, as nearly as circumstances permit, to what is considered its original physical and esthetic state."[1] Restoration, he continues, leans heavily on the critical judgment of the operator and stresses, therefore, "both the esthetic and historical phases of conservation." If treatment relies solely on scientific data, the result may be a gross aesthetic distortion or a violation of historic meaning; if it "relies entirely on esthetic criteria, the result may be, as it too often has been, a beauty treatment which neglects underlying and continuing disintegration."[2]

What I intend in this rather informal medley is to try to give you some insight into the conservator's critical judgment at work, to give you a glimpse of the great range and variety of problems encountered, and to describe our efforts toward meeting and solving these problems in the most appropriate and ethical ways that we can devise.

First, however, I would like to provide you with a bit of background that describes the origins of our laboratory and the development of our activity in the field of sculpture conservation.

The work of our group at Washington University in St. Louis began, as Arthur Beale has pointed out, only eleven

years ago—a relatively brief time. My work in conservation prior to that had been mainly in paintings. However, from involvement in the studio practice of sculpture from a very early age, I developed a very basic and long-term interest in sculpture and sculptural problems and, later, in the history of sculpture and sculpture techniques. After graduate training in art conservation at New York University and in Brussels and Rome and after a move to St. Louis in 1968, I was asked in 1970 to examine and treat a large sculpture-fountain complex in St. Louis, *The Meeting of the Waters* by Carl Milles. This marked the beginning of what has become a lifelong commitment to documenting, studying, and attempting to solve the challenging problems of sculpture conservation.

When preliminary studies on the Milles fountain began, I quickly became aware of the fact that one conservator working alone was not adequate for addressing the complex problems that presented themselves. So began a collaboration of people, mainly at Washington University in St. Louis, in a variety of disciplines, including chemistry, physics, engineering, art history, and others, and with a variety of experts, including engineers, conservators, art historians, museum curators, and other specialists in the United States and Europe who have all contributed in one way or another to what we have been able to accomplish in this brief time.

From the Milles fountain we went on to plan and initiate in 1974 a comprehensive program of research, treatment, and maintenance for the more than forty outdoor bronze sculptures owned by the city of St. Louis. This project, completed in 1978, appears to have been the first major campaign undertaken by an American city for the conservation treatment of its outdoor urban bronzes since the WPA project, headed by Karl Gruppe, which treated important New York bronzes in the late 1930s. The first round of maintenance for the St. Louis sculptures was performed after three years; the second, after five years, will be performed during 1984-85.

In 1967, when John Gettens addressed the ICOM Conservation Committee on the urgent questions of outdoor bronze sculpture conservation, there was some question in his mind whether or not conservation principles could be applied on the large, "engineering" scale of monumental sculpture. The past decade has convinced me that the answer is surely in the affirmative and that the application of conservation principles and ethics to the treatment of these works has made all the difference in both long-term preservation and aesthetic appearance.

Indoor Bronzes and Certain Outdoor Bronzes: No Treatment to Minimal Treatment

Well-preserved bronzes requiring minimal treatment can be found in abundance among those that have always been kept indoors. One particularly attractive example by a sculptor who also produced large-scale outdoor

bronzes, all of which have altered considerably since the time they were made, is a three-foot-high version of the *Appeal to the Great Spirit* (1912, Gorham cast) by Cyrus Dallin in a private collection in St. Louis. Like all of Dallin's well-preserved bronzes, it has a glossy dark-brown patina; the luminosity of the surfaces and the exceptional care and skill in the chasing contribute to the unusually fine quality of this exemplar.

The excellent condition of this piece results from the fact that it has been carefully handled and has been kept relatively clean and dry. Moisture in combination with gaseous and solid pollutants has not been in contact with the surfaces to activate the slow but inevitable destructive attack that occurs in an outdoor setting without effective protection.

The treatment approach to well-preserved bronzes is, of course, extremely simple. Basically, the care of such objects involves providing a safe and dry environment and keeping the dust off. Regular dusting may be done with a soft, clean cloth or brush. Normally, there is some wax on these pieces to begin with, typically a beeswax or beeswax-carnauba mixture applied as a finishing touch in the foundry, and so additional waxing may or may not be necessary. You do not want a thick wax accumulation, and it may be desirable to remove excessive build-up, particularly if the wax has deteriorated and has become opaque or discolored, typically to a light, opaque tan. More stable and nondiscoloring microcrystalline waxes are now available and may be used instead of the natural products.

It is important to remove any fingerprints or other foreign deposits, liquid or solid, for these may initiate corrosive attack. The polished surfaces typical of such artists as Arp, Brancusi, and Pomodoro may be permanently etched by the acidic components of skin oil deposited by human touch. The most severe case of such damage that I have observed was on a piece with a directional satin polish fabricated from unpatinated Everdur bronze.[3] Polished pieces accessible to touch must be professionally cleaned, polished, and treated with a corrosion inhibitor, and coated, preferably with a resin.[4] Such treatment will help to avoid surface loss from frequent polishing treatments and will protect from the damage and disfigurement that frequent touch imparts. A very light coating of microcrystalline wax over the resin coating may serve as a sacrificial layer, which can be maintained by simple means over the resin layer. Properly applied, these coatings can be scarcely noticed, if at all.

Coatings will provide a first line of defense, but as a general rule bronzes should never be handled or touched with bare hands. Clean cotton or surgical gloves should be worn, and handling should be kept to a minimum to avoid wear on the patina. Most patinas are extremely delicate, and, given enough touch, they can be worn away.

Figure 54 shows a detail of a Giacometti surface which is highly matte and opaque. In this case, I think it is quite

Figure 54: Alberto Giacometti, *Standing Female*. Formerly private collection, St. Louis, Missouri. Photograph by WUTA/SCL.

Figure 55: Daniel Chester French, *Jimmy Green,* 1926. Lawrence, Kansas. Photographed in 1977.

clear that no coating is appropriate; the intensely matte black appearance of the surface would be destroyed if wax or resin were applied. Such a coating would "saturate" the surface and significantly alter its matte appearance. Fortunately, this kind of patina is fairly durable outdoors, but if wear or corrosive attack becomes evident on a piece such as this, it should be brought inside with no treatment whatsoever, except perhaps for washing with a nonionic detergent and water and for occasional dusting to remove loose particulates that may collect in the crevices and cracks of the surface textures. Outdoors there is the problem of debris that may appear on a piece from insect nests, leaves, spiderwebs, bird deposits (of course), pollen, soot, dust, and so forth, and it is basic to maintenance that particles and loose deposits such as these be removed as regularly as possible because they all help to initiate corrosive attack and, as well, contribute a certain amount of disfigurement.

The sculpture in figure 55 is the *Jimmy Green* by Daniel Chester French, unveiled in 1926 in Lawrence, Kansas. Lawrence has far cleaner and dryer air, certainly,

than St. Louis or Philadelphia, and that has been a major factor contributing to the exceptionally good condition of this piece. It, like the *John Harvard,* receives coatings of paint and various kinds of attention from students, but as a result, like the *John Harvard,* it receives a periodic waxing. Thanks to this regular kind of maintenance, it has unusually well-preserved surfaces with only a very slight hint of green beginning to form in several places. The green is extremely thin, compact, enamel-like, and well adhered—both stable and aesthetically acceptable.

Outdoor Bronzes with Superficial Deterioration: Superficial Treatment

A bronze by Antoine-Louis Barye entitled *War (La Guerre)* (figures 56 and 57) is one of two Baryes treated at our laboratory during 1979-80. *War* and its mate, *Peace (La Paix),* were cast by Barbedienne around 1876, after Barye's death, from the artist's plaster models made about 1854 for the decoration of the Louvre courtyard facades.[5]

Figure 56: Antoine-Louis Barye, *War.* Museum of Fine Arts, St. Petersburg, Florida. Detail, before treatment. Photograph by WUTA/SCL.

Unlike the Baltimore exemplars, which have been exposed to an outdoor urban atmosphere since 1885 and which have suffered severe surface damage, these bronzes were exposed for only three years to a non-industrial marine atmosphere, resulting in the rusting of ferrous metal left inside the pieces and in superficial weathering of the patina.

The patina in this case is green, produced chemically using a well-known formula containing sal-ammoniac, on top of which is a pigmented wax (black with some burnt umber). Such a patina is frequently found on late French bronzes from the foundries of Barbedienne and Rudier and has a particular attractiveness in the subtle modulations of the wax coating achieved by rubbing to reveal more or less green beneath. When artfully applied, this patina subtly enhances the visual reading of the forms and the textures and is not so opaque that it does not allow some of the warm brown tones of the metal to appear as well.

The deterioration that had occurred, while producing a severely distorted visual effect, was, in fact, largely superficial weathering, in which some of the pigmented wax had been unevenly worn away to reveal the chemi-cally induced green patina layer beneath. The green layer in this case, unlike the greens produced from corrosive attack on urban bronzes, is fairly stable and imparts a degree of protection under certain conditions if it is not excessively thick. No corrosive attack had begun to develop. The conservation problem was, therefore, superficial and could be adequately treated with a protective coating to prevent future deterioration in an outdoor environment.

These pieces were first cleaned with detergent and water to remove particulates and other superficial accumulations. An initial protective coating of Incralac[6] was sprayed on, both to protect and to isolate all original material from subsequent additions. Surface reintegration was accomplished by using pigmented paste wax on top of the Incralac coating to match the original. The wax was then rubbed so that it would not be excessively opaque and would reveal the green beneath, as had been originally intended. A final coating of Incralac was then sprayed on and adjusted to the proper degree of matteness by a polyethylene dispersion matting agent.

We have occasionally encountered cases where corrosion products have accumulated on top of a wax or

Figure 57: Detail shown in Figure 56, after treatment. Photograph by WUTA/SCL.

other coating applied to an essentially "healthy" and well-preserved foundry patina. A slight amount of corrosive attack obviously takes place. The dissolved metallic ions have migrated as they normally do, upward through the porous wax coating, and have deposited themselves on the outermost surface on top of the wax. While visual disfigurement may be extreme, the treatment problem is essentially superficial. All we have to do in these cases is carefully, with very delicate abrasion, remove the corrosion products from the top of the remaining wax coating without removing much of the wax or any of the original patina to reveal the well-preserved original surface beneath.

Obviously, maintenance is a basic concern to us, and insuring that maintenance is both carried out and done properly is fundamental. We provide our clients with a maintenance manual and specific maintenance instructions for every treatment that we do.[7] Further, we provide instruction, when possible, to on-the-scene personnel who will be present and, therefore, able to observe the sculpture from time to time and who can report and record intelligently about its condition and any changes that may occur.

Outdoor Bronzes: Early Stages of Corrosive Attack

Corrosive attack normally begins in areas related to water retention. Areas on sculpture that are most exposed and that retain water longest are typically those where initial attack may be observed. Ultimately this is where the most severe attack occurs.

The appearance of a black, matte, opaque sulfide crust is the first stage of corrosive attack when corrosion occurs relatively slowly. This was seen in *Hercules and the Hydra* (figure 58), owned by the St. Louis Art Museum. It had been waxed in the past, so that the formation of a crust on top of the remaining wax was very gradual. A green crust—which is basic copper sulfate, generally equivalent to the mineral brochantite—covered primarily those areas that had been most washed by water. There were remains of gilding in the hair and on the Hydra's eyes. Core material from the interior had been dissolved by moisture and drawn to the surface of the bronze through fine pores and cracks, where it recrystallized. Rust stains on the surface had been formed by iron core pins or chaplets, which hold the inner and outer molds in position during the lost-wax casting process. Chaplets are normally removed but occasionally are overlooked in the

Figure 58: Mathias Gasteiger, *Hercules and the Hydra,* St. Louis Art Museum. Photograph after treatment by WUTA/SCL.

final chasing operations. A structural split had occurred where water had collected within the lower end of the club, subsequently freezing and bursting the bronze.

The treatment in this case consisted of: (1) very careful, delicate mechanical removal of the corrosion crust to reveal the patina, largely intact, beneath; (2) light spot repatination, required on areas where the most severe (green) corrosion had occurred, where the patina had been lost; (3) regilding the hair of the *Hercules* and the eyes of the *Hydra;* (4) drilling weep holes as required to allow for the escape of any accumulated interior moisture; (5) drilling out rusted chaplets and plugging with bronze; (6) brazing holes and cracks; and (7) applying a protective coating of Incralac, as in the previous example.

Outdoor Bronzes with Severe Corrosive Attack: Removal of Corrosion Products and Repatination

In a case where the corrosion crust, in its advanced state, is extensive, where the bronze has been damaged heavily and where there is severe loss and disfigurement from pitting attack, I believe there are sound reasons for removing the corrosion crust and repatinating the bronze. It should be obvious, however, that such a measure should not be undertaken without: (1) thorough preliminary technical, historical, and aesthetic documentation; and (2) the active involvement of a conservator with considerable experience in the treatment of bronze sculpture and with patination in particular.

For the removal of the crust, we normally utilize a controlled dry blasting technique at low pressure (60–80 psi) with glass microspheres approximately 75–150 microns in diameter. The glass spheres remove no metal and provide uniform surface treatment to all areas regardless of conformation or texture and length of exposure time to the blasting stream, unlike sand or alumina, both of which have sharp cutting edges.

Repatination may involve a variety of techniques, depending on the demands of historical evidence. A great range of highly stable warm browns, from golden to dark, almost black, may be achieved by the application of successive layers of highly dilute solutions of cupric and ferric nitrate and potassium sulfide. The bronze is heated area by area with a large blowtorch to the point at which water will vaporize on contact; the chemical solutions are then applied by brush or spray in a manner comparable to glazing in painting.

During the patination process we frequently wash the bronze with water to remove excess unreacted chemicals. Pigmented wax may be used as a finishing touch on top of the Incralac coating to make final adjustments, for example, a slight darkening of depths of forms or textures to enhance visual reading of the sculpture. Numerous cold patination techniques may be used as well, including the "French green" described on page 70, in which a mixture containing sal-ammoniac is applied to unheated bronze to develop a green patina, followed by pigmented dark wax which is modulated by rubbing. We follow patination with the application of Incralac coatings by spray.

I should strongly reiterate here that the decision to remove surface corrosion products is never undertaken lightly. There are often good reasons for not removing them: for example, in the case of certain archaeological bronzes where demarcation of original surface lies within the corrosion layer, where the crust contains valuable information relating to burial conditions; or in the case of sheet-copper sculptures where evenly formed, attractive, and highly protective corrosion crusts have developed over unpatinated surfaces, as in the examples of copper roofs and the *Statue of Liberty.*

In a previous publication, I described the formation, nature, mechanisms, and destructive character of the corrosion crust.[8] My rationale for removal of an advanced corrosion crust was given in detail at a recent conference in New York City.[9] In my opinion, the justifications for removal are:

1. The presence of a corrosion crust on a bronze surface in outdoor conditions presents a serious physical threat; it will actively promote corrosive attack in the presence of moisture and oxygen, even beneath coatings intended to mask and stabilize it.

2. The crust distorts and hides surface details and textures. No original surface is contained within it. Surface corrosion of bronze sculpture is a chemical alteration that has occurred subsequent to original

fabrication, a change in the artist's work in which the artist's will played no part. When artists express a desire for their bronzes to form green corrosion products in conditions of outdoor, unmaintained exposure, they are unaware of the actual destruction and distortions that will occur and thereby pose a complex problem for curators and conservators whose first concern is with preservation and stability.

3. The random coloration of the crust visually destroys sculptural form and readings of surface texture.

4. The element of metallic luster, important in most patinas, is lost in the formation of the crust and is not reobtainable without removing the crust. The "substitution" of surface luster in a coating for luster of the underlying metal is aesthetically unsatisfactory.

5. Many structural cracks and surface flaws are neither visible nor treatable without removal of the crust.

6. Removal of the crust allows a maximum range of possibilities in replicating original patination.

7. Removal of the crust allows maximum visibility of what remains of original surfaces.

Figure 61: Thomas Crawford and Randolph Rogers, *Washington Monument,* 1844-69, State Capitol Grounds, Richmond, Virginia. Before treatment. Photograph by WUTA/SCL.

8. Any signs of instability or corrosive attack will be immediately and clearly visible on a repatinated piece, whereas these will be concealed on a piece where corrosion products are covered by a pigmented coating.

Figure 59 (see page 74) illustrates a before-treatment condition in which many subtle details of chasing and surface texture are hidden from view. Figure 60 shows the crisp modeling and textural contrasts that are revealed by crust removal.

The thirteen bronzes on the *Washington Monument* (1849-69) (figure 61) by Thomas Crawford and Randolph Rogers, in Richmond, Virginia, were perfect candidates for a treatment consisting of corrosion crust removal by glass bead peening, followed by repatination and coating. Such a treatment was undertaken in the fall of 1982.

As in each of our treatments, large or small, actual work is preceded by a thoroughgoing technical examination and historic documentation. In the course of such an examination, basic information is compiled on the identification of materials, physical structure, fabrication methods, condition, and deterioration. Documentation is both written and photographic, including macrophotographs characterizing surface features. Radiography was also included in this instance for studying the attachment of the sculpture to the pedestal and of the tail to the horse.

In addition to compiling technical data, we gathered information about the history, fabrication, significance, and aesthetics of the bronzes, and information about the foundry, related works, and past treatments. Evidence regarding original and desired appearance was abundant; instructions for maintenance procedures (never carried out) were located. Thus, before beginning treatment, we had a document that served as the basis for the complex conservation decisions that were required, and we had a reasonably good idea of what potential problems might exist.

At close range, the surface of the *Washington Monument* during treatment, after corrosion removal, shows the serious extent of loss from corrosive attack (figure 62). However, at normal viewing distance, these disfigurements are not visually disturbing, and the golden, luminous color of the metal, a fundamental element of the originally intended aesthetic, is again apparent.

Two additional examples of instances where, in my opinion, micropeening followed by repatination has a useful and justifiable application are cases in which: (1) bronzes have been sandblasted in a misguided attempt to improve appearance; and (2) a bronze has been given a previous treatment that included repatination and an unknown coating, perhaps an epoxy, that had deteriorated and discolored markedly and was virtually insoluble.

In the case of the sandblasted bronze, micropeening is important for providing an initial surface treatment prior to patination that will repolish without abrading the surface metal. The cutting effect of the sand particles on a bronze

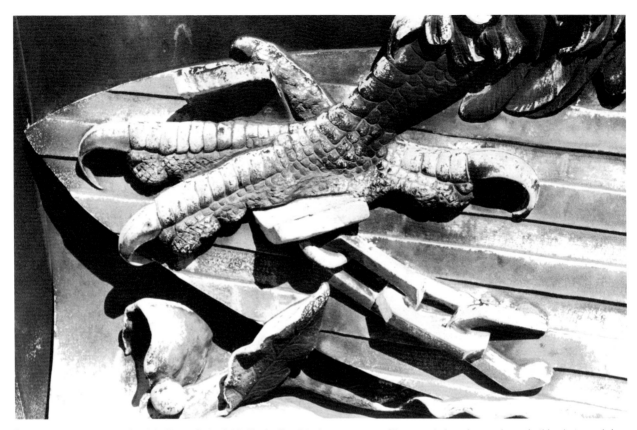

Figure 59: Larkin Mead, *Lincoln's Tomb,* Springfield, Illinois. Detail before treatment. (The actual size of area shown in this photograph is approximately 10 inches in width.) Photograph by WUTA/SCL.

surface demonstrably accelerates corrosive attack, whereas micropeened surfaces demonstrate greater resistance to corrosive attack. There are aesthetic benefits as well, in that the reflective qualities of the metal are enhanced by the peening which counteracts the dull, matte, nonmetallic appearance imparted by sandblasting.

The instance of the deteriorated and insoluble coating provides a good example of what the "reversibility principle" of the AIC Code of Ethics is intended to guard against. The particular case in question is our treatment of the J.Q.A. Ward *Washington* at Federal Hall previously mentioned by Mr. Riss (page 34). The *Washington* had previously been treated by commercial architectural metal restorers, who cleaned the piece to bare metal, repatinated, and applied the coating. Their methods and materials were not reported to the National Park Service, nor could this information be obtained on inquiry by us. The coating had become highly embrittled and discolored to a dark brown. In many areas it had checked and peeled away from the statue surfaces, leaving them vulnerable to corrosive attack. Removal of the coating was essential to aesthetic appearance, stability, and protection of the piece; and this was impossible to accomplish without removing both coating and patina. Micropeening was therefore required, whereas ordinarily

the problem should have been one of simple coating maintenance.

Some of the more dramatic transformations in appearance from the opaque, speckled, corrosion-encrusted state to the repatinated state may be found in Beaux-Arts sculpture, for which subtle surface manipulation and coloristic effects, dependent on texture, are fundamental characteristics. Such textural effects are normally heightened by manipulation of the patina itself where it appears thinner and lighter, more translucent on the bumps and swells of forms, and deeper and darker in the depths, producing an extraordinary variety of richness and interest in the surfaces. Such effects, basic to the aesthetic of such pieces, can only be achieved through knowledgeable and skilled repatination. Our treatment of Daniel Chester French's *Lincoln* on the State Capitol grounds in Lincoln, Nebraska, provides a good demonstration of these effects.

One treatment, completed by our lab in Chicago during the summer of 1983, was on a more colossal scale and of greater complexity than anything that we had ever undertaken before (figure 63). The two colossal *Equestrian Indians* by Ivan Mestrovic, flanking the Congress Street entrance to Grant Park, presented, in addition to severely corroded, pitted, and encrusted exterior surfaces, prob-

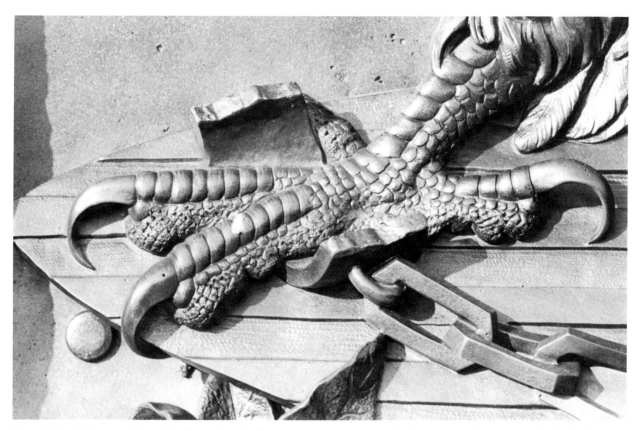

Figure 60: Detail shown in Figure 59, after treatment. (The actual size of area shown in this photograph is approximately 8 inches in width.) Photograph by WUTA/SCL.

lems of structural deterioration of the three supporting legs of each horse and of inherent vice from faulty casting techniques and from the presence of concrete in the legs, which served to burst the encasing bronze during the course of freeze-thaw cycles. The project required major engineering expertise and unusually extensive preliminary studies. Research and testing programs were conducted over a period of several years and included—aside from the normal procedures of historical research, technical examination, and photography—climatological data, finite element analysis, wind-load analysis, vibration analysis, welding research, studies of alloy structure and composition, radiography, research for and testing of concrete to be used in remounting, and the design of a new interior armature and reattachment system for the legs. Historical studies included a visit to the Mestrovic Atelier in Zagreb and the Mestrovic collections at Notre Dame. The Malvina Hoffman Properties yielded information significant to the study of the *Indians* in particular and to the history of sculpture techniques in general: an archival film made by Malvina Hoffman, recording the fabrication of the sculptures from armature through clay model, mold making, casting, chasing, and installation.

The first stage of treatment consisted of removal of the supporting legs. Heavy-duty scaffolding was erected over both sculptures, and the horses were suspended from nylon straps while the legs—three from each horse— were detached and taken to a nearby foundry. There they were split lengthwise. Interior concrete was removed, new stainless steel armatures were installed, and the legs were patched and rebrazed. They were then reattached both to the horses and to the pedestals. Surface corrosion was removed, using glass beads. Extensive surface and structural repair was required because of faulty casting techniques—for example, massive slag inclusions and porosity in the metal. Finally, the pieces were repatinated and given a protective coating.

Of course, there are many other alternative methods that could have been employed on the works that I have discussed. There is a great burden of responsibility on the owner or curator to become informed, sophisticated, and discerning in conservation matters. Conservators working in this area now are all treading on new territory, for the seriousness of the problems of sculpture conservation was scarcely recognized a decade ago. Today we have come to understand that the physical survival of a major class of artistic works of art is at stake. Preserving the "body" of sculptural works is the conservator's fundamental challenge, yet the complexity of his task comes in preserving the "soul" as well.

NOTES

1. Keck, Sheldon. "Training for Engineers in Conservation." In *Recent Advances in Conservation.* Contributions to the International Institute for Conservation Rome Conference. 1961. Edited by G. Thomson. London: 1963, p. 199.

2. Keck, p. 199.

3. Everdur® 655, Anaconda Brass Co.: 95.8% Cu, 3.1% Si, 1.0% Mn.

4. Surface preparation is crucial. No commercial cleaners should be used. Cleaning and polishing are normally done with micro alumina in ethyl alcohol. Before the application of the coating, the properly cleaned, polished piece must be treated with an inhibitor. We normally use a benzotriazole-tolutriazole mixture formulated by Sherwin Williams, Protina, applied in hot vapor form. Then follows a coating, either wax or any one of several resins with or without inhibitors. The resin coating must be applied by spray.

5. Lewis, Douglas. "The St. Petersburg Bronzes of Barye's *War* and *Peace." Pharos '77,* 14, no. 1: 3-11.

6. Incralac is an acrylic resin based on Acryloid B-44 (Rohm and Haas), soluble in toluene, and containing a corrosion inhibitor, benzotriazole, and various other components, such as ultra-violet inhibitors and leveling agents. It was formulated by the International Copper Research Association (INCRA) for coating the roof of the Mexico City Sports Palace about fifteen or twenty years ago to preserve the brilliant appearance of the polished copper. Incralac has been tested and used extensively, and data describing its properties and comparing its performance with a wide variety of coatings have been published. (Further references for information on Incralac may be found on page 6 of the bibliography included in the work cited in note 7.)

It should be applied by spray, because the structure of the dried spray film is far better than that which can be achieved by brush application. The trails left by the brush hairs as they pass through the liquid resin will be weak points where deterioration will initiate in the dried coating film. Spray application should be in several successively applied thin coats, with matting agent added, if required, in the final coating.

We have been pleased with Incralac's versatility and durability. Its gloss may be easily modified with a matting agent (polyethylene dispersion) to suit the specific demands of each sculpture. When properly applied, the coating is not unduly apparent. Its gloss may also be modified by the application of a wax coating on top of the Incralac when sculptures are easily accessible and surfaces are not rough or pitted.

Insofar as durability is concerned, most of the pieces that we treated four to five years ago show basically very little, if any, signs of corrosive attack. Outdoor bronzes in good condition coated in 1972 and maintained every three years have remained in a highly stable and protected state. In tests that we have conducted in our own laboratory in an environmental chamber, comparing a variety of coatings applied to bronze blanks both patinated and unpatinated, the spray-applied Incralac coating provided excellent protection after twenty-five days, whereas all of the waxes failed within three days. Further, underfilm attack along intentional coating flaws was effectively held in check by the corrosion inhibitor in the Incralac.

Typical maintenance procedures include: (1) visual inspection, yearly or more often if possible; (2) washing with mild detergent/water solution to remove superficial ac-

Figure 62: Detail from the monument shown in Figure 61, during treatment. Photograph by WUTA/SCL.

cumulations as often as required but no less frequently than every three to five years; and (3) application of additional Incralac by spray where the coating has begun to show wear. It is not normally necessary to remove previous Incralac coatings unless there is excessive build-up or unusual problems, such as vandalism or core material deposits on the surface. These problems can be treated locally in any case. It should be noted here that we have never encountered any unusual problems in the removal of Incralac films as much as ten years old.

7. Weil, Phoebe Dent. *Maintenance Manual for Outdoor Bronze Sculptures.* Washington University Technology Associates/Sculpture Conservation Laboratory, 8200 Brentwood Industrial Drive, St. Louis, MO 63144; 1981, 1983.

8. _____; Gasper, Peter; Gulbransen, Leonard; Lindberg, Ray; and Zimmerman, David. "The Corrosive Deterioration of Outdoor Bronze Sculpture." In *Preprints of the Contributions to the Washington Congress, 3-9 September 1982: Science and Technology in the Service of Conservation.* London: International Institute for Conservation, 1982, pp. 130-34.

9. _____. "Toward Ethical, Adequately Researched, Adequately Documented, Appropriate, and Maintainable Treatments for the Conservation of Outdoor Bronze Sculpture." In *Bronze and Masonry in the Park Environment.* Preprints, Center for Building Conservation and Central Park Conservancy, New York, October 1983.

Figure 63: Ivan Mestrovic, *Indian,* Grant Park, Chicago. After treatment. Photograph by WUTA/SCL.

QUESTIONS and ANSWERS

Q Robert Maerten, *sculptor:*
I have two questions. Has there been an attempt to involve the Copper Development Association in research into and about deterioration of bronze statuary? And, second, have people or companies in the copper-producing industry been approached about being involved in funding restoration and preservation?

A Mrs. Weil:
I have been communicating with the Copper Development Association and also with the International Copper Research Association (INCRA) since we first started working and I have received various responses. Both organizations have sponsored quite a bit of research. Most of their research, however, has been focused upon the large-scale problems of architectural copper, including patinas and protective coatings, and the various problems of maintaining architectural copper. They are not very interested in statues, but some interest has been expressed, particularly by INCRA. They have produced some very useful literature as a result of various research projects on patination and maintenance, and I hope that they can perhaps be stimulated to do more work related to sculpture. But so far, no.

A Mr. Beale:
The National Institute for Conservation has developed research proposals in this area. If any of you have suggestions about corporations or foundations that might be interested in furthering this research, I would be delighted to hear them. We have individuals who are ready to guide and direct these projects but need financial support.

Q Terry Weisser, *conservator:*
This is directed to anyone. We all know that continuing maintenance of treated bronze is necessary but never guaranteed, even with the best of intentions. Will a cleaned, coated bronze be better off in the long run than an untreated bronze, assuming follow-up maintenance is not carried out?

A Mr. Lins:
It is impossible to answer that question with complete certainty at this point, lacking adequate measurements and comparative data. It certainly depends to a large degree on the state of the corrosion on the bronze. Each bronze's corrosion is a product of its own environment. Amounts of unbonded corrodents in the corrosion film seem to be one of the main determinants as to whether or not the untreated piece will survive for long periods of time or not at all. In some cases, it appears that when the corrosion film has grown slowly enough in a rural setting, an area with less acid rain, the sulfate that eventually forms may actually provide some slowdown of the rate at which the corrosion continues; but to measure those rates and to compare one to the other is work that has not been done yet. Different coatings and different treatments prior to coating may show as yet unsuspected behavior on long-term exposure. It is so complicated. And every piece is so individual.

A Mr. Beale:
I will respond to that question also. Based on observation of outdoor metal sculptures that have been coated but whose coatings have not been maintained, I have noted that there are several things that can happen. One is that the pattern of erosion of the coating is quite similar to the normal pattern of corrosion of the sculpture. In other words, the upper surfaces and runoff areas that normally get the acid rainfall or acid snowmelt, ultraviolet sunlight exposure, and abrasion are also the first places where a coating breaks down. What results is differential corrosion exacerbated by these uncoated and coated areas. A similar problem appears in time from uneven application of a coating, because thinner areas wear and corrode first; brush or spray marks may begin to show as corrosion patterns. Although you will get differential corrosion and unusual wear patterns, the sculptures that I have seen that have had some protective coating, even if not maintained, are generally in better condition than those of the same age that never received a coating. However, that is not to say that this should be an excuse for not maintaining a coating.

Q Michael Panhorst, *art historian:*
My question is: If individuals around the country or organizations are interested in conserving the monuments in their care, is there any central facility or organization that would have information, photographic documentation, and such, that could provide the opportunity to see various procedures or the effects of these different procedures? Would it be the Academy, the Park Service, the NIC, Harvard?

A Raymond M. Pepi, *architectural conservator:*
I am at the Center for Building Conservation. We do not have a complete set of photodocumentation, although we have begun to collect it, and with the help of some of the people in this room,

we will continue to do that; but we do have a fair amount of literature on the subject which I will be happy to make available to any of you through our Research Library. We are putting together an annotated bibliography of some of that material and hope to publish it soon. So there is some literature, and if you contact me at the Center, I would be happy to make some of it available to you for the price of copying and postage. [Raymond M. Pepi, Director, Conservation Research Library, Center for Building Conservation, 40 Dover Street, New York, New York 10038 (212 608-6350).]

A Mr. Riss:
For the Park Service, those records that exist are not in any central place but are scattered around in the individual records of the individual parks. One of the things that we hope to accomplish is perhaps to gather these in one place so we have some better idea of what has been happening in the past. As far as gathering photographic evidence of what has been happening in the past, there are all kinds of resources, for instance, guidebooks to photo archives. You just need to search them out. [For archives with original photographs see *Picture Sources 4*, a guide to North American picture collections, Special Libraries Association, New York, 1983, $35. SLA is located at 235 Park Avenue South, New York (212 477-9250). See also *An Index to American Photographic Collections,* ed. James McQuaid, Boston, G. K. Hall, 1982, $75, but use with caution. See *Picturescope* 31, #1 (Spring 1983), p. 26, for a critical review of Terrance Pitts. There is also the *International Bulletin for the Photographic Documentation of the Visual Arts* from the Visual Resources Association, c/o Nancy De Laurier, 204 Fine Arts, University of Missouri, Kansas City, Missouri 64110. The photo collection mentioned in my comments is the Keystone-Mast Collection in the California Museum of Photography at the University of California, Riverside, California 92521, Edward Earle, curator (714 787-4787). Containing over 350,000 items, it is the world's largest-known collection of stereoscopic negatives. Supplementing this collection are the 28,000 images of the Underwood and Underwood Collection at the archives center of the Smithsonian's National Museum of American History (202 357-3270; contact David Haberstitch).]

A Mrs. Naudé:
I would like to add that included in the publication of this conference will be a list of monuments that have been treated recently in various centers so that people who want to have visual reference when they are considering treatments may see results of treatments for themselves. (See Appendix A.)

Q Jeffrey Gore, *curator:*
I have a question concerning something we touched on earlier when we were looking at some of the problems that these monuments have. The term "bronze disease" was generally used, and I have some questions about that. I have one piece in particular that I am faced with making some decisions on. It is a Nepalese, Chinese or Tibetan Buddha, who is showing white crust at his armpits and his groin, which I assume is coming from an investment still inside. My problem is to determine what immediate steps I could take to arrest the crystallization that is appearing on it. I have been told that this bronze disease is hard to stop, that I will have to put it in an argon-filled box; I have heard all kinds of advice. Having a large number of pieces to take care of and having to budget major kinds of restoration far in the future, what does one do in the short term for something like this problem?

A Mr. Tatti:
Determine first if it *is* bronze disease by having it tested. Bronze disease is a serious problem and you would have to treat it specifically for that. However, it sounds as if you have core material coming out, which is a different problem and a lot easier to deal with.

A Mrs. Weisser:
I just want to say that if, in fact, it is bronze disease and you want to know what you should do in the short term, you should keep it as dry as possible. If it is core material that is causing the problem, you should also try to keep it as dry as possible. You may find that if it is a problem with core material, there will be an initial increase in the amount of material that comes out through pitted areas, but this will stop as the moisture evaporates. So, in either case, the best thing to do in the short run is to keep it as dry as possible, which you could do by putting it in a dry silica gel environment.

Q Mr. Gore:
We just recently received in our collection at the Reading Museum, where I am the curator, a piece by Charles Parks that utilizes color patina. It has been installed outdoors and uses a range of orange, green, and blue patina as part of the design. So, in terms of having an ongoing maintenance program, what would you do?

A Mr. Tatti:
On a new piece like that you can either apply a cold-wax application or a cold light spray of a lacquer and just maintain it, since you are in an advantageous position with a new piece. You should be able to use one of those two solutions, but stay with it. And be consistent.

A Mrs. Weil:
I would add to that that Charles Parks has most of his pieces cast at the Tallix Foundry, Peekskill, New York. I think it is probably a good idea to contact both the artist and the foundry to find out what kind of experience they have had in the past with protecting this kind of patina outdoors and what they would recommend as a maintenance measure.

Mrs. Naudé:
We have a request to read a statement.

Mr. Honick:
I am Jeffrey Honick. I am with the City of Baltimore Commission for Historical and Architectural Preservation. Baltimore was a pioneer in creating a comprehensive conservation program for urban outdoor monuments. It began in 1980, and after very careful consideration and a public forum at which all the various methods and techniques were presented, the city selected Mr. Tatti's methods and Mr. Tatti to perform the services. Up to now, funding for our projects has come primarily from city sources, but lately we have been witnessing increasing interest on the part of private organizations and corporations in cosponsoring the preservation of some individual monuments. Also, I would like to add, regarding funding and regarding the cost of these programs, one advantage of the method chosen is that the semiannual maintenance applications can be and, to some extent, are being done by city staff. Beyond that, I want to add that the city is eager to share the benefits of its experiences and to compare notes with other local governments and other custodians of large scattered outdoor collections. If anyone would want to compare notes with what we have done, feel free to get in touch with us in Baltimore. [601 City Hall, Baltimore, Maryland 21202 (301 396-4866).]

Q Douglas Kwart, *conservator:*
I am working free lance as a conservator of objects and sculpture out of New York. My question deals with bronzes that have been stripped of their patina or cases in which the bronze surface has become heavily pitted and corroded. Would one consider the rechasing of that surface to try to reattain a surface more like the original when it came from the foundry?

A Mrs. Weil:
I would say absolutely not. The metal itself should be left without any manipulation at all, without filling in pits or chasing the surface, physically altering it as little as possible.

Q Mr. Kwart:
The reason I bring this up is that mechanical impingement of the surface through the use of glass beads does alter the reflective nature of the bronze surface. It gives a more diffused satin appearance to the plainer areas of the bronze. I am wondering if it couldn't be returned to a more original state with a mild abrasive. After all, we are creating through the use of glass beads some alteration of the surface character of the metal. And we are also accomplishing some loss of original material. It is undeniable. Therefore, I am wondering if it couldn't be taken a step further and return the metal to a more original appearance or at least an appearance that is more traditionally associated with the surface of a cast and chased bronze.

A Mrs. Weil:
First of all, a highly reflective bronze would never require peening. A highly reflective bronze, such as a polished Arp or Brancusi, would indeed be unacceptably altered by peening to a satin finish. However, peening, as I have explained in my lecture, is normally required *only* on bronzes with highly corroded surfaces, surfaces that have suffered severe pitting attack and are covered with a "mature" corrosion crust with no remains of original patina beneath. Normally, we follow peening with a light, selective polishing to give luster to the swells in the forms prior to patination. Very fine abrasive pads are all that is required to polish a peened bronze surface. The surface manipulation is extremely slight and more than justified, we believe, by the stability and aesthetic appearance of the end result, which minimizes the visual effects of the disfigurement inflicted by the pits. In this way, there is no need to remove the major amounts of material that would be required to actually smooth down a pitted surface. Alteration of surfaces on that scale could, in my opinion, never be justified.

It is difficult for someone without direct experience to understand the degree of the effect of peening on the surface character of bronze and the extent to which it is infinitesimal compared with the immensity of damage inflicted by corrosive attack. This comparison must be seen and

experienced firsthand to be fully appreciated. The advantages of using the beads—complete cleaning, no residues, uniform surface treatment, increased corrosion resistance, efficiency of effort—far outweigh the disadvantage of micro-surface distortion. Where microsurface distortion *is* a problem, it is *always* the case that the piece can and should be treated in a different way. I should strongly reiterate that there is *no* loss of metal using glass beads of 100 microns diameter at 60-80 psi.

A Mrs. Naudé:
This is obviously a very problematic issue, but I think we would all agree that any protective treat-ment of a severely corroded bronze sculpture will alter the appearance in some way. Aesthetic decisions as to the nature and extent of change have to be made during several of the treatment stages when there are maximum known factors about the individual case. Regarding the question at hand, I can conceive of an extreme instance where, after a badly corroded surface had been peened, it would be thought appropriate to work the uniformly textured surface to suggest textural differentiation between clothing and skin, for example. This could only be considered if a differentiation was clearly documented in old photographs as the artist's intent. Also, such a treatment should not be initiated by the person working at the clean metal surface; it should be carried out as the result of a collaborative decision between the curator, the conservator, and others responsible for the conservation project.

Q Barbara Millstein, *curator:*
I am curator of the sculpture garden at the Brooklyn Museum in New York City. We have no budget. What happens if we try to maintain by cleaning with detergent and soft brushes and using cold wax? Is there any hope at all, if it is done regularly?

A Mr. Beale:
Yes.

Q Suzanne Schnepp, *student:*
I am a second-year student at Winterthur. I want to know if using the "hot-wax" method on a very thin casting could alter the cast grain structure?

A Mr. Tatti:
The heat is not high enough to alter the cast grain structure, but this brings up another point: You have to know the heat and the way it disperses through the metal. And the metal changes with thickness so that you have to be careful with your heat; but there are also other reasons, like lead fills. You have to work your heat over a large area of the surface and not concentrate too long on one spot.

A Mr. Lins:
I think there is another problem that you might worry about a little with the excessive use of a propane torch. It is not changing the grain structure, because with a really deteriorated surface you have almost a spongy remain of metal with the grain structure almost obliterated. It is more that the very fine sponge of metal that is left on a severely attacked area is so liable to oxidation. Also, if there is entrapped water, there is a certain amount of steam generated. You might just weaken the surface more than change the grain structure, which really requires quite high temperatures. The temperatures that Steve Tatti works at are barely enough to drive off some of the entrapped moisture. You are not talking about getting much above 80° or 90° centigrade most of the time, which is too low, in most cases, to recrystallize the interior grain structure in a cast bronze. But there are other effects that could occur.

Q Mrs. Weisser:
This is directed to Phoebe Weil. You mentioned sculptors' comments on fears of their works being altered by the environment. I have heard of sculptors both past and present who want their works to interact with the environment. How would you deal with this view? For example, in Baltimore, in one of the parks, we have a statue, a sculpture by Grace Turnbull, who was still living during the hippie era. The hippies living in the park decided to clean up their environment, and they cleaned the green corrosion products off her sculpture and called her up to come down and admire their work. She was furious; she said she had waited all those years for that patina to develop, and she probably would not live to see it come back again.

A Mrs. Weil:
If an artist is living, that person is one of the first that we always try to contact to discuss the problems with preserving the work—what the artist expects or desires. Their responses will vary as much as the number of living artists. Most artists have not been at all aware of what the processes of deterioration of outdoor bronzes are and what actually does occur. How they react to that will certainly vary. It has been typical of modern times for artists to be fascinated with deterioration. We live in an age in which art, like anything else, has become something of a disposable item; and this

is evident in the attitudes of many artists, such as Picasso, who seem to delight in the effects of deterioration. They are rather fascinated with the effects that time and the environment have on their work. This poses a continual dilemma for conservators, who must be concerned with the preservation of a message as well as the preservation of the material. We even have artists who intentionally create works that have "inherent vice," that were meant to deteriorate. I would say that it varies with each piece. When an artist is interested in the effects of deterioration and when that is intended to be a part of the work of art, a conservator can only respect that. Artistic intent is a very complex issue; not infrequently, it is in conflict with the owner's or curator's desire for preservation.

Q George Gurney, *sculpture consultant:*
I am a historian and a sculpture consultant. I have worked on Michael Shapiro's exhibition and on the problems of the casting processes. [Exhibition at the National Museum of American Art, September 18, 1981-January 3, 1982; the Denver Art Museum, January 23-March 14, 1982; and Amon Carter Museum, May 7-July 4, 1982. See exhibition publication: Michael Edward Shapiro, *Cast and Recast: The Sculpture of Frederic Remington,* Washington, 1981.] In the process of working on that project, we learned a lot about the switch from sand to lost wax as the preferred way of casting at the end of the nineteenth century in the United States. My question may be projected in the future for conserving items. Is there any difference in those works that are or were cast in sand as opposed to those that are or were cast in wax? In other words, are the sand-cast surfaces harder, less pitted? Do they last longer? Do the wax casts tend to deteriorate faster? Is there any noticeable difference?

A Mrs. Weil:
This question has fascinated me, and I have observed that normally the sand-cast pieces are far better preserved for the reason that much more chasing of the surfaces was required. Fins had to be removed. Surfaces in the von Miller foundry were chased over every little square inch. In the tiny core sample that we took from a von Miller cast piece, we observed the microstructure, and the surfaces all had a wrought structure, meaning that they were all chased and hammered and gone over very, very carefully, peened and compressed so that the grain structure was very compact and very homogeneous on the surfaces. This had a definite effect on the corrosion resistance of that piece. This was the oldest statue

in St. Louis. A lost-wax cast nearby, some twenty-five years younger, had severe damage, whereas the good old von Miller cast, which had been chased and carefully hammered, was in extraordinarily good condition.

A Mrs. Weisser:
With sand-cast pieces, one thing that I have noticed is the faster rate of corrosion where the pieces of the mold have come together. In these areas some of the molten metal flowed out through the joins of the mold, creating fins; these fins had to be removed in the final process of finishing. The areas where the metal was removed seemed to corrode first. The reason for this is that there is a fine-grained chill-cast structure on the surface which solidifies first. This structure has been removed where the fins were, but the chill-cast structure remains on the rest of the surface. The chill-cast surface tends to be more corrosion-resistant than the larger-grained structure exposed by the removal of the fins.

Alan Postlethwaite, *conservation scientist:*
I would like to make a comment. There was a question about INCRA and the sort of work that they have done. We have to remember that INCRA is looking at structures made industrially, which are much finer grained and much more homogeneous in their structure than those that we see in castings. Hence, the kind of corrosion that you see on a piece of molding for a storefront is going to be very different from that which you get on a casting. With casting, when the metal first hits the front surface of the mold, it is very fine grained and homogeneous in its composition. As the metal further solidifies you begin to get primary deposition of relatively pure, larger crystal dendrites. In between the relatively pure crystals you get the eutectic, which is different in its composition. Later, when the piece is subject to electrochemical corrosion, you see such things on statues as areas in which the pure primary metal dendrites stand up relatively unattacked and others where the intergranular material is etched away. So it is perfectly true that a chilled front surface is very homogeneous and, therefore, is much less likely to suffer differential electrochemical corrosion than the material that is actually in the body of the casting. How objects are cast, where the thin/thick sections occur, and whether the top surface has been mechanically removed will make a great difference in the corrosion effects that one sees.

GLOSSARY

The following are technical terms used in the preceding articles. They are defined within the context of this book, stressing meanings that apply particularly to bronze sculpture. In instances where a term is fully explained in one or more of the articles, page numbers are given instead of, or to supplement, a definition.

acid precipitation Rain, snowfall, or atmospheric moisture with a reading below 7 on the pH scale. "Clean rain" is slightly acidic, so that 5.6 pH has become acceptable or "normal" for the Northeast; but current readings in that region average 4.3 pH and sometimes fall as low as 3.6 pH.

alloy A metallic material formed by mixing (in the molten state) two or more chemical elements. It usually possesses properties different from those of the components, one of which is often a lower melting point.

armature A skeleton or framework used by sculptors during modeling to support a plastic material; also an interior framework designed to support large sculptures in their finished state. If an armature is used during casting, it must have a melting point higher than the metal cast.

barrier coating See *coating.*

base The bottom of a sculpture, implying a broad bottom, considered its support and intended to be seen as part of the work of art. It may be formed from the same material as the sculpture (then also called a *plinth*) or attached to it.

bimetallic corrosion See pp. 12-13.

blowholes Small voids in a metal casting caused by trapped air or gas from the metal or mold.

brass An alloy of copper with a varying amount of zinc.

brazing A method of joining nonferrous metals by use of a nonferrous alloy that melts at a lower temperature than that of the metal to be joined. Brazing is similar to soldering except that a higher temperature is required.

bronze An alloy of copper and varying percentages of other metals, usually tin and, typically, lead and zinc.

bronze disease A corrosion reaction that occurs when moisture and oxygen interact with certain chloride compounds occasionally found in the corrosion layers of bronze. This reaction is self-perpetuating, causes pitting in the bronze, and produces, as a byproduct, a powdery, light-green corrosion product. However, the light-green often seen on outdoor bronzes is rarely, if ever, bronze disease.

BTA (benzotriazole) A chemical whose presence inhibits copper corrosion. BTA is applied to a bronze sculptural surface in a solvent or mixed with a coating material.

burnish To smooth the rough surface of a metal object by compression and deformation, using a tool made from a harder metal.

cast The reproduction of an object obtained when a material in a liquid state is poured into a mold and allowed to harden.

cast bronze (as opposed to *wrought bronze*) A term referring to shapes formed by the solidification of molten bronze in a mold.

chaplets Also called *core pins.* Metallic supports or spacers used in a mold to maintain cores which are not self-supporting. Chaplets are made from metal with a higher melting point than the metal being cast. If they are made of iron, they are normally drilled out and replaced with bronze plugs, during the chasing process, to avoid bimetallic corrosion. See pp. 8-9.

chasing Referring to several procedures in the finishing of a bronze casting: removal or repair of casting flaws, such as fins or porosity; surface manipulation by chisels and files to smooth rough areas where sections have been welded together; addition of surface detail.

coating A layer of any material over another.
protective coating Specifically for metal, a layer to protect the surface from deterioration for a limited period of time and requiring maintenance. Also called *barrier coating* or *sacrificial coating.* See pp. 18-19.

conservation See p. 35 and p. 40.

core A body of refractory aggregate, used to make a casting hollow. Its external shape becomes the internal shape of the casting.

core pins See *chaplets.*

corrosion The deterioration of a metal by chemical or electrochemical reaction with its environment. *bronze corrosion* The formation of a new substance, usually a metallic salt, at the surface of a bronze object caused by the reaction of any of the metals in the bronze with chemicals in soil, air, or precipitation.

epoxy A thermosetting cross-linking resin sometimes used as a coating or adhesive which has been shown to corrode some metals and which is often very difficult to remove.

exemplar A sculpture of which multiple casts have been made, each of which, then, is called an exemplar.

ferrous Referring to metal alloys in which iron is the dominant metal.

fin A thin projection of metal found on a cast when it is taken from the mold; it is caused by molten metal flowing into a crack in the mold or between improperly fitting mold sections. See pp. 9-10.

finishing See *chasing.*

gild To overlay with a thin covering of gold; also *gilded* or *gilt.*

glass bead See p. 72.

"hot wax" See *wax.*

inclusions Particles of impurities, such as mold material, ferrous metal, or slag in the casting.

Incralac See p. 76.

inherent vice Unstable construction or incompatible materials used in the original fabrication of an art object. Such features typically promote later deterioration in the object even in the absence of outside damaging forces.

investment The refractory material that completely covers or invests the model to form the mold for casting sculpture.

lacquer A liquid coating; traditionally referring to shellacs, gum resins, and other naturally occurring materials. In modern usage, any kind of coating (natural resin or synthetic material) that is suspended in a solvent for application and dries on the surface of an object by evaporation of the solvent. Usually glossy, but may be modified by matting agents.

lost-wax casting A process in which a wax model, with or without a clay core or armature, is surrounded by refractory mold material; after the mold has dried, it is heated to melt out the wax, forming a cavity which is subsequently filled with molten metal.

nonferrous Referring to metal alloys in which iron is not present or is present in extremely small amounts.

patch See *plug.*

patina The surface coloration of a metal, the result of chemical alteration of the clean metal surface or application of a colored lacquer.

pedestal A support that elevates a sculpture to display it to better advantage; often made in a different material.

peen To hammer with a rounded surface.

plastic 1. Referring to substances soft enough to be molded but capable of setting in a fixed position.

2. Any of numerous synthetic materials that can be molded or cast.

plating A very thin layer of metal deposited on the surface of another metal.

plinth The lowest part of a sculpture and its apparent support, formed out of the same continuous material. Also called a *base.*

plug (or *patch*) A piece of bronze, normally of an alloy similar to the casting bronze, set into a surface where a flaw or damage has created an unsightly or unstable area or where removal of core pins has caused holes.

porosity Unsoundness of a metal casting, due to the presence of blowholes, gas holes, or shrinkage cavities. See p. 12 and pp. 14-15.

protective coating See *coating.*

refractory material Nonmetallic material capable of resisting high temperatures, changes of temperature, and the action of molten metals, slags, and hot gases carrying solid particles during the casting process.

registration The alignment of parts fabricated separately but designed to form a continuous final surface.

relief A form of sculpture in which figurative elements project outward in varying degrees from a common background plane.

repatinate To re-form a new colored layer on a metal surface where the original colored layer is no longer present.

replica A copy of an art object, closely related to the original by being fabricated as part of a sculptural process (see pp. 8-9) or by being reproduced or authorized by the artist himself.

reproduction A copy.

resin

natural resins Any number of film-forming substances found in insects or plants that provide the basis of natural coating materials (shellac, rosin, etc.).

synthetic resins Substances produced chemically to approximate natural resins. Their properties can be manipulated so that certain defects of the natural resins (yellowing, embrittlement) can be altered or eliminated (acrylics, polyesters, etc.).

restoration See p. 35 and p. 40.

rosin A hard resin left after the distillation of crude turpentine.

sacrificial coating See *coating.*

sand casting See pp. 8-10.

shellac The resinous secretion of the lac insect.

stripping Removal of unwanted material from a surface, using chemical or mechanical action.

varnish A general term for a resinous (often transparent) protective coating.

walnut shells A material used in pulverized form along with compressed air to clean loose particles off a sculptural surface.

wax A chemically complex coating material widely used because of its solubility in mild solvents, its protective properties, and its ease of manipulation from matte to glossy. There are naturally occurring waxes, such as beeswax and carnauba. Synthetic waxes, such as microcrystalline, are generally purer than natural waxes.

"hot wax" A term generally used to describe a treatment of bronze sculpture in which the metal is heated to drive out entrapped moisture, directly after which wax at ambient temperature is applied to the hot metal surface.

weep holes Openings provided on a metal outdoor sculpture to permit drainage of water from the interior.

welding The process of joining a metal to a similar metal at a temperature near or above the melting point of the metal, producing a homogeneous join.

wrought bronze (as opposed to *cast bronze*) A term referring to shapes formed by heating bronze and then working it by rolling or hammering.

Frank Furness, Newel Post Lanterns, Pennsylvania Academy of the Fine Arts. Photograph by Rick Echelmeyer.

SELECTED BIBLIOGRAPHY

To supplement the specific texts cited by the authors in their notes, the following titles (taken in part from the notes) are suggested for background information on some of the topics addressed at the conference.

HANDBOOKS OF MATERIALS AND TECHNIQUES

Ammen, C.W. *The Metalcaster's Bible.* Blue Ridge Summit, Pa.: Tab Books, Inc., 1980.

Gettens, Rutherford J., and Stout, George L. *Painting Materials: A Short Encyclopaedia.* © 1942. New York: Dover Publications, 1966.

Hiorns, Arthur M. *Metal-Colouring and Bronzing.* 2nd ed. London: Macmillan and Co., 1911.

Krause, Hugo. *Metal Coloring and Finishing.* New York: 1938.

Mayer, Ralph. *The Artist's Handbook of Materials and Techniques.* New York: Viking Press, 1940; revised ed. 1970.

Partridge, W.O. *The Techniques of Sculpture.* Boston: 1895.

Rich, Jack C. *The Materials and Methods of Sculpture.* New York: Oxford University Press, 1947, 1970.

Shrager, Arthur M. *Elementary Metallurgy and Metallography.* New York: Dover Publications, 1969 (Glossary pp. 371-97).

Slobodkin, Louis. *Sculpture, Principles and Practice.* Cleveland: 1949.

SCULPTORS WRITING ABOUT THEIR OWN WORK

Hoffman, Malvina. *Sculpture Inside and Out.* 1st ed. New York: W.W. Norton and Company, 1939.

Zorach, William. *Zorach Explains Sculpture.* New York: 1947.

HISTORY OF TECHNOLOGY

Gayle, Margot; Look, David W.; and Waite, John G. *Metals in America's Historic Buildings: Uses and Preservation Treatments.* Washington, D.C.: 1980. U.S. Department of the Interior, Heritage Conservation and Recreation Service, Technical Preservation Services Division. (For sale by the Superintendent of Documents, U.S. Government Printing Office.)

Shapiro, Michael Edward. *Bronze Casting and American Sculpture: 1850-1900.* Newark, Delaware: University of Delaware Press, 1985.

Weil, Phoebe Dent. "A Review of the History and Practice of Patination." In *Corrosion and Metal Artifacts—A Dialogue Between Conservators and Archaeologists and Corrosion Scientists.* Washington, D.C.: National Bureau of Standards, Special Publication 479, 1977.

SCIENTIFIC STUDIES

Ailor, W.H., ed. *Atmospheric Corrosion.* The Electrochemical Society Corrosion Monograph Series. New York: John Wiley and Sons, 1982.

Brubaker, George R., and Phipps, P. Beverley P., eds. *Corrosion Chemistry.* ACS Symposium Series 89. Washington, D.C.: American Chemical Society, 1979.

Leidheiser, Henry, Jr. *The Corrosion of Copper, Tin, and Their Alloys.* The Electrochemical Society Corrosion Monograph Series. New York: John Wiley and Sons, 1971.

Merk, Linda. "The Effectiveness of Benzotriazole in the Inhibition of the Corrosive Behavior of Stripping Reagents on Bronzes." *Studies in Conservation* 26, no. 2 (1981): 73-76.

_____. "A Study of Reagents Used in the Stripping of Bronzes." *Studies in Conservation* 23, no. 1 (1978): 15-22.

Pourbaix, Marcel. *Lectures on Electrochemical Corrosion.* (A publication of CEBELCOR, Brussels.) Translated by J.A.S. Green. New York-London: Plenum Press, 1973.

Richey, W.D. "Recent Advances in Corrosion Science." In *Preprints of the Contributions to the Washington Congress, 3-9 September 1982: Science and Technology in the Service of Conservation.* London: International Institute for Conservation, 1982, pp. 108-18.

Sease, Catherine. "Benzotriazole: A Review for Conservators." *Studies in Conservation* 23 (1978): 76-85.

Sherwin Williams Chemical Company. COBRATEC, Technical Bulletin #531, 1976.

Vernon, W.H.J., and Whitby, L. "The Open-Air Corrosion of Copper: A Chemical Study of the Surface Patina." *Journal of the Institute of Metals* 42, no. 2 (1929): 181-95.

_____. "The Open-Air Corrosion of Copper, Part II—The Mineralogical Relationships of the Corrosion Products." *Journal of the Institute of Metals* 44, no. 2 (1930): 402, 407.

Weil, Phoebe Dent. "The Approximate Two-Year Lifetime of Incralac on Outdoor Bronze Sculpture." Preprint no. 75/22/2, ICOM Committee on Conservation, 4th Triennial Meeting, Venice, 1975.

_____; Gasper, Peter; Gulbransen, Leonard; Lindberg, Ray; and Zimmerman, David. "The Corrosive Deterioration of Outdoor Bronze Sculpture." In *Preprints*

of the Contributions to the Washington Congress, 3-9 September 1982: Science and Technology in the Service of Conservation. London: International Institute for Conservation, 1982, pp. 130-34.

CONSERVATORS REPORTING SPECIFIC ANALYSIS OR TREATMENT

Block, Ira, and Sommer, Sheldon, with Buckingham, William, and Jensen, Nancy. *Analysis of Bronze Statuary.* (PX400-0-3052) U.S. National Park Service, Gettysburg National Military Park, 1981.

Chase, W.T. "An Introduction to Outdoor Bronze Corrosion and Treatment." In *Bronze and Masonry in the Park Environment.* Preprints, Center for Building Conservation and Central Park Conservancy, New York, October 1983.

Fink, C. "The Care and Treatment of Outdoor Bronze Statues." *Technical Studies in the Field of the Fine Arts* 2, no. 1 (July 1933): p. 34.

Jack, J.F.S. "The Cleaning and Preservation of Bronze Statues." *Museums Journal* 50, no. 10 (Jan. 1951): pp. 231-36.

Morris, K., and Krueger, J. "The Use of Wet Peening in the Conservation of Outdoor Bronze Sculpture." *Studies in Conservation* 24 (1979): 40-43.

Ogburn, Fielding; Passaglia, Elio; Burnett, Harry C.; Kruger, Jerome; and Picklesimer, Marion L. "Restoration of Large Gilded Statues Using Various Electrochemical and Metallurgical Techniques." In *Corrosion and Metal Artifacts—A Dialogue Between Conservators and Archaeologists and Corrosion Scientists.* Washington, D.C.: National Bureau of Standards, Special Publication 479, 1977.

Tatti, Steven. "General Considerations Pertaining to the Conservation of Outdoor Bronze." In *Bronze and Masonry in the Park Environment.* Preprints, Center for Building Conservation and Central Park Conservancy, New York, October 1983.

van Zelst, Lambertus, and Lachevre, Jean-Louis. "Outdoor Bronze Sculpture: Problems & Procedures of Protective Treatment." *Technology and Conservation Magazine* 8, no. 1 (Spring 1983): 18-24.

Veloz, Nicolas F. "Selected Problems in the Preservation of Outdoor Sculpture." In *Bronze and Masonry in the Park Environment.* Preprints, Center for Building Conservation and Central Park Conservancy, New York, October 1983.

Weil, Phoebe Dent. "The Conservation of Outdoor Bronze Sculpture." *National Sculpture Review.* November 1976, pp. 26-30.

_____. "The Conservation of Outdoor Bronze Sculpture: A Review of Modern Theory and Practice." In *Preprints of the Eighth Annual Meeting of the American Institute for Conservation, San Francisco,* 1980, pp. 129-40.

_____. "Problems of Preservation of Outdoor Bronze Sculpture: Examination and Treatment of *The Meeting of the Waters* in St. Louis, Missouri." *Bulletin of the American Institute for Conservation of Historic and Artistic Works* 14, no. 2:84-92.

_____. "Toward Ethical, Adequately Researched, Adequately Documented, Appropriate, and Maintainable Treatments for the Conservation of Outdoor Bronze Sculpture." In *Bronze and Masonry in the Park Environment.* Preprints, Center for Building Conservation and Central Park Conservancy, New York, October 1983.

_____. "The Use of Glass Bead Peening to Clean Large-Scale Outdoor Bronze Sculpture." *Bulletin of the American Institute for Conservation of Historic and Artistic Works* 15, no. 1:51-58.

Zycherman, Lynda A., and Veloz, Nicolas F. "Conservation of a Monumental Outdoor Bronze Sculpture: *Theodore Roosevelt* by Paul Manship." *Journal of the American Institute for Conservation* 19, no. 1 (Fall 1979): 24-33.

MAINTENANCE STUDIES

Veloz, Nicolas F. "An Ounce of Prevention: The Preservation Maintenance of Outdoor Sculpture and Monuments." Master's thesis, George Washington University, 1983.

Weil, Phoebe Dent. *Maintenance Manual for Outdoor Bronze Sculpture.* St. Louis, Missouri: Washington University Technology Associates/Sculpture Conservation Laboratory, 1981.

PREVIOUS CONFERENCES ON OUTDOOR SCULPTURE

Workshop on the Conservation of Outdoor Sculpture. Johnson Atelier, Princeton, New Jersey, October 1981. On audiocassette from Audio Archives of Canada, 7449 Victoria Park Avenue, Markham, Ontario, Canada L3R2Y7.

Bronze and Masonry in the Park Environment. Preprints, Center for Building Conservation and Central Park Conservancy, New York, October 1983.

PUBLICATIONS IN CONNECTION WITH MUSEUM EXHIBITIONS ON BRONZE SCULPTURE

Shapiro, Michael Edward. *Cast and Recast: The Sculpture of Frederic Remington.* Washington, D.C.: 1981.

Wasserman, Jeanne L., ed. *Metamorphoses in Nineteenth-Century Sculpture.* Cambridge, Massachusetts: Fogg Art Museum, 1975.

LIST OF OUTDOOR BRONZE
SCULPTURES RECENTLY CONSERVED

The following information, arranged alphabetically by location, is provided so that persons considering conservation treatments for outdoor statues can utilize visual reference material in decision making. The date given below for the monument is, to the best of our knowledge, the year the cast was installed outdoors.

Information is presented as it was submitted by persons who responded to a request through the American Institute for Conservation. In treatment descriptions it should be understood that wax is usually brushed and Incralac resin sprayed unless otherwise noted. Treatments are reported for which written and photographic documentation is believed available. Inclusion on this list implies neither that the publisher of this conference has any knowledge of the actual treatment performed nor that the person or company who provided the treatment is endorsed by the Pennsylvania Academy of the Fine Arts.

After publication, information collected to date will be transferred to the National Institute for Conservation, from whom updated versions of the list may be obtained.

National Institute for the Conservation of Cultural Property
A & I—2225, Smithsonian Institution
Washington, DC 20560 (Tel: 202 357-2295)

Location	Sculptor, Title, Date	Year, Treated by, Treatment
AK Sitka, Alaska Pioneers' Home	Lewis, Alonzo Victor, *The Prospector,* 1949	1980 Weil, Phoebe Dent – Superficial cleaning, Incralac
		1983 Weil, Phoebe Dent – Maintenance, repair of vandalism, superficial cleaning, Incralac
CA Los Angeles, LA County Museum of Art	Rodin, Auguste, *Eve* (M-73.108.2), 1881	1977 LA County Museum of Art/Milam, Billie – Cleaned, Incralac (3-5%), waxed
		1978+ LA County Museum of Art/Milam, Billie – Waxed twice annually since
CA Los Angeles, LA County Museum of Art	Maillol, Aristide, *Flora Nude* (M-68.3), 1912	1977 LA County Museum of Art/Milam, Billie – Cleaned, Incralac (3-5%), waxed
		1978+ LA County Museum of Art/Milam, Billie – Waxed twice annually since
CA Los Angeles, LA County Museum of Art	Rodin, Auguste, *Jean D'Aire* (M-73.110.4), 1971	1977 LA County Museum of Art/Milam, Billie – Cleaned, Incralac (3-5%), waxed
		1978+ LA County Museum of Art/Milam, Billie – Waxed twice annually since
CA Los Angeles, LA County Museum of Art	Rodin, Auguste, *Large Torso of Man* (M-73.108.5), 1970	1977 LA County Museum of Art/Milam, Billie – Cleaned, corrosion mechanically removed, treated with silver oxide, Incralac (3-5%), waxed
		1978+ LA County Museum of Art/Milam, Billie – Waxed twice annually since
CA Los Angeles, LA County Museum of Art	Kolbe, Georg, *Maria* (M-73.109.3), 1943	1977 LA County Museum of Art/Milam, Billie – Cleaned, Incralac (3-5%), waxed
		1978+ LA County Museum of Art/Milam, Billie – Waxed twice annually since
CA Los Angeles, LA County Museum of Art	Rodin, Auguste, *Monument to Balzac* (M-69.59), 1967	1977 LA County Museum of Art/Milam, Billie – Cleaned, Incralac (3-5%), waxed
		1978+ LA County Museum of Art/Milam, Billie – Waxed twice annually since
CA Los Angeles, LA County Museum of Art	Rodin, Auguste, *Monumental Head of Jean D'Aire* (M-73.110.2), 1971	1977 LA County Museum of Art/Milam, Billie – Cleaned, Incralac (3-5%), waxed
		1978+ LA County Museum of Art/Milam, Billie – Waxed twice annually since
CA Los Angeles, LA County Museum of Art	Rodin, Auguste, *Monumental Head of Pierre Wiessant* (M-69.110.1), 1971	1977 LA County Museum of Art/Milam, Billie – Cleaned, Incralac (3-5%), waxed
		1978+ LA County Museum of Art/Milam, Billie – Waxed twice annually since
CA Los Angeles, LA County Museum of Art	Rodin, Auguste, *Orpheus* (M-73.108.3), 1969	1977 LA County Museum of Art/Milam, Billie – Cleaned, Incralac (3-5%), waxed

Location	Sculptor, Title, Date	Year, Treated by, Treatment
		1978+ LA County Museum of Art/Milam, Billie – Waxed twice annually since
CA Los Angeles, LA County Museum of Art	Rodin, Auguste, *Prodigal Son* (M-73.108.7), n.a.	1977 LA County Museum of Art/Milam, Billie – Cleaned, corrosion mechanically removed, Incralac (3-5%), waxed
		1978+ LA County Museum of Art/Milam, Billie – Waxed twice annually since
CA Los Angeles, LA County Museum of Art	Rodin, Auguste, *The Shade* (M-73.108.1), 1969	1977 LA County Museum of Art/Milam, Billie – Cleaned, Incralac (3-5%), waxed
		1978+ LA County Museum of Art/Milam, Billie – Waxed twice annually since
CA Los Angeles, LA County Museum of Art	Moore, Henry, *Three Part Reclining Figure* (M-65.74), 1961	1977 LA County Museum of Art/Milam, Billie – Investment material excavated, cleaned, Incralac (3-5%), waxed
		1978+ LA County Museum of Art/Milam, Billie – Waxed twice annually since
CT Hartford, American School for the Deaf	Conrad, C., *Clerc*, 1874	1983 Weil, Phoebe Dent – Glass bead peened, repatinated, Incralac
CT Hartford, American School for the Deaf	French, Daniel Chester, *Gallaudet*, 1924	1983 Weil, Phoebe Dent – Glass bead peened, repatinated, Incralac
DC Washington, Georgetown University	Connor, Jerome, *Bishop John Carroll*, 1912	1982 Tatti, Steven – Washed, heated/waxed
DC Washington, Hirshhorn Museum	Various, Statues in Sculpture Garden	Museum Staff – Annually detergent washed, degreased, rewaxed
DC Washington, Lincoln Memorial Circle	Fraser, James Earle, *Arts of Peace – Agriculture*, 1951	1972 Ogburn et al. – Structure repaired, surface cleaned, electroplated, Incralac – See Bibliography
		1982 Veloz, Nicolas F. – Incralac removed, washed, BTA, spray waxed (BTA)
		1984 Veloz, N./Stromberg, C./Austin, M. – Washed with hot water, steam, BTA, spray waxed (BTA)
DC Washington, Lincoln Memorial Circle	Fraser, James Earle, *Arts of Peace – Aspiration*, 1951	1972 Ogburn et al. – Structure repaired, surface cleaned, electroplated, Incralac – See Bibliography
		1982 Veloz, Nicolas F. – Incralac removed, washed, BTA, spray waxed (BTA)
		1984 Veloz, N./Stromberg, C./Austin, M. – Washed with hot water, steam, BTA, spray waxed (BTA)
DC Washington, Lincoln Memorial Circle	Friedlander, Leo J., *Arts of War – Sacrifice*, 1951	1972 Ogburn et al. – Structure repaired, surface cleaned, electroplated, Incralac – See Bibliography

Location	Sculptor, Title, Date	Year, Treated by, Treatment
		1982 Veloz, Nicolas F. – Incralac removed, washed, BTA, spray waxed (BTA)
		1984 Veloz, N./Stromberg, C./Austin, M. – Washed with hot water, steam, BTA, spray waxed (BTA)
DC Washington, Lincoln Memorial Circle	Friedlander, Leo J., *Arts of War – Valor,* 1951	1972 Ogburn et al. – Structure repaired, surface cleaned, electroplated, Incralac – See Bibliography
		1982 Veloz, Nicolas F. – Incralac removed, washed, BTA, spray waxed (BTA)
		1984 Veloz, N./Stromberg, C./Austin, M. – Washed with hot water, steam, BTA, spray waxed (BTA)
DC Washington, McPherson Square	Rebisso, Lewis T., *General James B. McPherson,* 1876	1984 Veloz, N./Stromberg, C./Austin, M. – Washed with hot water, walnut shell blasted, BTA, spray waxed (BTA)
DC Washington, National Gallery of Art	Moore, Henry, *Two Piece Mirror Knife Edge,* 1978	1983 Tatti, Steven – Washed, oiled
DC Washington, Roosevelt Island	Manship, Paul, *Theodore Roosevelt,* 1967	1978 Veloz, N./Zycherman L. – Cleaned with solvent, BTA, waxed (BTA)
		1979 Veloz, Nicolas F. – Washed, BTA, rewaxed
		1983 Veloz, Nicolas F. – Cleaned with solvent, BTA, waxed (BTA)
DC Washington, Smithsonian Institution	Story, William Wetmore, *Joseph Henry,* 1883	1984 Tatti, Steven – Cleaned, heated/waxed
DC Washington, U.S. Capitol	Story, William Wetmore, *Chief Justice John Marshall,* 1884	1981 Tatti, Steven – Washed, heated/waxed
DC Washington, U.S. Capitol	Williams, Wheeler, *Robert A. Taft Memorial,* 1959	1983 Tatti, Steven – Washed, heated/waxed
FL St. Petersburg, Museum of Fine Art	MacNeil, Hermon, *A Chief of the Multonomah Tribe,* 1960s	1981 Weil, Phoebe Dent – Superficial cleaning, Incralac
FL St. Petersburg, Museum of Fine Art	Carrier-Belleuse, A., *La Source,* 1960s	1980 Weil, Phoebe Dent – Superficial cleaning, retouched patina, Incralac
FL St. Petersburg, Museum of Fine Art	Barye, Antoine-Louis, *Peace,* 1976	1980 Weil, Phoebe Dent – Superficial cleaning, retouched patina, Incralac
FL St. Petersburg, Museum of Fine Art	Jennewein, Carl Paul, *The First Step,* 1960s	1980 Weil, Phoebe Dent – Superficial cleaning, retouched patina, Incralac
FL St. Petersburg, Museum of Fine Art	Barye, Antoine-Louis, *War,* 1976	1980 Weil, Phoebe Dent – Superficial cleaning, retouched patina, Incralac
IL Cairo, Cairo Public Library	Unknown, *Clio,* 1890s	1979 Weil, Phoebe Dent – Glass bead peened, repatinated, Incralac

Location		Sculptor, Title, Date	Year, Treated by, Treatment
IL	Cairo, Cairo Public Library	Unknown, *Concordia*, 1890s	1979 Weil, Phoebe Dent – Glass bead peened, repatinated, Incralac
IL	Cairo, Cairo Public Library	Scudder, Janet, *Fighting Boys Fountain*, 1911	1979 Weil, Phoebe Dent – Structural repairs, glass bead peened, repatinated, Incralac
IL	Cairo, Halliday Park	Barnard, George Gray, *The Hewer*, 1903	1979 Weil, Phoebe Dent – Glass bead peened, repatinated, Incralac
IL	Chicago, Adler Planetarium	Moore, Henry, *Sundial*, 1980	1980 Weil, Phoebe Dent – Superficial cleaning, Incralac
			1983 Weil, Phoebe Dent – Maintained, superficial cleaning, Incralac
IL	Chicago, Art Institute of Chicago	Moore, Henry, *Large Interior Form*, 1983	1983 Weil, Phoebe Dent – Superficial cleaning, Incralac
IL	Chicago, Art Institute of Chicago	Polasek, Albin, *Spirit of Music*, 1923	1984 Weil, Phoebe Dent – Glass bead peened, repatinated, Incralac
IL	Chicago, Grant Park/Congress Street	Mestrovic, Ivan, *Two American Indians* (2 sculptures), 1928	1983 Weil, Phoebe Dent – Structural repairs, glass bead peened, repatinated, Incralac
			1984 Weil, Phoebe Dent – Maintained, superficial cleaning, Incralac
IL	Chicago, Lincoln Park Zoo	McCartan, Edward, *Eugene Field Memorial*, 1922	1979 Weil, Phoebe Dent – Glass bead peened, repatinated, Incralac
			1983 Weil, Phoebe Dent – Maintained, superficial cleaning, Incralac
IL	Chicago, University of Chicago	Moore, Henry, *Nuclear Energy*, 1967	1979 Weil, Phoebe Dent – Superficial cleaning, Incralac
			1983 Weil, Phoebe Dent – Maintained, superficial cleaning, Incralac
IL	Chicago, University of Chicago, Smart Gallery	Pomodoro, Arnaldo, *Grande Radar*, 1963	1984 Weil, Phoebe Dent – Glass bead peened, repolished, partial repatination, Incralac
IL	Chicago, University of Chicago, Smart Gallery	Moore, Henry, *Reclining Figure*, 1956	1984 Weil, Phoebe Dent – Superficial cleaning, retouched patina, Incralac
IL	Springfield, Franklin Insurance Company	Fraser, James Earle, *Benjamin Franklin*, 1949	1979 Weil, Phoebe Dent – Superficial cleaning, Incralac
IL	Springfield, Lincoln's Tomb	Meade, Larkin, *Eagle Relief*, 1874	1981 Weil, Phoebe Dent – Glass bead peened, repatinated, Incralac
IL	Springfield, Lincoln's Tomb	Meade, Larkin, *Infantry, Cavalry, Artillery, Navy . . .*, 1874	1981 Weil, Phoebe Dent – Glass bead peened, repatinated, Incralac
IL	Springfield, Lincoln's Tomb	Borglum, Gutzon, *Lincoln*, 1930	1978 Weil, Phoebe Dent – Glass bead peened, repatinated, Incralac

Location	Sculptor, Title, Date	Year, Treated by, Treatment
		1981 Weil, Phoebe Dent – Maintained, superficial cleaning, Incralac
IL Springfield, Lincoln's Tomb	Meade, Larkin, *Standing Lincoln,* 1874	1981 Weil, Phoebe Dent – Glass bead peened, repatinated, Incralac
IL Sumner, Red Hills State Park	Unknown, *Lincoln Crossing Wabash* (plaque), 1938	1984 Harpers Ferry Center NPS – Washed, graffiti removed, heated/waxed
IN Indianapolis, University Park	Niehaus, Charles H., *Benjamin Harrison,* 1908	1983 Veloz, Nicolas F. – Walnut shell blasted, BTA, spray waxed (BTA)
		1984 Dugger, John – Washed, localized application of BTA, spray waxed (BTA)
IN Vincennes, George Rogers Clark NHP	Unknown, *VFW Marker to WW I Veterans* (plaque), 1937	1984 Harpers Ferry Center NPS – Washed, heated/waxed
MD Baltimore, Calvert/ Lexington Streets	Lewis, James, *Negro Heroes of the United States Monument,* 1971	1982 Tatti, Steven – Washed, heated/waxed
MD Baltimore, Children's Zoo	Boethos (copy), *Boy with a Goose,* 1866	1982 Tatti, Steven – Washed, heated/waxed
MD Baltimore, Court House	Weinert, Albert, *Calvert Statue,* 1908	1982 Tatti, Steven – Washed, heated/waxed
MD Baltimore, Druid Hill Park	Golde, R.P., *Wagner Bust,* 1901	1982 Tatti, Steven – Washed, heated/waxed
MD Baltimore, Druid Hill Park	Stevenson, D.W., *Wallace Monument,* 1893	1982 Tatti, Steven – Washed, heated/waxed
MD Baltimore, Fort McHenry	Niehaus, Charles H., *Key Monument,* 1922	1984 Tatti, Steven – Cleaned, heated/waxed
MD Baltimore, Johns Hopkins University	Schuler, Hans, *Hopkins Monument,* 1935	1982 Tatti, Steven – Washed, heated/waxed
MD Baltimore, Johns Hopkins University	Schuler, Hans, *Lanier Monument,* 1942	1982 Tatti, Steven – Washed, heated/waxed
MD Baltimore, Maryland/ Mount Royal Avenue	Ezekiel, Sir Moses, *Poe Monument,* 1921	1982 Tatti, Steven – Washed, heated/waxed
MD Baltimore, Mount Vernon Place	Crenier, Henri, *Boy and Turtle,* 1924	1981 Tatti, Steven – Washed, heated/waxed
MD Baltimore, Mount Vernon Place	Fremiet, Emmanuel, *Howard Monument,* 1904	1981 Tatti, Steven – Washed, heated/waxed
MD Baltimore, Mount Vernon Place	O'Conner, Andrew, *Lafayette Monument,* 1924	1981 Tatti, Steven – Washed, heated/waxed
MD Baltimore, Mount Vernon Place	DuBois, Paul, *Military Courage,* 1885	1981 Tatti, Steven – Washed, heated/waxed
MD Baltimore, Mount Vernon Place	Turnbull, Grace, *Naiad,* 1962	1981 Tatti, Steven – Washed, heated/waxed

Location	Sculptor, Title, Date	Year, Treated by, Treatment
MD Baltimore, Mount Vernon Place	Story, William Wetmore, *Peabody Statue*, 1878	1981 Tatti, Steven – Washed, heated/waxed
MD Baltimore, Mount Vernon Place	Berge, Henry (after Edward), *Sea Urchin*, 1961	1981 Tatti, Steven – Washed, heated/waxed
MD Baltimore, Mount Vernon Place	Barye, Antoine-Louis, *Seated Lion*, 1885	1981 Tatti, Steven – Washed, heated/waxed
MD Baltimore, Mount Vernon Place	Rinehart, William Henry, *Taney Statue*, 1887	1981 Tatti, Steven – Washed, heated/waxed
MD Baltimore, Mount Vernon Place	Marqueste, Laurent, *Wallis Statue*, 1906	1981 Tatti, Steven – Washed, heated/waxed
MD Baltimore, Mount Vernon Place	Barye, Antoine-Louis, *War, Peace, Force, Order*, 1885	1981 Tatti, Steven – Washed, heated/waxed
MD Baltimore, Mount Royal Avenue/Mosher Street	Ruckstuhl, F.W., *Confederate Soldiers and Sailors Monument*, 1903	1982 Tatti, Steven – Washed, heated/waxed
MD Baltimore, Mount Royal Terrace/North Avenue	Berge, Edward, *Lt. Col. William H. Watson Monument*, 1907	1982 Tatti, Steven – Washed, heated/waxed
MD Baltimore, Patterson Park	Schuler, Hans, *Pulaski Monument*, 1942	1984 Tatti, Steven – Cleaned, heated/waxed
MD Baltimore, St. Paul Place/ Saratoga Street	Brooks, Richard E., *John Mifflin Hood Monument*, 1911	1982 Tatti, Steven – Washed, heated/waxed
MD Baltimore, University Parkway/Charles Street	Miller, J. Maxwell, *Confederate Women's Monument*, 1918	1982 Tatti, Steven – Washed, heated/waxed
MD Baltimore, Utah Place/ Lanvale Street	Mencie, Gene, *Francis Scott Key Monument*, 1911	1984 Tatti, Steven – Cleaned, heated/waxed
MD Baltimore, Wyman Park Drive/31st Street	Berge, Edward, *Harris Bust*, 1922	1982 Tatti, Steven – Washed, heated/waxed
MD Baltimore, Wyman Park Drive/31st Street	Weinman, Adolph, *Union Soldiers and Sailors Monument*, 1909	1982 Tatti, Steven – Washed, heated/waxed
MA Boston, Arlington Street	Adams, Herbert, *William Ellery Channing*, 1902	1981 Boston Museum of Fine Arts, Research Laboratory – Cleaned, spot repatinated, Incralac, waxed
		1982+ Boston Museum of Fine Arts, Research Laboratory – Washed and waxed annually since
MA Boston, Boston Common	Paramino, John, *Founders Memorial*, 1930	1983 Conservation Center, Harvard University – Washed, cleaned with bronze wool, repatinated, Incralac, waxed
MA Boston, Boston Common	Saint-Gaudens, Augustus, *Robert Gould Shaw/54th Regiment Memorial*, 1898	1981 Conservation Center, Harvard University – Washed, cleaned with bronze wool, chemically repatinated, parts replaced, Incralac, waxed

Location	Sculptor, Title, Date	Year, Treated by, Treatment
		1983 Conservation Center, Harvard University – Washed, Incralac retouched, waxed, sword replaced
MA Boston, Boston Museum of Fine Arts	Dallin, Cyrus E., *Appeal to the Great Spirit*, 1909	1980 Boston Museum of Fine Arts, Research Laboratory – Cleaned, coated with pigmented Incralac, waxed
		1981+ Boston Museum of Fine Arts, Research Laboratory – Washed and waxed annually since
MA Boston, Boston Public Gardens	French, Daniel Chester, *Casting Bread Upon the Waters*, 1924	1981 Boston Museum of Fine Arts, Research Laboratory – Cleaned, Incralac, waxed
		1982+ Boston Museum of Fine Arts, Research Laboratory – Washed and waxed annually since
MA Boston, Boston Public Gardens	Pratt, Bela Lynn, *Edward Everett Hale*, 1912	1983 Dennis & Craine, Associates – Mechanically cleaned, spot repatinated, Incralac, waxed
MA Boston, Boston Public Gardens	Ball, Thomas, *Equestrian George Washington*, 1869	1984 Dennis & Craine, Associates – Mechanically cleaned, spot repatinated, Incralac, waxed
MA Boston, Commonwealth Avenue	Warner, Olin, *William Lloyd Garrison*, 1885	1984 Conservation Center, Harvard University – Washed, Incralac, inpainted, waxed
MA Boston, Dock Square	Whitney, Anne, *Samuel Adams*, 1880	1984 Dennis & Craine, Associates – Mechanically cleaned, spot repatinated, Incralac, waxed
MA Boston, Hanover Street, North End	Dallin, Cyrus E., *Paul Revere Equestrian Statue*, 1940	1984 Dennis & Craine, Associates – Mechanically cleaned, spot repatinated, Incralac, waxed
MA Boston, Old City Hall	Greenough, R.S., & Ball, Thomas, *Benjamin Franklin* (bas reliefs), 1856	1983 Dennis & Craine, Associates – Mechanically cleaned, spot repatinated, Incralac, waxed
MA Boston, Old City Hall	Greenough, R.S., *Benjamin Franklin* (statue), 1856	1983 Dennis & Craine, Associates – Mechanically cleaned, spot repatinated, Incralac, waxed
MA Boston, Old City Hall	Ball, Thomas, *Josiah Quincy*, 1878	1984 Dennis & Craine, Associates – Paint removed, mechanically cleaned, repatinated, Incralac, waxed
MA Boston, Trinity Church	Saint-Gaudens, Augustus, *Phillips Brooks*, 1910	1983 Conservation Center, Harvard University – Cleaned, chemically repatinated, Incralac, waxed
		1984 Trinity Church Staff – Washed, waxed
MA Boston, Winthrop Square, Charlestown	Unknown, *Bunker Hill Memorial Plaques*, 1930	1984 Dennis & Craine, Associates – Paint removed with solvents, mechanically cleaned, spot repatinated, Incralac, waxed

Location	Sculptor, Title, Date	Year, Treated by, Treatment
MA Cambridge, Harvard Square	Whitney, Anne, *Charles Sumner,* 1900	1984 Dennis & Craine, Associates – Mechanically cleaned, repatinated, Incralac, waxed
MA Cambridge, Harvard University	Moore, Henry, *Reclining Woman,* 1973	1982 Conservation Center, Harvard University – Washed, Incralac, waxed
		1983 Conservation Center, Harvard University – Washed, Incralac retouched, waxed
		1984 Conservation Center, Harvard University – Washed, Incralac retouched, waxed
MA Cambridge, MIT	Moore, Henry, *Three Piece Reclining Figure, Draped,* 1976	1976 Conservation Center, Harvard University – Washed, chemically spot repatinated, waxed
		1977+ Conservation Center, Harvard University – Washed and waxed annually since 1976
MA Charlestown, Bunker Hill	Story, William Wetmore, *Colonel William Prescott,* 1881	1982 Boston Museum of Fine Arts, Research Laboratory – Cleaned, repatinated, infilled, Incralac, waxed – sword replaced
		1982+ Boston Museum of Fine Arts, Research Laboratory – Washed and waxed annually since
MA Concord, Old North Bridge	French, Daniel Chester, *Minute Man,* 1874	1983 Dennis & Craine, Associates – Mechanically and solvent cleaned, Incralac, waxed
MA Harvard, Fruitlands Museum	Sears, Philip S., *Pumunanquet,* 1930	1984 Conservation Center, Harvard University – Chemically cleaned, chemically repatinated, Incralac, waxed
MA Harvard, Fruitlands Museum	Sears, Philip S., *Wo Peen,* 1938	1984 Conservation Center, Harvard University – Chemically cleaned, chemically repatinated, Incralac, waxed
MA Northampton, Smith College	Rodin, Auguste, *Walking Man,* 1965	1979 Conservation Center, Harvard University – Washed, inpainted, waxed
		1979 Conservation Center, Harvard University – Washed and waxed annually since
MA Stockbridge, Chesterwood	French, Daniel Chester, *Standing Lincoln,* ca. 1912	1976 Conservation Center, Harvard University – Washed, inpainted, waxed
		1977+ Conservation Center, Harvard University – Washed and waxed annually
MA Worcester, College of the Holy Cross	Kolbe, Georg, *Die Nacht,* 1930	1983 Dennis & Craine, Associates – Cleaned, Incralac, waxed
MA Worcester, College of the Holy Cross	Gross, Chaim, *Isaiah,* 1977	1983 Dennis & Craine, Associates – Old wax removed, cleaned, Incralac, waxed

Location	Sculptor, Title, Date	Year, Treated by, Treatment
MA Worcester, College of the Holy Cross	Plazzotta, Enzo, *L'Arrive,* 1965	1983 Dennis & Craine, Associates – Old wax removed, cleaned, Incralac, waxed
MA Worcester, College of the Holy Cross	Welerick, R., *L'Offrand,* 1937	1983 Dennis & Craine, Associates – Mechanically cleaned, spot repatinated, Incralac, waxed
MO Diamond, George Washington Carver NM	Amendola, Robert, *The Boy Carver,* 1960	1981 Weil, Phoebe Dent – Superficial cleaning, Incralac
MO St. Louis, Aloe Plaza	Milles, Carl, *Meeting of the Waters,* 1939	1974 Weil, Phoebe Dent – Glass bead peened, repatinated, Incralac
		1978 Weil, Phoebe Dent – Maintenance, removed Incralac, repatination, Incralac
MO St. Louis, City Hall	Bringhurst, Robert P., *Grant,* 1888	1977 Weil, Phoebe Dent – Glass bead peened, repatinated, Incralac
		1978 Weil, Phoebe Dent – Maintained, superficial cleaning, Incralac
MO St. Louis, Compton Reservoir Park	Wandschneider, William, *Truth,* 1914	1977 Weil, Phoebe Dent – Glass bead peened, repatinated, Incralac
		1978 Weil, Phoebe Dent – Maintained, superficial cleaning, Incralac
MO St. Louis, Forest Park	Niehaus, Charles H., *Apotheosis of St. Louis,* 1906	1975 Weil, Phoebe Dent – Glass bead peened, not patinated, Incralac
		1978 Weil, Phoebe Dent – Maintained, superficial cleaning, Incralac
MO St. Louis, Forest Park	MacDonald, James W.A., *Bates,* 1876	1976 Weil, Phoebe Dent – Glass bead peened, repatinated, Incralac
		1978 Weil, Phoebe Dent – Maintained, superficial cleaning, Incralac
MO St. Louis, Forest Park	Gardner, Wellington W., *Blair,* 1885	1976 Weil, Phoebe Dent – Glass bead peened, repatinated, Incralac
		1978 Weil, Phoebe Dent – Maintained, superficial cleaning, Incralac
MO St. Louis, Forest Park	Zolnay, George Julian, *Confederate Memorial,* 1914	1977 Weil, Phoebe Dent – Glass bead peened, repatinated, Incralac
		1978 Weil, Phoebe Dent – Maintained, superficial cleaning, Incralac
MO St. Louis, Forest Park	Cauer, Robert, *Jahn,* 1913	1977 Weil, Phoebe Dent – Glass bead peened, repatinated, Incralac
		1978 Weil, Phoebe Dent – Maintained, superficial cleaning, Incralac
MO St. Louis, Forest Park	Lipchitz, Jacques, *Joie de Vivre,* 1962	1977 Weil, Phoebe Dent – Superficial cleaning, Incralac

Location	Sculptor, Title, Date	Year, Treated by, Treatment
		1978 Weil, Phoebe Dent – Maintained, superficial cleaning, Incralac
MO St. Louis, Forest Park	Cauer, Robert, *Sigel,* 1906	1976 Weil, Phoebe Dent – Glass bead peened, repatinated, Incralac
		1978 Weil, Phoebe Dent – Maintained, superficial cleaning, Incralac
MO St. Louis, Forest Park	Mose, Carl, *St. Francis,* 1962	1977 Weil, Phoebe Dent – Superficial cleaning, Incralac
		1978 Weil, Phoebe Dent – Maintained, superficial cleaning, Incralac
MO St. Louis, Forest Park, Zoo	Hancock, Walker, *Bird Charmer,* 1932	1977 Weil, Phoebe Dent – Superficial cleaning, Incralac
		1978 Weil, Phoebe Dent – Maintained, superficial cleaning, Incralac
MO St. Louis, Kiener Plaza	Zorach, William, *Kiener Fountain,* 1966	1977 Weil, Phoebe Dent – Superficial cleaning, Incralac
		1978 Weil, Phoebe Dent – Maintained, superficial cleaning, Incralac
MO St. Louis, Lafayette Square	Hosmer, Harriet, *Benton,* 1868	1976 Weil, Phoebe Dent – Glass bead peened, not patinated, Incralac
		1978 Weil, Phoebe Dent – Maintenance
MO St. Louis, Lafayette Square	Houdon, Jean Antoine, *Washington,* 1873	1976 Weil, Phoebe Dent – Glass bead peened, repatinated, Incralac
		1978 Weil, Phoebe Dent – Maintained, superficial cleaning, Incralac
MO St. Louis, Lucas Garden	Hahn, Nancy C., *Kincaid Fountain,* 1930s	1977 Weil, Phoebe Dent – Glass bead peened, repatinated, Incralac
		1979 Weil, Phoebe Dent – Maintained, superficial cleaning, Incralac
MO St. Louis, Lyon Park	Steubenraugh, Charles, *Lyon Monument,* 1929	1978 Weil, Phoebe Dent – Glass bead peened, repatinated, Incralac
		1979 Weil, Phoebe Dent – Maintained, superficial cleaning, Incralac
MO St. Louis, Memorial Plaza	Rau, Ernst, *Schiller,* 1898	1977 Weil, Phoebe Dent – Glass bead peened, repatinated, Incralac
		1978 Weil, Phoebe Dent – Maintained, superficial cleaning, Incralac
MO St. Louis, Missouri Botanical Garden	Walker, Robert, *Birds Fountain,* 1976	1976 Weil, Phoebe Dent – Glass bead peened, repatinated, Incralac
		1980 Weil, Phoebe Dent – Maintained, superficial cleaning, Incralac

Location	Sculptor, Title, Date	Year, Treated by, Treatment
MO St. Louis, Missouri Botanical Garden	Romanelli, *Fountain Angel,* ca. 1902	1975 Weil, Phoebe Dent – Superficial cleaning, patina retouched, Incralac
MO St. Louis, Missouri Botanical Garden	Rau, Marcel, *Mother & Child,* 1929	1982 Weil, Phoebe Dent – Superficial cleaning, Incralac
MO St. Louis, Missouri Botanical Garden	Moore, Henry, *Reclining Figure,* 1960	1976 Weil, Phoebe Dent – Superficial cleaning, Incralac
		1978 Weil, Phoebe Dent – Maintained, superficial cleaning, Incralac
		1982 Weil, Phoebe Dent – Maintained, superficial cleaning, Incralac
MO St. Louis, Missouri Historical Society	Bitter, Karl, *Signing of the Treaty,* 1904	1977 Weil, Phoebe Dent – Superficial cleaning, Incralac
		1978 Weil, Phoebe Dent – Maintained, superficial cleaning, Incralac
		1979 Weil, Phoebe Dent – Maintained, superficial cleaning, Incralac
		1980 Weil, Phoebe Dent – Maintained, superficial cleaning, Incralac
MO St. Louis, St. Louis Art Museum	Milles, Carl, *Folke Filbyter,* 1928	1982 Weil, Phoebe Dent – Superficial cleaning, retouched patina, Incralac
MO St. Louis, St. Louis Art Museum	Gasteiger, Matthias, *Hercules & the Hydra,* ca. 1920	1982 Weil, Phoebe Dent – Superficial cleaning, retouched patina, Incralac, localized regilding
MO St. Louis, St. Louis Art Museum	Moore, Henry, *Reclining Figure,* 1960	1976 Weil, Phoebe Dent – Superficial cleaning, Incralac
		1978 Weil, Phoebe Dent – Superficial cleaning, Incralac
		1982 Weil, Phoebe Dent – Superficial cleaning, Incralac
MO St. Louis, St. Louis Art Museum	Seifert, Franz, *Siegfried,* 1915	1982 Weil, Phoebe Dent – Superficial cleaning, Incralac
MO St. Louis, Tower Grove Park	von Miller, Ferdinand, II, *Columbus,* 1886	1976 Weil, Phoebe Dent – Glass bead peened, repatinated, Incralac
		1979 Weil, Phoebe Dent – Maintained superficial cleaning, Incralac
MO St. Louis, Tower Grove Park	Ruckstuhl, F.W., *Mercury,* 1891	1977 Weil, Phoebe Dent – Glass bead peened, repatinated, Incralac
		1978 Weil, Phoebe Dent – Maintained, superficial cleaning, Incralac
MO St. Louis, Tower Grove Park	von Miller, Ferdinand, II, *Shakespeare,* 1878	1976 Weil, Phoebe Dent – Glass bead peened, repatinated, Incralac

Location	Sculptor, Title, Date	Year, Treated by, Treatment
		1979 Weil, Phoebe Dent – Maintained, superficial cleaning, Incralac
MO St. Louis, Tower Grove Park	von Miller, Ferdinand, II, *von Humboldt,* 1878	1976 Weil, Phoebe Dent – Glass bead peened, repatinated, Incralac
		1979 Weil, Phoebe Dent – Maintained, superficial cleaning, Incralac
MO St. Louis, Tower Grove Park	Unknown, *von Steuben,* 1904	1978 Weil, Phoebe Dent – Glass bead peened, repatinated, Incralac
		1979 Weil, Phoebe Dent – Maintained, superficial cleaning, Incralac
MO St. Louis, Washington Park	Zolnay, George Julian, *LaClede,* 1914	1977 Weil, Phoebe Dent – Glass bead peened, repatinated, Incralac
		1978 Weil, Phoebe Dent – Maintained, superficial cleaning, Incralac
NB Lincoln, State Capitol Grounds	French, Daniel Chester, *Abraham Lincoln,* 1912	1980 Weil, Phoebe Dent – Glass bead peened, repatinated, Incralac
		1983 Weil, Phoebe Dent – Maintained, removed spray paint (vandalism), superficial cleaning, Incralac
NH Cornish, Saint-Gaudens NHS	Saint-Gaudens, Augustus, *Adams Memorial,* 1968	1982 Conservation Center, Harvard University – Washed, chemically repatinated, Incralac, waxed
		1983 Conservation Center, Harvard University – Washed, Incralac retouched, waxed
		1984 Conservation Center, Harvard University – Washed, Incralac retouched, waxed
NH Cornish, Saint-Gaudens NHS	Saint-Gaudens, Augustus, *Angel with Tablet/Amor Caritas,* 1975	1982 Conservation Center, Harvard University – Washed, waxed
		1983+ Conservation Center, Harvard University – Washed, waxed
NH Cornish, Saint-Gaudens NHS	Saint-Gaudens, Augustus, *Bust from the Standing Lincoln,* 1922	1982 Conservation Center, Harvard University – Washed, chemically repatinated, Incralac, waxed
		1983 Conservation Center, Harvard University – Washed, waxed
		1984 Conservation Center, Harvard University – Washed, waxed
NJ Princeton University Campus, Chapel/Firestone Library	Segal, George, *Abraham and Isaac: in Memory of May 4, 1970, Kent State,* 1976	1979 The Art Museum, Princeton University – Washed annually, NOT waxed at artist's suggestion

Location	Sculptor, Title, Date	Year, Treated by, Treatment
NJ Princeton University Campus, Compton Court, Graduate College	Lachaise, Gaston, *Floating Figure,* 1969	1976+ The Art Museum, Princeton University – Washed and waxed annually
NJ Princeton University Campus, Firestone Library/ Chapel	Lipchitz, Jacques, *Song of the Vowels,* 1969	1976+ The Art Museum, Princeton University – Washed and waxed annually, patina losses colored as required
NJ Princeton University Campus, Garden Pool at Prospect	Hadzi, Dimitri, *Centaur,* 1971	1976+ The Art Museum, Princeton University – Cleaned and waxed annually
NJ Princeton University Campus, Hamilton Hall Courtyard	Butler, Reg, *The Bride,* 1970	1970+ The Art Museum, Princeton University – Washed and waxed annually
NJ Princeton University Campus, Jadwin Hall Courtyard	Pevsner, Antoine, *Construction in the Third and Fourth Dimension,* 1972	The Art Museum, Princeton University – No treatment at artist's request – listed here for contrast
NJ Princeton University Campus, Lourie-Love Halls	Pomodoro, Arnaldo, *Sphero VI,* 1969	1976+ The Art Museum, Princeton University – Washed and waxed annually, polished as required
NJ Princeton University Campus, School of Engineering & Applied Science	Hadzi, Dimitri, *Thermopylae,* 1961	1976 The Art Museum, Princeton University – Washed and waxed annually
NJ Princeton University Campus, Stanhope Hall & West College	Moore, Henry, *Oval with Points,* 1971	1976+ The Art Museum, Princeton University – Washed and waxed annually, periodic repair and coloring of scratches
NY Albany, Rockefeller Plaza	Bolomy, Roger, *Untitled I and II,* 1971	1982 Tatti, Steven – Cleaned, heated/waxed
NY Albany, Rockefeller Plaza	Callery, Mary, *Z,* 1963	1982 Tatti, Steven – Structural reconstruction, cleaned, waxed
NY Bethpage, Bethpage Fire Department	Ascasibar, L., *Fire Rescue,* 1960	1961+ Comerford, Jim – Washed and waxed annually since 1961
NY New York, Brooklyn Botanical Garden	Moore, Henry, *Large Interior Form,* 1981	1984 Merk, Linda – Removed coatings and corrosion, localized application of BTA, Incralac, waxed
NY New York, Brooklyn Botanical Garden	Moore, Henry, *Large Slow Form,* 1968	1984 Merk, Linda – Removed coatings and corrosion, localized application of BTA, Incralac, waxed
NY New York, Brooklyn Botanical Garden	Moore, Henry, *Reclining Figure No. 2,* 1953	1984 Merk, Linda – Removed coatings and corrosion, localized application of BTA, Incralac, waxed
NY New York, Brooklyn Botanical Garden	Moore, Henry, *Reclining Mother and Child,* 1975	1984 Merk, Linda – Removed coatings and corrosion, localized application of BTA, Incralac, waxed
NY New York, Brooklyn Botanical Garden	Moore, Henry, *Working Model for Spindle Piece,* 1969	1984 Merk, Linda – Removed coatings and corrosion, localized application of BTA, Incralac, waxed

Location	Sculptor, Title, Date	Year, Treated by, Treatment
NY New York, Central Park	Ball, Thomas, *Daniel Webster*, 1876	1983 Weil, Phoebe Dent – Glass bead peened, repatinated, Incralac, waxed
NY New York, Central Park	MacDonald, James W.A., *Fitz-Greene Halleck*, 1877	1983 Tatti, Steven – Cleaned, heated/waxed
NY New York, Central Park	Moore, Henry, *Large Spindle*, 1978	1984 Merk, Linda – Removed coatings and corrosion, localized application of BTA, Incralac, waxed
NY New York, Central Park	Ward, J.Q.A., *Pilgrim*, 1885	1979 Weil, Phoebe Dent – Glass bead peened, repatinated, Incralac
		1983 Weil, Phoebe Dent – Maintained, superficial cleaning, Incralac
NY New York, Central Park	Moore, Henry, *Reclining Figure Angles*, 1979	1984 Merk, Linda – Removed coatings and corrosion, localized application of BTA, Incralac, waxed
NY New York, Central Park	Moore, Henry, *Two Piece Reclining Figure: Cut*, 1978	1984 Merk, Linda – Removed coatings and corrosion, localized application of BTA, Incralac, waxed
NY New York, Central Park	Moore, Henry, *Two Piece Reclining Figure: Points*, 1970	1984 Merk, Linda – Removed coatings and corrosion, localized application of BTA, Incralac, waxed
NY New York, Central Park	Schott, Walter, *Untermeyer Fountain*, 1910	1980 Weil, Phoebe Dent – Glass bead peened, repatinated, Incralac
		1983 Weil, Phoebe Dent – Maintained, superficial cleaning, Incralac
NY New York, City Hall	Moore, Henry, *Seated Woman*, 1957	1984 Merk, Linda – Extensive corrosion removal, BTA, Incralac, waxed
NY New York, Columbia University	Moore, Henry, *Reclining Figure Prop*, 1969	1984 Merk, Linda – Cleaned, Incralac, waxed
NY New York, Federal Hall	Ward, J.Q.A., *George Washington*, 1883	1978 Weil, Phoebe Dent – Glass bead peened, repatinated, Incralac
		1980 Weil, Phoebe Dent – Maintained, superficial cleaning, Incralac
NY New York, Hamilton Grange	Partridge, W.O., *Alexander Hamilton*, 1890s	1978 Weil, Phoebe Dent – Glass bead peened, repatinated, Incralac
		1980 Weil, Phoebe Dent – Maintained, superficial cleaning, Incralac
NY New York, New York Botanical Garden	Moore, Henry, *Large Torso: Arch*, 1963	1984 Merk, Linda – Removed old coating, Incralac, waxed
NY New York, New York Botanical Garden	Moore, Henry, *Reclining Figure 69*, 1969	1984 Merk, Linda – Removed corrosion, BTA, Incralac, waxed
NY New York, New York Botanical Garden	Moore, Henry, *Reclining Figure: Hand*, 1979	1984 Merk, Linda – Cleaned, Incralac, waxed

Location	Sculptor, Title, Date	Year, Treated by, Treatment
NY New York, New York Zoological Society	Moore, Henry, *Three Way Piece No. 1: Points,* 1965	1984 Merk, Linda – Removed old coating, Incralac, waxed
NY New York, New York Zoological Society	Moore, Henry, *Two Piece Reclining Figure: No. 1,* 1959	1984 Merk, Linda – Removed corrosion, BTA, Incralac, waxed
NY New York, New York Zoological Society	Moore, Henry, *Working Model for Sheep Piece,* 1971	1984 Merk, Linda – Cleaned, removed corrosion, BTA, Incralac, waxed
NY New York, Queens Museum	Moore, Henry, *Atom Piece,* 1965	1984 Merk, Linda – Cleaned, Incralac, waxed
NY New York, Queens Museum	Moore, Henry, *Falling Warrior,* 1957	1984 Merk, Linda – Removed corrosion, BTA, Incralac, waxed
NY New York, Queens Museum	Moore, Henry, *Figure on Steps: Draped Seated Woman* (model), 1956	1984 Merk, Linda – Cleaned, Incralac, waxed
NY New York, Queens Museum	Moore, Henry, *Standing Figure: Knife Edge* (model), 1961	1984 Merk, Linda – Removed corrosion, BTA, Incralac, waxed
NY New York, Trinity Church, Wall Street	Bitter, Karl, East Doors, 1896	1984 Tatti, Steven – Cleaned, spot repatinated, Incralac
NY New York, Trinity Church, Wall Street	Rhind, J. Massey, North Doors, 1896	1984 Tatti, Steven – Cleaned, spot repatinated, Incralac
NY New York, Trinity Church, Wall Street	Niehaus, Charles H., South Doors, 1896	1984 Tatti, Steven – Cleaned, spot repatinated, Incralac
NY Saratoga Springs, Congress Park	French, Daniel Chester, *Spencer Trask Memorial,* 1915	1983 Weil, Phoebe Dent – Replaced parts, glass bead peened, repatinated, Incralac
NY Staten Island, Snug Harbor	Moore, Henry, *Large Totem Head,* 1968	1984 Merk, Linda – Removed old coating, Incralac, waxed
NY Staten Island, Snug Harbor	Moore, Henry, *Reclining Connected Forms,* 1969	1984 Merk, Linda – Removed corrosion, BTA, Incralac, waxed
NY Staten Island, Snug Harbor	Moore, Henry, *Seated Woman,* 1959	1984 Merk, Linda – Removed corrosion, BTA, Incralac, waxed
NC Raleigh, North Carolina Museum of Art	Moore, Henry, *Large Spindle Piece,* 1976	1983 Tatti, Steven – Washed, heated/waxed
		1984+ Museum Conservation Staff – Washed and waxed annually
OH Akron, Akron Art Museum	Bourdelle, Emile-Antoine, *Figures Hurlantes,* 1894	1982 Wisenbaugh, Steven – Cleaned, heated/waxed
		1982+ Museum Staff – Biannual maintenance, cleaned, heated/waxed
OH Akron, Akron Art Museum	Hunt, Bryan, *Shift Falls,* 1976	1982 Wisenbaugh, Steven – Shimmed with stainless steel, cleaned, heated/waxed

Location	Sculptor, Title, Date	Year, Treated by, Treatment
		1982+ Museum Staff – Biannual maintenance, cleaned, heated/waxed
OH Akron, Akron Art Museum	Graves, Nancy, *Variability and Repetition . . .*, 1979	1982 Wisenbaugh, Steven – Drilled weep holes, cleaned, reapplied chemical patina, heated/waxed (pigmented)
OH Columbus, City Hall	Alfieri, E., *Christopher Columbus*, ca. 1955	1979 Weil, Phoebe Dent – Glass bead peened, repatinated, Incralac
OH Columbus, Columbus Museum of Art	Various, Statues in Sculpture Garden	Museum Staff – Bronzes cleaned and waxed annually
OH Columbus, Franklin Commons Park	Anderson, James P., *Benjamin Franklin*, 1974	1981 Wisenbaugh, Steven – Mechanically cleaned, patina reapplied, heated/waxed
		1983 Wisenbaugh, Steven – Washed, waxed
OH Columbus, Franklin Commons Park	Iselin, Lewis, *Eve*, 1964	1983 Wisenbaugh, Steven – Welding repairs, patina reapplied as needed, cleaned, heated/waxed
		1985 Wisenbaugh, Steven – More extensive repairs of damage, patina reapplied as needed, cleaned, heated/waxed
OH Columbus, Franklin Commons Park	Moore, Henry, *Oval with Points*, 1970	1981 Wisenbaugh, Steven – Cleaned, heated/waxed
		1983 Wisenbaugh, Steven – Washed, waxed
OH Gambier, Kenyon College President's House	Waddell, *Dance Mother*, 1974	1982 Wisenbaugh, Steven – Repaired torn leg, welded, reapplied patina, cleaned, heated/waxed
PA Gettysburg NMP, East Cemetery Hill	Elwell, Frank Edwin, *Hancock Equestrian*, 1896	1981 Karkadoulias Bronze Art – Washed, heated/waxed
PA Gettysburg NMP, East Cemetery Hill	Aitken, Robert, *Howard Equestrian*, 1932	1981 Karkadoulias Bronze Art – Washed, heated/waxed
PA Gettysburg NMP, Hancock Avenue	Walz, John, *106th Pennsylvania Infantry* (relief), 1889	1981 Karkadoulias Bronze Art – Washed, heated/waxed
PA Gettysburg NMP, Hancock Avenue	Buberl, Caspar, *111th New York Infantry*, 1891	1979 Karkadoulias Bronze Art – Glass bead peened, repatinated, Incralac
PA Gettysburg NMP, Hancock Avenue	Brooks & Beattie, *12th New Jersey Infantry* (relief), 1892	1981 Karkadoulias Bronze Art – Washed, heated/waxed
PA Gettysburg NMP, Hancock Avenue	Ellicott, H.L., *1st Pennsylvania Cavalry*, 1890	1979 Karkadoulias Bronze Art – Glass bead peened, repatinated, Incralac
PA Gettysburg NMP, Hancock Avenue	Boyle, John J., *42nd New York Infantry*, 1891	1979 Karkadoulias Bronze Art – Glass bead peened, repatinated, Incralac
PA Gettysburg NMP, Hancock Avenue	Rhind, J. Massey, *Alexander S. Webb*, 1915	1980 Karkadoulias Bronze Art – Glass bead peened, repatinated, waxed
PA Gettysburg NMP, Hancock Avenue	Hamilton, J.G., *Cowan's 1st New York Battery* (relief), 1887	1981 Karkadoulias Bronze Art – Washed, heated/waxed

Location	Sculptor, Title, Date	Year, Treated by, Treatment
PA Gettysburg NMP, Hancock Avenue	Murray, Samuel, *Father Corby*, 1910	1981 Harpers Ferry Center NPS – Water washed, degreased, heated/waxed
PA Gettysburg NMP, Hancock Avenue	O'Kelley, Stephen J., *Fitzhugh's New York Battery K* (relief), 1888	1982 Karkadoulias Bronze Art – Glass bead peened, repatinated, Incralac
PA Gettysburg NMP, Hancock Avenue	Bonnard, Henry, *High Water Mark*, 1892	1979 Karkadoulias Bronze Art – Glass bead peened, repatinated, Incralac
PA Gettysburg NMP, Hancock Avenue	Bush-Brown, Henry K., *Meade Equestrian*, 1896	1981 Karkadoulias Bronze Art – Washed, heated/waxed
PA Gettysburg NMP, Hancock Avenue	Schweizer, J. Otto, *Pleasonton, Pennsylvania Monument*, 1910	1981 Karkadoulias Bronze Art – Washed, heated/waxed
PA Gettysburg NMP, Little Round Top	Gerhardt, Karl, *Gouverneur K. Warren*, 1888	1981 Karkadoulias Bronze Art – Washed, heated/waxed
PA Gettysburg NMP, Little Round Top	Unknown, *U.S. Signal Corps*, 1919	1981 Karkadoulias Bronze Art – Washed, heated/waxed
PA Gettysburg NMP, Meade School	Pausch, Edward, *26th Pennsylvania Emergency*, 1892	1980 Karkadoulias Bronze Art – Mechanically cleaned, waxed
PA Gettysburg NMP, National Cemetery	Bush-Brown, Henry K., *Lincoln Speech Memorial*, 1912	1982 GNMP/Vorhees, Arthur R. – Washed, heated/waxed
PA Gettysburg NMP, Sedgwick Avenue	Unknown, *New Jersey Brigade* (relief), 1888	1982 Karkadoulias Bronze Art – Glass bead peened, repatinated, Incralac
PA Gettysburg NMP, Sedgwick Avenue	Karkadoulias, Elefitherios, *New Jersey Brigade* (relief — replacement), 1982	1982 Karkadoulias Bronze Art – Glass bead peened, repatinated, Incralac
PA Gettysburg NMP, Sedgwick Avenue	Unknown, *New Jersey Brigade* (tablets), 1888	1981 Karkadoulias Bronze Art – Washed, heated/waxed
PA Gettysburg NMP, Sedgwick Avenue	Bush-Brown, Henry K., *Sedgwick Equestrian*, 1913	1981 Karkadoulias Bronze Art – Washed, heated/waxed
PA Gettysburg NMP, Sickles Avenue	O'Donovan, William Rudolph, *Irish Brigade*, 1888	1979 Karkadoulias Bronze Art – Glass bead peened, repatinated, Incralac
PA Gettysburg NMP, Slocum Avenue, Stevens Knoll	Potter, Edward C., *Slocum Equestrian*, 1902	1981 Karkadoulias Bronze Art – Washed, heated/waxed
PA Gettysburg NMP, Stone Avenue	Bureau, Albert G., *John Burns*, 1903	1980 Karkadoulias Bronze Art – Glass bead peened, repatinated, waxed
PA Gettysburg NMP, The Angle	Stephens, George Frank (?), *72nd Pennsylvania Infantry*, 1891	1980 Karkadoulias Bronze Art – Glass bead peened, repatinated, waxed
PA Gettysburg NMP, US 30	Bush-Brown, Henry K., *Reynolds Equestrian*, 1899	1981 Karkadoulias Bronze Art – Washed, heated/waxed
PA Gettysburg NMP, West Confederate Avenue	DeLue, Donald, *Mississippi Monument*, 1973	1980 GNMP/Vorhees, Arthur R. – Washed, heated/waxed

Location	Sculptor, Title, Date	Year, Treated by, Treatment
PA Gettysburg NMP, Ziegler's Grove	Schweizer, J. Otto, *Alexander Hays,* 1915	1982 Karkadoulias Bronze Art – Glass bead peened, repatinated, Incralac
PA Haverford, Merion Cricket Club	Bitter, Karl, *Memorial to Alexander J. Cassatt,* 1910	1982 Fuller, Tamsen – Mechanically cleaned, BTA, heated/waxed
PA Philadelphia, Broad Street/ Packer Avenue	Davidson, Jo, *Walt Whitman,* 1939	1983 Tatti, Steven – Washed, heated/waxed
PA Philadelphia, Clark Park (43rd/Chestnut)	Elwell, Frank Edwin, *Dickens and Little Nell,* 1890	1983 Tatti, Steven – Washed, heated/waxed
PA Philadelphia, College of Physicians	Hoffman, Edward Fenno, III, *Girl with Basin,* 1960	1984 Fuller, Tamsen – Mechanically cleaned, solvent cleaned, BTA, heated/waxed
PA Philadelphia, Drexel University, 32nd/Market Streets	Ezekiel, Sir Moses, *Anthony J. Drexel,* 1904	1984 Fuller, Tamsen – Mechanically cleaned, washed, solvent cleaned, BTA, heated/waxed
PA Philadelphia, Fairmount Park	Laessle, Albert, *Galusha Pennypacker,* 1934	1984 Tatti, Steven – Cleaned, heated/waxed
PA Philadelphia, Fairmount Park – Boat House Row	Saint-Gaudens, Augustus, *The Pilgrim,* 1904	1983 Tatti, Steven – Washed, heated/waxed
PA Philadelphia, Fairmount Park – Boat House Row	Jonsson, Einer, *Thorfinn Karlsefni,* 1918	1984 Tatti, Steven – Cleaned, heated/waxed
PA Philadelphia, Fairmount Park – East River Drive	Rogers, Randolph, *Abraham Lincoln,* 1871	1983 Tatti, Steven – Washed, heated/waxed
PA Philadelphia, Fairmount Park – East River Drive	Remington, Frederic, *Cowboy,* 1908	1983 Tatti, Steven – Washed, missing parts replaced, heated/waxed
PA Philadelphia, Fairmount Park – East River Drive	Saint-Gaudens, Augustus, *Garfield Monument,* 1895	1983 Tatti, Steven – Washed, heated/waxed
PA Philadelphia, Fairmount Park – East River Drive	French, Daniel Chester, *General Ulysses S. Grant,* 1897	1983 Tatti, Steven – Washed, heated/waxed
PA Philadelphia, Fairmount Park – Logan Circle	Calder, Alexander Stirling, *Shakespeare Memorial,* 1926	1984 Tatti, Steven – Cleaned, heated/waxed
PA Philadelphia, Fairmount Park – Philadelphia Museum of Art	Siemering, Rudolf, *George Washington Monument,* 1897	1984 Tatti, Steven – Cleaned, heated/waxed
PA Philadelphia, Fairmount Park – Philadelphia Museum of Art	Kiss, August, *The Amazon,* 1843	1984 Tatti, Steven – Cleaned, heated/waxed
PA Philadelphia, Fairmount Park – Philadelphia Museum of Art	Wolf, Albert, *The Lion Fighter,* 1858	1984 Tatti, Steven – Cleaned, heated/waxed
PA Philadelphia, Fairmount Park – near Memorial Hall	Schweizer, J. Otto, *All Wars Mem. to Colored Soldiers & Sailors,* 1934	1984 Tatti, Steven – Cleaned, heated/waxed

Location		Sculptor, Title, Date	Year, Treated by, Treatment
PA	Philadelphia, Fairmount Park – near Memorial Hall	Calder, Alexander Milne, *Major General George Gordon Meade,* 1887	1983 Tatti, Steven – Washed, heated/waxed
PA	Philadelphia, Fairmount Park – near Sweetbriar	Boyle, John J., *Stone Age in America,* 1887	1983 Tatti, Steven – Washed, heated/waxed
PA	Philadelphia, John F. Kennedy Plaza	Moore, Henry, *Three Way Piece No. 1: Points,* 1964	1983 Tatti, Steven – Washed, heated/waxed
PA	Philadelphia, Philadelphia College of Art	Moore, Henry, *Reclining Figure 1951,* 1951	1979 Fuller, Tamsen – Mechanically cleaned, BTA
			1984 Fuller, Tamsen – Mechanically cleaned, BTA, heated/waxed
PA	Philadelphia, Philadelphia Museum of Art	Lipchitz, Jacques, *Prometheus,* 1952	1981 Philadelphia Museum of Art – Cleaned, repatinated, BTA, heated/waxed
PA	Philadelphia, Rittenhouse Square	Manship, Paul, *Duck Girl,* 1911	1983 Tatti, Steven – Washed, heated/waxed
PA	Philadelphia, Rittenhouse Square	Barye, Antoine-Louis, *Lion Crushing a Serpent,* 1832	1983 Tatti, Steven – Washed, heated/waxed
PA	Philadelphia, Thomas Jefferson University	Calder, Alexander Stirling, *Dr. Samuel Gross,* 1897	1982 Tatti, Steven – Washed, heated/waxed
SC	Murrells Inlet, Brookgreen Gardens	Various, Statues in Sculpture Garden	Museum Staff – Bronze sculptures washed and waxed several times a year
TX	Austin, Harry Ransom Center, University of Texas	Hyatt, Anna V., *Joan of Arc,* 1925	1984 Storch, Paul S. – Sword and belt reconstructed, mechanically & chemically cleaned, Incralac, waxed
TX	Ft. Worth, Burnett Square	Matisse, Henri, *Backs* (4 relief sculptures), 1931	1983 Weil, Phoebe Dent – Superficial cleaning, Incralac
TX	Ft. Worth, Kimbell Art Museum	Maillol, Aristide, *L'Air,* 1960s	1983 Weil, Phoebe Dent – Superficial cleaning, retouched patina, Incralac
			1984 Weil, Phoebe Dent – Superficial cleaning, retouched patina, Incralac
TX	Ft. Worth, Kimbell Art Museum	Bourdelle, Emile-Antoine, *Penelope,* 1960s	1983 Weil, Phoebe Dent – Superficial cleaning, retouched patina, Incralac
			1984 Weil, Phoebe Dent – Superficial cleaning, retouched patina, Incralac
TX	Houston, Houston Museum of Fine Arts	Bourdelle, Emile-Antoine, *Adam,* 1889	1984 Weil, Phoebe Dent – Superficial cleaning, Incralac
TX	Houston, Houston Museum of Fine Arts	Hunt, Bryan, *Arch Falls,* 1981	1984 Weil, Phoebe Dent – Superficial cleaning, Incralac
TX	Houston, Houston Museum of Fine Arts	Matisse, Henri, *Backs* (4 relief sculptures), 1931	1984 Weil, Phoebe Dent – Superficial cleaning, Incralac
TX	Houston, Houston Museum of Fine Arts	Steiner, Michael, *Egypt II,* 1979	1984 Weil, Phoebe Dent – Superficial cleaning, Incralac

Location	Sculptor, Title, Date	Year, Treated by, Treatment
TX Houston, Houston Museum of Fine Arts	Maillol, Aristide, *Flore Nue,* 1910	1984 Weil, Phoebe Dent – Superficial cleaning, Incralac
TX Houston, Houston Museum of Fine Arts	Graham, Robert, *Fountain Sculptures,* 1983	1984 Weil, Phoebe Dent – Superficial cleaning, Incralac
TX Houston, Houston Museum of Fine Arts	Manship, Paul, *Hercules,* 1918	1984 Weil, Phoebe Dent – Superficial cleaning, Incralac
TX Houston, Houston Museum of Fine Arts	Rodin, Auguste, *Homme Qui Marche,* 1968	1984 Weil, Phoebe Dent – Superficial cleaning, Incralac
TX Houston, Houston Museum of Fine Arts	Duchamp-Villon, Raymond, *Le Cheval Majeur,* 1967	1984 Weil, Phoebe Dent – Superficial cleaning, Incralac
TX Houston, Houston Museum of Fine Arts	Umlauf, Carl, *Pietà,* 1947	1984 Weil, Phoebe Dent – Superficial cleaning, Incralac
TX Houston, Houston Museum of Fine Arts	Fontana, Lucio, *Space Concept* (2 sculptures), 1965	1984 Weil, Phoebe Dent – Superficial cleaning, Incralac
TX Jefferson	Moretti, G., & Mott, J.L., *The Sterne Fountain,* 1913	1981 Weil, Phoebe Dent – Glass bead peened, repatinated, Incralac
VA Arlington	de Weldon, Felix, *Marine Corps War Memorial (Iwo Jima),* 1954	1984 Veloz, N./Stromberg, C./Austin, M. – Washed, BTA, heated/waxed
VA Arlington, Memorial Drive	Zuckermann, Bernhard, *101st Airborne Memorial,* 1976	1984 Veloz, N./Stromberg, C./Austin, M. – Washed, BTA, spray waxed (BTA)
VA Arlington, Memorial Drive	de Weldon, Felix, *Rear Admiral Richard Evelyn Byrd,* 1961	1979 Veloz, Nicolas F. – Walnut shell blasted, BTA, waxed
		1984 Veloz, N./Stromberg, C./Austin, M. – Walnut shell blasted, BTA, spray waxed (BTA)
VA Arlington, Memorial Drive	de Weldon, Felix, *Seabees* (relief panels), 1972	1979 Veloz, Nicolas F. – Washed, BTA, spray waxed
		1984 Veloz, N./Stromberg, C./Austin, M. – Washed, BTA, spray waxed (BTA)
VA Arlington, Memorial Drive	de Weldon, Felix, *Seabees* (sculptural group), 1972	1979 Veloz, Nicolas F. – Walnut shell blasted, BTA, waxed
		1984 Veloz, N./Stromberg, C./Austin, M. – Washed, BTA, spray waxed (BTA)
VA Arlington, Memorial Drive	Kitson, T.A.R., *The Hiker,* 1965	1979 Veloz, Nicolas F. – Walnut shell blasted, BTA, waxed
		1984 Veloz, N./Stromberg, C./Austin, M. – Washed, BTA, spray waxed (BTA)
VA Manassas, Manassas NBP	Pollia, Joseph P., *General Thomas Jonathan (Stonewall) Jackson,* 1940	1984 Veloz, N./Stromberg, C./Austin, M. – Walnut shell blasted, BTA, spray waxed (BTA)

Location	Sculptor, Title, Date	Year, Treated by, Treatment
VA Mt. Vernon, Mt. Vernon Circle	Unknown, George Washington Memorial Parkway plaque, 1932	1982 Veloz, Nicolas F. – Walnut shell blasted, BTA, waxed
VA Richmond, Capitol Grounds	Rudy, Charles, *Edgar Allen Poe*, 1956	1981 Weil, Phoebe Dent – Superficial cleaning, Incralac
		1982 Weil, Phoebe Dent – Maintained, superficial cleaning, Incralac
VA Richmond, Capitol Grounds	Mercie, J.A., *General Robert E. Lee*, 1889	1982 Weil, Phoebe Dent – Glass bead peened, repatinated, Incralac
VA Richmond, Capitol Grounds	McVey, W., *Senator Harry F. Byrd*, 1976	1981 Weil, Phoebe Dent – Superficial cleaning, Incralac
		1982 Weil, Phoebe Dent – Maintained, superficial cleaning, Incralac
VA Richmond, Capitol Grounds	Foley, J., *Stonewall Jackson*, 1875	1981 Weil, Phoebe Dent – Glass bead peened, repatinated, Incralac
		1982 Weil, Phoebe Dent – Maintained, superficial cleaning, Incralac
VA Richmond, Capitol Grounds	Crawford, T., & Rogers, R., *Washington Monument*, 1869	1982 Weil, Phoebe Dent – Glass bead peened, repatinated, Incralac
VA Richmond, Capitol Grounds	Sheppard, W., *William Smith*, 1906	1981 Weil, Phoebe Dent – Glass bead peened, repatinated, Incralac
		1982 Weil, Phoebe Dent – Maintained, superficial cleaning, Incralac
VA Winchester	Hibbard, Frederick, *Confederate Memorial*, 1916	1979 Weil, Phoebe Dent – Glass bead peened, repatinated, Incralac
VA Yorktown, Peace Memorial	Unknown, Commemorative plaques (2), 1932	1984 Veloz, Nicolas F. – Washed, BTA, waxed (BTA)
WV Bolivar, Washington Street	de Weldon, Felix, *Simon Bolivar*, 1957	1983 Harpers Ferry Center NPS – Washed, degreased, heated/waxed

CANADA

Location	Sculptor, Title, Date	Year, Treated by, Treatment
Quebec City, Parc Montmorency	Laliberte, Alfred, *Louis-Herbert Monument*, 1917	1981 Centre de Conservation du Quebec – Glass bead peened, BTA, repatinated, Incralac, wax
Quebec City, Place Jacques Cartier	Bareau, Georges, *Jacques Cartier Monument*, 1924	1982 Centre de Conservation du Quebec – Glass bead peened, BTA, repatinated, Incralac, wax
Quebec City, Terrasse Dufferin	Cheure, Paul, *Champlain Monument*, 1898	1983 Centre de Conservation du Quebec – Glass bead peened, BTA, repatinated, Incralac, wax

AIC Code of Ethics and Standards of Practice

PART ONE — CODE OF ETHICS

I. PREAMBLE

Conservation of historic and artistic works is a pursuit requiring extensive training and special aptitudes. It places in the hands of the conservator* cultural holdings which are of great value and historical significance. To be worthy of this special trust requires a high sense of moral responsibility. Whether in private practice or on the staff of an institution or regional center, the conservator has obligations not only to the historic and artistic works with which he** is entrusted, but also to their owners or custodians, to his colleagues and trainees, to his profession, to the public and to posterity. The following code expresses principles and practices which will guide the conservator in the ethical practice of his profession.

II. OBLIGATIONS TO HISTORIC AND ARTISTIC WORKS

A. Respect for Integrity of Object
All professional actions of the conservator are governed by unswerving respect for the esthetic, historic and physical integrity of the object.

B. Competence and Facilities
It is the conservator's responsibility to undertake the investigation or treatment of a historic or artistic work only within the limits of his professional competence and facilities.

C. Single Standard
With every historic or artistic work he undertakes to conserve, regardless of his opinion of its value or quality, the conservator should adhere to the highest and most exacting standard of treatment. Although circumstances may limit the extent of treatment, the quality of the treatment should never be governed by the quality or value of the object. While special techniques may be required during treatment of large groups of objects, such as archival and natural history material, these procedures should be consistent with the conservator's respect for the integrity of the objects.

D. Suitability of Treatment
The conservator should not perform or recommend any treatment which is not appropriate to the preservation or best interests of the historic or artistic work. The necessity and quality of the treatment should be more important to the professional than his remuneration.

E. Principle of Reversibility
The conservator is guided by and endeavors to apply the "principle of reversibility" in his treatments. He should avoid the use of materials which may become so intractable that their future removal could endanger the physical safety of the object. He also should avoid the use of techniques the results of which cannot be undone if that should become desirable.

F. Limitations on Esthetic Reintegration
In compensating for damage or loss, a conservator may supply little or much restoration, according to a firm previous understanding with the owner or custodian and the artist, if living. It is equally clear that he cannot ethically carry compensation to a point of modifying the known character of the original.

G. Continued Self-Education
It is the responsibility of every conservator to remain abreast of current knowledge in his field and to continue to develop his skills so that he may give the best treatment circumstances permit.

H. Auxiliary Personnel
The conservator has an obligation to protect and preserve the historic and artistic works under his care at all times by supervising and regulating the work of all auxiliary personnel, trainees and volunteers under his professional direction. A conservator should not contract or engage himself to clients as a supervisor of insufficiently trained auxiliary personnel unless he can arrange to be present to direct the work.

*Hereafter in the text the word "conservator" also denotes "conservation scientist" when applicable.
**In this text "he" and related pronouns are used in the classical sense to denote the person, male or female.

AIC National Office
3545 Williamsburg Lane, N.W.
Washington, DC 20008
202 364-1036

III. RESPONSIBILITIES TO THE OWNER OR CUSTODIAN

A. Contracts

Contract practice may permit a conservator to enter into an agreement with individuals, institutions, corporations or governmental agencies to provide conservation services, provided that the contract or agreement does not contravene the principles of ethics as laid down or implied in this code.

B. Changes in Treatment or Fee

Any changes on the part of the conservator in the contracted planned procedure in treating historic and artistic works, or changes in the fee which has previously been estimated should, unless circumstances intervene, be made known to the owner or custodian and be approved in writing before the changes are effected.

C. Abrogation of Contract

The conservator should understand that an owner or custodian is free to select, without persuasion or admonition, the services of any conservator of his choice or of more than one conservator simultaneously, and is also at liberty to change from one conservator to another at his own discretion. However, after a contract, oral or written, has been made for the treatment of a specific object, neither the conservator nor the owner may ethically withdraw from it except by mutual agreement.

D. Proper Course of Treatment

Inasmuch as an owner may not be competent to judge the conservation requirements of his historic and artistic possessions, the conservator should honestly and sincerely advise what he considers the proper course of treatment.

E. Report of Examination

Before performing any treatment on an object, the conservator should first make an adequate examination and record of condition.* The conservator is obliged to report his findings and recommendations to the owner or custodian or their delegate and await instructions before proceeding.

F. Record of Treatment

A record of treatment* should also be made by the conservator. He has the obligation to record and report in detail to the owner or custodian the materials and methods of procedure employed in treating the object.

*Standard procedures for engaging in and reporting of examination and treatment of historic and artistic works are described in Part Two, Sections IV and V.

G. Punctuality and Expedition

It is the obligation of the conservator to estimate the length of time it will take to complete the treatment and to abide by his contract with reasonable punctuality.

H. Fees

Fees for conservation service should be commensurate with the service rendered, with due regard to fairness to the owner or custodian and to the conservator and for respect for the profession.

In determining the amount of the fee, it is proper to consider (1) time and labor required, (2) cost of materials and insurance, (3) novelty and difficulty of the treatment, (4) customary charges of others for like services, (5) the problems involved in treating a work of high value, (6) character of the employment—casual or constant client.

An owner's ability to pay cannot justify a charge in excess of the value of the service.

Conservators should avoid charges that overestimate the worth of their services, as well as those that undervalue them.

Because of variations in the treatment of similar conditions, it is impossible to establish with mathematical accuracy a set fee for a particular type of service.

I. Warranty or Guarantee

Although the conservator at all times should follow the highest standards and, to the best of his knowledge, the most acceptable procedures, to warrant or guarantee the results of a treatment is unprofessional. This is not to be construed to mean that he should not willingly and freely correct defects or unforeseen alterations which, in his opinion, have occurred prematurely following his treatment.

IV. RELATIONS WITH COLLEAGUES, TRAINEES AND THE PROFESSION

A. Contribution to Profession

A conservator has an obligation to share his knowledge and experience with his colleagues and with serious students. He should show his appreciation and respect to those from whom he has learned and to those who have contributed in the past to the knowledge and art of the profession by presenting without thought of personal gain such advancements in his techniques of examination and treatment which may be of benefit to the profession. The originator of a novel method of treatment or a new material should make full disclosure of the composition and properties of all materials and techniques employed. The originator is expected to cooperate with other conservators and conservation scientists employing or evaluating the proposed methods or

materials. None of the above is intended to infringe upon the proprietary rights of the originator.

B. Trainees and Interns

The conservator, private or institutional, has a responsibility to undertake the training and instruction of apprentices, trainees and interns, but only within the limits of his expert knowledge and the technical facilities available. The rights and objectives of both the trainer and the apprentice should be clearly stated and mutually agreed upon in writing, and should include such items as anticipated length of apprenticeship, areas of competence to be taught and payments.

C. References

A conservator should not recommend or provide a reference for a person applying for a position as a professional conservator unless the conservator has personal knowledge that the applicant's training, experience and performance qualify him for the position.

D. Intermediaries

The professional services of a conservator should not be controlled or exploited by any agency, personal or corporate, that intervenes between client and practitioner; the conservator's responsibilities and qualifications are individual and personal. He should avoid all relationships that direct the performance of his duties by or in the interest of such intermediary. This does not preclude his working under the direction of another qualified conservator, whether in private practice or within an institutional system.

E. Request for Consultation

If, for any reason, before or during treatment the owner or custodian desires another opinion on procedure through consultation with another conservator, this should not be regarded as evidence of lack of confidence and should be welcomed by the conservator.

F. Consultation

No person engaged in the profession of conservation can expect to be expertly informed on all phases of examination, analysis and treatment. In instances of doubt there should be no hesitation in seeking the advice of other professionals, or in referring the owner to a conservator more experienced in the particular special problems.

G. Misuse of Referral in Client-Conservator Relations

Where clients have been referred for consultation or treatment, the conservator to whom they have been referred should, unless it was obviously otherwise intended, return the client to the original conservator as soon as possible. Efforts, direct or indirect, in any way to encroach upon the professional employment of another conservator are considered unprofessional.

H. Fee Splitting

The payment of a commission or fee to another conservator or any other person for the reference of a client is to be condemned as unprofessional. Division of a fee is only acceptable where it is based on a division of service or responsibility.

I. Comment on Qualifications of Another Conservator

It is unethical for a conservator to volunteer adverse judgment on the qualifications of and procedures rendered by another conservator except as such comment shall be to the mutual benefit of all concerned. In expressing an opinion about another practitioner, either voluntarily or at the request of someone outside the profession, the conservator must always conscientiously consider the iniquity of slander and must scrupulously base his statement on facts of which he has personal knowledge. If his opinion is uncertain or dependent on hearsay, it is more constructive to withhold comment and to recommend instead someone of whom he has no doubt.

V. OBLIGATIONS TO THE PUBLIC

A. Education of the Public

In his relations with the public, every conservator should accept such opportunities as may be presented to educate the public in the aims, desires and purposes of his profession in order that a better popular understanding of conservation may be established. Such presentations should be in accordance with accepted principles of the time.

B. Safeguarding the Public Interests

In the interests of the public as well as their own profession, conservators should observe accepted standards and laws, uphold the dignity and honor of the profession and accept its self-imposed disciplines. They should do their part to safeguard the public against illegal or unethical conduct by referring the facts of such delinquency to the appropriate professional committee. Further, it is the right of any conservator to give proper advice when it is requested by those seeking relief against negligent or unethical practices.

C. Expertise

Although the results of his examination and treatment of historic and artistic works may make it possible for him to contribute knowledge to the history of art and to the verification of the authorship or authenticity of an object, the issuing of paid expertises or authentications may involve conflict of interest and is not an appropriate or ethical activity for a conservator.

D. Appraisals

Because of his intimate contact with and knowledge of techniques of fabrication and the physical condition

of historic and artistic works, a conservator is often asked to appraise for a fee the monetary value of an object. Since this activity may involve conflicts of interest inconsistent with the profession of conservation and since appraising requires other specialized knowledge of market values and connoisseurship, appraisal for a fee is not recommended unless the individual is a professional member of a recognized professional society of appraisers.

E. Art Dealing
Engaging in the business of selling or purchasing for personal profit or acting as a paid or commissioned agent in the sale of historic and artistic works are activities considered to be inconsistent with the professional integrity of conservators.

F. Advertising
It is an accepted principle that the foundation of effective advertising is the establishment of a well-merited reputation for professional ability and integrity. Thus it is recommended that conservators limit all forms of notices and communications which may be construed as advertising to the following:

1. Use of such sign or signs which in size, character, working and position reasonably may be required to indicate the entrance of the premises in which the practice is performed;

2. Use of professional cards and letterheads on stationery, bill and receipt forms, indicating only the name, academic degree, Fellowship in AIC, conservation specialty, office address and telephone number. Only Fellows may use the name of AIC;

3. Use of announcements of commencement of practice, change of location or restriction of practice;

4. Use of advertisements in newspapers, magazines and telephone directories, provided that their form and content do not detract from the high professional standards reflected elsewhere in this code of ethics and do not contain comparisons of ability and cost.

G. Solicitation of Clients
1. It is recommended that solicitations be confined to discreet announcements in newspapers and magazines inviting clients. Direct mailing to individuals, museums and institutions may be construed as an attempt to solicit clients unethically.

2. The judicious distribution of reprints and communications to colleagues is acceptable and an author may honor requests for his articles. Indiscriminate mailing without sufficient reason is construed as an attempt to solicit clients unethically or an attempt to bring undue attention to the author.

H. Statements in the Name of AIC
Individual members of AIC should not present opinions in the name of AIC to outside organizations or individuals.

PART TWO — STANDARDS OF PRACTICE

I. PREAMBLE

The following standards and procedures are approved by AIC as detailed guidelines to professional practice by conservators* in the examination and treatment of historic and artistic works. Such practice is considered to comprise three categories:

A. Examination, treatment and systematic maintenance of historic and artistic works, whether by private or institutional conservators;

B. Scientific analytical study of art objects for such purposes as identifying materials, method of construction, modifications by age or other agents, comparison with comparable material;

C. Supplying previously developed reference data which may bear on condition, authenticity, authorship or age of specific objects. This can be either by formal publication or private communication.

II. GENERAL CONSIDERATIONS OF POLICY

These are broadly applicable to all categories:

A. Professional Attitude
It must be axiomatic that all professional actions of a conservator be governed by unswerving respect for the integrity of historic and artistic works. Such respect is manifest not only in policies of restoration, but in selection of courses of treatment, in safeguarding against accident, protection against loss and strict avoidance of misinterpreting technical evidence.

B. Contractual Relationships
A contract should include the need for a clear written statement of the following: the exact work to be done, the basis for charges, if any, the extent and substance of reports, including photographs as appropriate, responsibility for insurance coverage deemed adequate for operator, owner and object, provisions for safeguarding objects, method of delivery and any subcontracting or reassignment of work.**

C. Assumption of Responsibility
It is a conservator's responsibility to contract for investigation or treatment only to the limits of his professional competence and facilities. Should he not be trained or equipped for a full scientific study by generally accepted current technical means, any specific limitations must be stated and accepted by both parties from the beginning.

*"Conservators" in the text also denotes "conservation scientists" when applicable.

**It is recommended that a lawyer be consulted in the preparation of such contracts.

Wherever further opinion seems to be required, such further opinion or opinions are a necessary part of a comprehensive report. In the same manner, a conservator will be held irresponsible if he undertakes to carry out a course of treatment for which he is inadequately trained or equipped.

D. Interpretation of Evidence

An investigator has the obligation to present all the evidence he has developed about an object commissioned to him for study, favorable or otherwise, and also to supply from his professional knowledge a clear exposition of the significance of each part of the evidence. It will be held improper for him to make outright formal declarations as to age, authenticity and the like (which subsequently might form the basis of a claim or legal action) when each declaration exceeds the logical development of the specific evidence.

E. Limitations on Esthetic Reintegration

In compensating for losses or damage, a conservator can be expected to carry out little or much restoration according to a firm previous understanding with the owner or custodian and the artist if living. However, he cannot ethically carry compensation to a point of modifying the known character of the original.

F. Outside Activities

It shall be considered inconsistent with the professional integrity of conservators in any of the three categories of procedure to engage in the following outside activities:

1. Issuing paid "expertises" or authentication;

2. Acting as paid or commissioned agent in the selling or purchasing of historic or artistic works;

3. Engaging in such selling or purchasing for personal profit;

4. Appraising for a fee the monetary value of historic and artistic works unless the conservator is a professional member of a recognized professional society of appraisers.

III. PROCEDURE FOR INITIATING, CONDUCTING AND REPORTING IN SCIENTIFIC ANALYTICAL STUDIES OF HISTORIC AND ARTISTIC WORKS

Whenever it becomes necessary for owners of historic and artistic works to request institutional or commercial analytical laboratories or private consultants to engage in scientific study of objects for the purpose of developing data which may bear on condition, authenticity, authorship or age of a specific object, the following procedure shall be followed by all parties concerned.

A. Initiating the Study

The owner of the object, or his qualified agent or a qualified officer of an institution, shall send to the ex-amining agency a written request with statements covering the following points as required:

1. The purpose of the study, listing any specific questions to be answered.

2. Whether (a) the whole object or (b) samples from the object are to be made available for study. If samples only are to be sent to the laboratory, the exact location of the samples on the object and the name of the person who took the samples and the date taken are to be given.

3. If the whole object is to be sent to the analyst, (a) the legal owner, (b) its value, (c) to what extent it is covered by insurance, (d) by what carrier it is to be sent to the laboratory and returned to the owner and (e) that the object is to be sent to the investigating laboratory at the owner's risk and expense.

4. Explicit permission to take samples from the object during examination, defining any limitations.

5. Whether the investigator (a) is merely to report facts and observations or (b) is expected to draw conclusions from the facts.

6. Whether the laboratory findings (a) are to be kept in strict confidence or (b) can be used regardless of their nature, by the investigator in formal publications and in oral declarations.

7. Whether any of the evidence to be produced is intended for use in legal proceedings.

B. Conducting the Study

The analyst or laboratory official on receiving the object shall:

1. Supply a written receipt to the owner verifying its condition and inform the owner how the object will be stored and guarded.

2. Inform the owner what fees, if any, are to be charged for the analytical services. If there is to be no charge, state that fact explicitly. State also what other charges may be made for photography, radiography and for other analytical services.

3. Make a photographic record of the condition of the object and of any subsequent alteration that may occur in the course of the study.

4. Keep a careful and detailed written record of all observations and findings, giving dates.

C. Preparing and Submitting the Report

On completion of the investigation, the investigator shall:

1. Render to the owner a typewritten report of his finding with conclusions, if conclusions have been requested. The report shall cover methods of testing, kind and type of instruments and equipment used and analytical procedures employed in sufficient detail so that, if the owner wishes, the tests can be repeated and checked on the same object by

an independent investigator in another laboratory. If it has been necessary, with the owner's permission, to take samples from the object, give location and amount of each sample. Give location and dosage of irradiations (e.g., exposure to X rays, gamma rays, iridium or other forms of radiant energy).

2. List all other persons who assisted or cooperated in the scientific investigation.

3. List what published works or authorities he has consulted in the course of the study.

4. State what limitations, if any, he may wish to place on the use of the findings. That is, whether or not the findings may be used voluntarily in legal proceedings; whether or not they may be quoted in formal publications or in oral declarations.

IV. PROCEDURE FOR ENGAGING IN AND REPORTING OF EXAMINATION AND TREATMENT OF HISTORIC AND ARTISTIC WORKS BY PROFESSIONAL CONSERVATORS IN INSTITUTIONS AND REGIONAL CENTERS

A. Report of Examination
Such reports shall include in writing the following information where applicable:

1. Date of examination and name of examiner.

2. Identification of object with the one referred to in the report by means of photographs, verbal descriptions, measurements and identification numbers.

3. Descriptions of materials, structure and method of fabrication. Physical, chemical and biological identification of materials composing the object. Statement of method of determination employed or referenced to published standard method.

4. Record of alteration and deterioration. Locations and extent of physical defects, chemical alteration and its products, previous repairs and compensation. Statement of method of determination sufficiently detailed to permit duplication by another examiner.

5. Deductions or interpretations of observations and analyses. Comments relative to the degree of alteration.

6. Where evidence indicates forgery, tests which can supply the necessary information on materials and structure shall be employed. After thoroughly checking his results, the examiner shall recommend consultation with one or two disinterested individuals qualified by scientific or art historical training to review the evidence.

B. Proposal for Treatment
Before any treatment is undertaken, a summary or copy of the examination record shall be supplied to the responsible custodian of the object. This shall be accompanied by:

1. A statement of exactly what conditions it is proposed to correct.

2. An outline of the proposed treatment.

3. An estimate of the probable time required for the treatment.

The official custodian's written approval shall be secured before treatment is begun.

C. Report of Treatment
Such report shall include where applicable:

1. A statement of the procedures followed in the current treatment with exact descriptions of materials and methods, including:

 (a) The method by which accretion or deterioration products were removed.

 (b) Method and materials used in correcting distortion in form and shape and in reinforcing, consolidating, stabilizing and protecting structure and surface.

 (c) Kind, extent, and location of compensation employed.

2. Photographs, as follows:

 (a) Condition before treatment, with date.

 (b) Photograph in "actual state" after accretion and deterioration products have been removed, but before compensation has begun.

 (c) Photograph, after treatment, with date.

 (d) Photographs as required to supply data about structure, method of fabrication and state of object as revealed during process of treatment. Photographs or diagrams which clarify method of reconstruction or compensation.

V. CONTRACTUAL PROCEDURES APPLYING TO EXAMINATION AND TREATMENT OF HISTORIC AND ARTISTIC WORKS BY PRIVATE PROFESSIONAL CONSERVATORS

These do not differ from those applying to institutional conservators except in the fields of contractual relations* and assumption of responsibility. Procedures in these fields shall include:

A. Written proposals stating:
1. Work to be done, estimated charges and estimated date of completion.

2. Arrangements for insurance and its specific coverage, method of delivery and provisions for safeguarding objects. (See VI.B.)

*It is recommended that a lawyer be consulted as to the adequacy of the contract until such time as a standard form is adopted.

3. Any subcontract or reassignment of work proposed.

B. A signed contract by the owner or his authorized agent, which may be a signed copy of the letter of proposal.

C. Agreement to give due notice to owner or custodial institution and to receive authorization before objects are removed from operating or storage building to a new location, unless such action is required for emergency safety reasons.

VI. OPERATING SAFETY PROCEDURES FOR CONSERVATORS

A. Safety of Personnel
All practitioners must follow the latest codes of the appropriate government regulations regarding occupational safety and health.*

1. **Radiation.** X-ray installation and operation procedures and use of radioactive sources should conform to approved specifications. Most state health or labor departments will supply an inspection service to determine the operating safety of radiographic installations.

2. **Toxic Vapors.** Adequate exhaust and ventilation must be a part of all laboratory installations where volatile toxic materials are habitually used. Appropriate vapor respirators should be available at all times.

3. **Mechanical Equipment.** Power tools of all kinds should be provided with adequate light, operating space and safety guards. Their use should be restricted to properly qualified and authorized persons. Cleanliness should be rigidly enforced. Instruments producing dust, abrasive powders and the like should be equipped with positive exhaust systems and operators should be provided with appropriate respirators.

4. **Corrosive Liquids.** Standard laboratory requirements for quantity storage and operating containers of acids, alkalis and other reagents as well as solvents should be rigidly followed. Only authorized personnel should have access to them. Disposal of chemicals should follow approved procedures.

B. Safety of Historic and Artistic Works
in the laboratory is of paramount importance.

1. **Protection Against Environmental Hazards** such as unsuitable levels of relative humidity, temperature, light and atmospheric pollution (including solvent vapors) should be provided.

*Up-to-date information may be obtained regionally through the U.S. Department of Labor, Occupational Safety and Health Administration area office listed in the telephone directory.

2. **Protection Against Theft.** Working and storage areas should be of adequate construction and capable of a systematic locking routine. Only authorized personnel should have access.

3. **Protection Against Accidental Damage.**
 (a) Working and storage areas should be adequate for safe handling and storage of objects. Individual storage racks for paintings and shelves for three-dimensional objects should be available. Working equipment should include sturdy, well-designed furniture such as tables, easels and horses.

 (b) Objects should be moved or handled only by experienced persons. Auxiliary personnel should not be permitted to handle objects without adequate training and supervision. They should not engage in activities for which they have inadequate professional training.

 (c) Objects should not be removed from the operating or storage building except on due notice and with authorization by the owner or custodial institution, except when required for safety reasons.

 (d) Transportation and packing of objects should be approved by agencies and according to established methods.

4. **Protection Against Fire.** Adequate precautions should be taken to meet the requirements of the particular insurance underwriter used. Working and storage areas should be equipped with alarm, smoke detection and extinguishing apparatus. Other parts of the building housing the studio or laboratory may not be used for purposes of a hazardous nature.

PART THREE — ENFORCEMENT
Violation of the AIC Code of Ethics and Standards of Practice can lead to revocation of a member's Fellowship. Upon receipt of substantial evidence of repeated violations in the face of notice and objection thereto from the Board of Directors of AIC, the board may take any action deemed necessary to protect the integrity of the institute. Such action shall be subject to appeal, review and final decision by the Grievances Committee described in the AIC Bylaws.

PART FOUR — AMENDMENTS
Amendments or changes in the Code of Ethics and Standards of Practice must be initiated by petition from at least five Fellows of AIC to the Board of Directors, who will direct the appropriate committee to prepare the amendments for vote. Acceptance into the code of amendments or changes must be affirmed by at least two-thirds of all AIC Fellows voting.